A Reading of Modern Art

Books by Dore Ashton

Abstract Art Before Columbus
Poets and the Past
Philip Guston
Redon, Moreau, and Bresdin (with John Rewald)
The Unknown Shore: A View of Contemporary Art
Thirty-four Drawings for Dante's Inferno
Modern American Sculpture
Richard Lindner
A Reading of Modern Art

A Reading of Modern Art

Revised Edition

Dore Ashton

Icon Editions
Harper & Row, Publishers
New York, Evanston, San Francisco, London

Published by arrangement with The Press of Case Western Reserve University.

STANDARD BOOK NUMBER: 06-430228-6

LIBRARY OF CONGRESS CATALOG CARD NUMBER: 68-19064

Foreword to the Revised Edition

The dilatory pace of the ruminative critic is less and less consonant with contemporary life. Swift social change coupled with unconscious technological habits of mind (such as the habit of stressing the "now" or of accumulating unevaluated facts) offer the critic countless obstacles to the measured development of his thoughts, and this situation he shares with the contemporary artist.

Very often the mechanics of writing a book, finding a publisher, and waiting for publication take years. By the time the first edition appears, the more topical references seem stale. When still more time elapses between the hardcover publication and the paperback edition, the author has very likely found many modifications and additions to his original thoughts.

When this book was begun in 1965, many of the issues that draw my attention today were scarcely visible. A friendly reviewer pointed out that "predictably, minimal art gets a fairly thin time," and he was quite right for the simple reason that minimal art was only faintly determined when I began the book. All the same, its fundamental concerns are not alien to one of the leitmotifs in the book—the urge toward "stripping" modern art to its barest essences. There were also many other variations on the modern tradition after 1965, and many other terminologies which, like minimalism, can still be linked with the incipient tendencies suggested in my text. It would make no sense to attempt to bring this essay into the present, especially as I am convinced that there is never a present in art history, but I have added a few afterthoughts in italics at the end of some chapters.

I wrote the book without attempting to be inclusive. Looking it over, I think that I might have talked a little more about one of the important germinative movements, Expressionism. I mention Kandinsky and his Blue Rider group, and their rapport with the French abstract painters, particularly Delaunay, but I neglect the other group, The Bridge, which was certainly influential in Europe before the First World War.

v

The Bridge, with its most forceful member, Ernst Ludwig Kirchner, was one of the earliest groups to express the twentieth-century artist's disaffection with the past. When Kirchner wrote about the group, he stressed their hatred for "bourgeois materialism" and stated that they hoped to attract "all the revolutionary and surging elements." Their program was deliberately vague, but stressed at all times both their determination to defy their own culture—artistically first, and by corollary, politically—and to defend the principle of the deep, communal sources of the art impulse. At the time when the Cubists were discovering African sculpture at the Trocadero, the Expressionists were discovering the art of the South Seas in the Dresden ethnological museum. In their wild desire to sweep away their own immediate past, The Bridge artists turned to the art of primitives and children, much as Dubuffet and, after him, Oldenburg were to do many decades later.

The Bridge artists differed from The Blue Rider largely in their suspicion that abstract art was basically decorative. Kirchner and his friends were interested in the expression of the human being—his inner being, how he felt about the world and not how he looked in it. Writing in the third person about himself, Kirchner said, "Kirchner grew to recognize that a new form, created from intensive study of nature with the aid of imagination, had a much stronger effect than naturalistic representation. He developed the hieroglyph." Of course Kirchner, whose favorite poet was Whitman, was remote from many of his contemporaries in the abstract movement, but his interests were extended frequently during the century. Gorky, as Breton said, treated nature as a cryptogram, and many others developed hieroglyphic vocabularies. De Kooning is more an heir to the Expressionists than most American critics like to concede.

The persistent interest in rendering the human figure in the twentieth century is probably deeply related to that brief moment of German Expressionism. (Also, the political aspects of the German movement take on special interest now as art is increasingly approached by politicizers.) More curiously, it can be related to what appears to be its very opposite, the Purist movement as conceived by Ozenfant and Jeanneret (Le Corbusier). Anthony Eardley, the British architect, has reminded me of this odd conception of Purism, which turns away from the strictly formal, universalizing tendency of other Purist strains. Both the founders were markedly concerned with the retention of the human figure. Ozen-

fant himself has stressed one sentence in the original manifesto written in 1918: "There is a hierarchy in the arts: decorative art at the bottom, and the human form at the top."

To the degree that I permitted myself to be topical in the first draft of this book, I included some observations on recent developments. They are of course no longer recent. The stirrings of cultural disarray were there, but not nearly as poignantly as they are today. The acceleration of distinct cultural change between 1965 and 1970 has cast a circuit of vastly confusing, clashing lights on the arts, and in some cases has obliterated the traditional clear outlines. Often in a period of swift change on all levels the artist is stimulated and strikes out in many directions with enthusiasm. He seems bound by no system, and is keenly aware of his individuality once released from measured rate of social change. But there also seems to be a point beyond which rapid change prohibits action, and throws up a barrage of conflicting values that it is hard to penetrate for meaning. I believe we are at the point now.

Most artists today are exceptionally uneasy. Many have abjured traditional ways of thinking about art. There have been significant upheavals which have spurred some of the most imaginative members of our society to challenge the entire context of the arts. The May events in Paris in 1968, and those in the United States in 1970, had a deeper reverberation in the art world than most commentators have remarked. It was probably not fortuitous that within those two years symptoms of the collapse of earlier assumptions, concerning both the arts and the nature of society, suddenly became visible. The many young artists all over the world who suddenly announced new roles for themselves were certainly acting because they found the traditional support hopelessly inadequate.

These rebels from tradition, and especially from the modern tradition as conveyed through painting and sculpture, operate variously. Some ply the narrow interstices between philosophy and science. They call themselves "conceptualists" and have abandoned the sensuous formative tradition in favor of intellectualized pursuits. They include geometers of a visionary stamp, littérateurs stressing the visual aspects of language, and, at the fringes, sophisticated epigones of the old Dada tradition. There are also transcontinental troubadors, celebrating a new vision of the universe composed of endlessly interlocking systems; they also borrow heavily

from the sciences. There are still others, avatars of the East, who stage their rebellion on a platform of antimaterialism. All of these artistic rebels share the frantic determination not to be contained by the traditional apparatus of the art world; not to be defined by school or nation; and not to accept any definitive set of values. In their eagerness not to accede to bourgeois demands for permanence, they mount campaigns against objects. Some move outside the art community into spaces beyond the pale—deserts, mountains, city streets. These centrifugal movements are, I think, symptomatic of the dissolution of most previous assumptions governing the evolution of modern art.

The pressures of social facts, such as the wars in Vietnam and elsewhere, the new awareness of technological destructive power, increasing loss of individual liberty everywhere, and the eminence of eschatalogical themes have become so immense that the arts are seriously affected. Everywhere critics and artists are discussing "counter-culture" which in its lowest form becomes agit prop art, but in its highest (yet to be defined) shows signs of true expression of a revolution in culture.

I see as part of the counter-culture psychology the serious efforts to formulate a philosophy of art that would be consonant with the feelings of doom that have accompanied us since The Bomb. Theoreticians have become increasingly unwilling to accept any of the long-range esthetic arguments, particularly those that suggest permanence, or eternal verities. There have been recurring efforts to forge an esthetic based on selected principles of phenomenology. Much of the work that has been exhibited in museums during the past two years as specifically ephemeral is categorized by its apologists as "anti-illusionist." By this they mean "a non-symbolic, non-ordered approach, one which does not depend on a conceptual framework to be understood," as Marcia Tucker, a curator at the Whitney Museum has written. She continues: "The work is realistic in the fullest sense because it does not rely on descriptive, poetic, or psychological referents. The approach is phenomenological in nature, dealing with the appearances and gestural modes by means of which physical things are presented to our consciousness."

Such "realism" nearly always carries with it an abnegation of past and future. It accepts the strictures of technological societies which are obliged to subsist on a determined fare of nowness. Several generations have worked within the depressing situation in which, as the young often

say, they feel they are powerless to effect change, and are forced to regard the future as extremely tentative. It is not surprising that artists and their commentators seek some esthetic orientation apposite to their experience in the world. By dismantling all previous esthetic constructions, they have hoped to find what they often call a "new vision."

It turns out that the new vision is borrowed from the psychologists who have studied perception, most notably Merleau-Ponty. Reversing procedures, the new-vision enthusiasts seem to study the texts and then make gestures to illustrate them. But a psychology of perception which tells us *how* we see is not always helpful in telling us *what* we see. A theory of perception is not necessarily a theory of art, as Merleau-Ponty would have been the first to suggest. When he wrote about Cézanne, he demonstrated that what we see is inexorably bound to our personality and our own imagination with its store of transformational possibilities.

Still, those who turn to phenomenology to impose some meaning on the chaotic diversity of what we see are serious witnesses of our period, where undoubtedly a new vision is being formed to replace the new vision that was formed at the turn of the century. Every epoch seems to broach its spiritual survival in terms of the (often illusory) new vision. Ours is not an exception. Observing these new veins of exploration, my view of the continuities and discontinuities in the twentieth century is in no way altered. Only the details change.

I want to thank Professor Frederick Thursz and Anthony Adams for their urging this book into paperback.

New York, January, 1971

Preface

The mission of the contemporary critic is often construed as a purgative activity, aimed at ridding commentary of ornamental maunderings. The modern critic is, with some justice, wary of poetic flights that depart from the work of art and travel great distances on their own momentum. But in the passionate effort to deal with essences, or things in themselves, much modern criticism has deleted a whole realm of experience.

The trouble with the purist or isolationist critical approach is not that it is in itself improper, but rather that it is arbitrarily limited. The first effort of the critic should be to see the unique quality inherent in a work, the quality that immediately attracts the receiver and moves him. But the critic must also remember that other action of a work of art: its expansiveness. If it moves us, it can move us emotionally, morally, psychologically, intellectually, historically, depending on a host of subtle considerations.

It seems to me that twentieth-century art must be considered in a double perspective. The individual work must be seen for its uniqueness, its inherent character—in other words *in itself*, lying wrapped in its own ambiance like the moth in the cocoon. And it must be seen in its other capacity, as a vital germ that incites the mind to allegorize.

In a sense, art history is nothing other than allegory. It need not be the linear allegory of textbooks. Twentieth-century art is not a relay race, in which one breathless runner holds out the torch to the next. Rather, it is like a globe on which each city, each topographical symbol becomes a subject for reflection. The horde of modern paintings, when they are brought together, serves symbolically as a signal for commentary. Each painting is like a city, unique in its own atmosphere. Yet, each city and town has something in common with its neighbor, if only in terms of common geography and temporal links. Like a big city, twentieth-century art has many *quartiers*.

Because on this metaphorical globe there is movement to and fro in time and space, and because each point exists in relationship to another, the history of modern art must be seen both in its grand lines (shared assumptions) and in its particulars. The main thoroughfares of modern art are well traveled, and the patterns of continuity and connection must be acknowledged. Moving through the annals of modern art is, in a way, like going through a dark room which is rather familiar: presences and even shapes are sensed. The context, the surroundings, even though only dimly apparent, are strongly influential.

In order to define these presences, allegory need not be comprehensive. It is enough to examine a few of the basic assumptions on which major twentieth-century artists have worked and to find their extensions. This essay, then, is decidedly turned away from all-inclusive historicity. I have, in fact, omitted many important aspects of modern art for various reasons. Among the reasons: certain movements, notably Cubism, have been exhaustively discussed already, and are familiar to most readers. It seems to me superfluous to stress once again the importance of Cubism to all modern art. Another, more personal, reason is that I myself have discussed other phases and aspects at length elsewhere, and do not wish to repeat myself. Since the essay form, unlike the general history, honors isolated insights and permits telescoping, or enlargement, or even poeticizing, I have not felt constrained to link each thought, but only each vein of inquiry.

A word about illustrations: I have discussed, wherever possible, works that are easily accessible. Sometimes I have even chosen broadly reproduced works deliberately, since my hope is not so much to add to the body of knowledge as to reach sensibilities. A great painting, such as Matisse's *Red Studio*, can never be examined frequently enough. The sequence of plates in the illustration section reflects the order of mention in the text.

I warmly thank Thalia Selz for her suggestions concerning this manuscript in its early stages, and Walter Kidney for his invaluable editing.

Many of the ideas broached in this essay were explored first in *Arts & Architecture* and in *Studio International*. I have received

grants from the Graham Foundation and the Guggenheim Foundation, for which I am most grateful, since they helped me find the time to write.

Dore Ashton
New York, 1967

Contents

Illustrations

1

A World Without Walls

In Matisse's lucid essay "Notes of a Painter," published in 1908, he said that he wanted to reach that "state of condensation of sensations which constitutes a picture."[1] When he chose the word "condensation," Matisse threw into relief a basic assumption of twentieth-century art, an assumption inherited from the nineteenth century, which had long before questioned the propriety of imitative painting clogged with specious detail. Long before Matisse, painters had been seeking an ideal of simplicity. The driving current at the turn of the century, which caught the major talents in its momentum, was streaming toward what Matisse called a condensation of sensation.

Simplicity was believed to be derived from intuitional choices—that is, choices which flared in the imagination of the painter as he worked, without conscious preparation. Even Matisse, so stable and reflective an artist, whose work is often aligned in the "rational" French tradition, waited anxiously throughout his life for those moments of intuitional enlightenment. When Matisse was working in Collioure, a small, bleached, sunswept southern French port not far from Spain, he asked a visiting acquaintance to look at a picture that he said had just been painted by the local postman. The postman, he remarked offhandedly, had been taking an interest in his paintings, but the small picture which Matisse tried to pass off as the work of the postman was in fact his own *Pink Onions*. The misrepresentation was a sign of the insecurity of an artist who has been visited by an intuitional insight and is not sure of its value. In fact, in *Pink Onions*, Matisse had found a new kind

of condensation, a dazzling, direct treatment of his subject in low
relief, painted in planes that scarcely recede. This original conden-
sation was to lead to fundamental innovations just a few years
later.

Another anecdote reveals Matisse's readiness for the impor-
tant shock of intuition. A friend visited his studio when his great
Dance was stretched out on the floor. Matisse, having for the mo-
ment forgotten it was there, saw it suddenly out of the corner of his
eye and jumped back in astonishment. The artist's surprise in the
face of his own audacity is an essential experience in the twentieth
century. At about the same time, Kandinsky made his own crucial
discovery:

> I was returning immersed in thought from my sketching when,
> on opening the studio door, I was suddenly confronted by a pic-
> ture of indescribable and incandescent loveliness. Bewildered I
> stopped; staring at it. . . . Finally, I approached closer and, only
> then, recognized it for what it really was—my own painting,
> standing on its side on the easel.[2]

Matisse told Guillaume Apollinaire in a 1907 interview that he
had developed his style by counting above all on intuition and
"returning again and again to fundamentals."[3] Matisse understood
that the fundamentals revealed by the free play of his intuition
would alter painting radically, and his conversation with Apolli-
naire undoubtedly took place in an atmosphere of mutual sym-
pathy. Apollinaire, that gadfly whose writings range from su-
premely refined poetry to precious journalism, had already declared
for the *esprit nouveau*, the new spirit which would revolutionize
the arts. Matisse and the other major talents of his generation ex-
pressed the new spirit mainly in their conception of spaces.

We recognize the spaces in paintings as metaphorical. Who can
remain unaltered when entering Matisse's azure paradise in *Dance*,
and who, to this day, is not as pleasurably shocked as was Matisse
himself by its profound simplicity? Matisse did not write about this
new experience; he lived it, painted it. He shared the assumptions
and aspirations of his time, those furnishings of the darkened
room, as he said every man must. "Whether we want it or not,
between our period and ourselves an indissoluble bond is estab-
lished."[4]

These new spaces had been expressed in the vision of poets such as Mallarmé (the opaque spaces in which past and present, here and there, circulate and touch unaccountably); of philosophers such as Bergson; of writers such as Proust (panoramas composed of intimate details, paradoxes of minute relief and vastness); and of such a dreamer of the cosmos (and yet a neighborhood gossip) as Baudelaire. These new spaces were Matisse's heritage, property inherited by him as well as by the others. Few, however, were as aware as he of the nature of this property.

Matisse's few public statements have been studied assiduously, each generation of students taking what it needed from them. But there are passages which only now, as the century enters its last third, emerge luminously in relief. He wished, he said, to render his emotion only, "a state of the soul created by the objects which surround me and influence me, all the way from the horizon to myself."[5] Here—in his "all the way from the horizon to myself"—Matisse states a conception of pictorial space that radically differs from anything that went before. The horizon, far away, a boundary of vastness, is brought into the room with the painter in a paradoxical, a psychological way. The dialectic of cosmos and microcosmos, as the philosophers would designate it, is stated with striking simplicity.

Far from being exclusively concerned with the things of his life —the pots, shawls, models, windows, hats, easels, and southern palms—Matisse was participating in the great spiritual adventure of twentieth-century painting: the search for a new gauge for time and space. Exactly how he saw his working spaces can be judged from his description:

> Often, I put myself into my picture and I am conscious of what exists behind me. I express space and the objects situated in it just as naturally as if I had before me only the sea and the sky, that is to say, the simplest things in the world. I say this to indicate that unity is not hard for me to obtain for it comes to me naturally: I think only of rendering my emotion.[6]

"Only the sea and the sky . . ." Those who have avoided this aspect of Matisse's emotion, this affinity for the apprehension of great spaces, are mistaken. Matisse took his first journey to the great spaces when he set out for Algeria in 1906. Many nineteenth-cen-

tury painters had made their voyages into the exotic colonies be-
fore him, seeking local color and new sensations of light. Matisse's
reasons for going were probably largely traditional, yet he claimed
specifically that he went to see the desert. The desert, the sky, the
sea are brilliant, vast references against which Matisse pits his sense
of intimate relationships.

Like Apollinaire, who sang of the new century with its great
technical potentials; like Saint-Exupéry, who sang of the new vistas
made possible by flying; like Gertrude Stein, who thought Picasso's
paintings were best understood after you had been up in a plane,
Matisse was aware, curious, excited by the newly revealed spaces.
Twice in the few public statements by him, he uses the experience
of flying for metaphorical purposes. Once, he objects to the mod-
ern method of projecting a picture, exactly copied, from a smaller
to a larger canvas, saying that "the man with a searchlight trying
to pick out an aeroplane in the immensity of the sky does not
traverse it in the sense that the aviator does."[7] Elsewhere, he says
that the role of the artist, like that of the scholar, consists in pene-
trating truths as well known to others as to him, but which will
henceforth take on a new meaning. "Thus, if aviators were to ex-
plain to us the researches which led to their leaving earth and ris-
ing in the air, they would be merely confirming very elementary
principles of physics neglected by less successful inventors."[8]

In 1942, answering a reporter's simple question, How do you ex-
plain the charm of your paintings of open windows? Matisse an-
swered: "Probably from the fact that for me the space from the
horizon to the inside of the room is continuous and that the boat
which passes lives in the same space as the familiar objects around
me: the wall around the window does not create two worlds. . . ."[9]

Matisse no doubt knew of the tremendous shift in philosophic
notions of space and time. As he said, aviators merely confirmed
very elementary principles of physics. He himself merely confirmed
very elementary principles of philosophy; he did it through expe-
rience. If such notions as the space-time continuum were beginning
to take root in the universal consciousness, Matisse was shaping a
parallel vision through his work: the wall around the window does
not create two worlds.

In text after text, utterance after utterance, the artists of the early

part of the century established the philosophical distinction between cosmos and chaos—cosmos in its secondary sense of a self-inclusive system characterized by order, harmony, and complexity of detail. Apollinaire had made clear, in the 1907 interview, that the late nineteenth-century preoccupation with the unconscious, with the natural unity sensed in the non-rational stream of life, was finding exemplars in twentieth-century artists who *lived* the theories the speculation had posited. Instinct was found again, he said of Matisse's efforts at simplification: "You at last subordinated your human consciousness to the natural unconscious." And, in the diction which recurs in many early twentieth-century texts, "To make order out of chaos—that is creation." That order, exemplified in a painting, is the room in which the wall around the window does not create two worlds.

How Matisse arrived at this world, so lucid, so instinctively correct, cannot be narrated, for he arrived within the painting. Instinct, the need to find elemental unity, led him wordlessly through a series of reductions to that condensation of sensation that he extolled as his aim. When Bonnard visited Matisse's studio, he asked why Matisse had painted the figures in *Dance* all one color. Matisse replied:

> I know the sky throws a blue reflection on the figures and the grass a green one. Perhaps I should indicate some light and shade, but what's the use of complicating my problem? It's of no value in the picture and would interfere with what I want to say.[10]

Bonnard also erased the wall around the window. What he had to say in his paintings was given in terms of the same continuity of light, the same roundelay of objects related to figures, walls related to sky, gardens related to seas of light. The coursing flow of strokes bringing teeming life to the simplest subjects was Bonnard's means to cosmos. When he painted a nude in a bathtub, the contrapuntal flutter of light reflected from water, from flesh, from tiles did not come from outside the canvas, and, indeed, served to make a unity which does not complicate Bonnard's problem but sets it up as identical with Matisse's.

Bonnard became convinced, while still a student, that a paint-

ing had a voice of its own quite independent of motif. He was of
the generation that listened respectfully to Gauguin, who had de-
clared war on naturalistic art. He participated in the "Nabis"
group that enthusiastically adopted Symbolist principles and held,
with Mallarmé, that to *name* an object is to destroy poetic enjoy-
ment. In recalling the days of student ferment in the early 1890s,
when Bonnard had participated in philosophic discussions about
painting with many gifted artists and poets, Maurice Denis noted
that the young artists went out toward those who made a clean
sweep not only of academic teachings but, above all, of naturalism,
either romantic or photographic.

"The starting point of a picture is an idea,"[11] Bonnard said late
in his career, and that idea in his own work remained very close to
the revolutionary poetic idea of Mallarmé, who spoke of "the vola-
tile dispersion that is the spirit which is only concerned with the
musicality of the whole." Throughout Bonnard's mature work,
there is a "volatile dispersion" which refuses to accede to the de-
mands of commonplace seeing. It was no mere commentary on the
idiosyncrasies of perception that made Bonnard blur his figures
and merge them with animate and inanimate forms. Rather, it was
a vision of a universal continuum, of an *idea* embodied and em-
bedded in the perceived world. That "idea" could as well be set
forth in a scene of a nude bathing in a middle-class bathroom as in
one of a basket of fruit on a table near a window. And it was not
essentially different from the ideas of Matisse and later generations
of twentieth-century revolutionists in painting. It was an extension
of the Symbolist notion of the relatedness of all things and experi-
ences, of analogy that likens the unlike, and places all life within a
large, cosmically conceived space.

Bonnard's insistence on what Mallarmé called the "musicality
of the whole," translated so matter-of-factly in his own definition
of a painting, is felt throughout his art ("A painting is a series of
spots which are joined together and ultimately form the object, the
unit over which the eye wanders without obstruction").[12] His fre-
quent assertion that he worked only from memory in order to stay
close to his initial conception is borne out in the thoroughly imag-
inative cast of his work, in which no law is sacred. He ignores West-

ern perspective, he deforms figures and objects to suit his overall vision, he disdains the laws of color and is not concerned with exact definition. His allusions to objects are always oblique and must never be read in isolated terms.

Bonnard's concern with what might be called the abstract properties of painting was evident at the very beginning, when he was still influenced by Japanese prints and painted his views of Paris in their bold, structurally ornamental modes. It was to be seen after the turn of the century, when he lightened his palette and let in some of the Impressionist air, but persisted in placing queer accents of color that could not by the furthest stretch of the imagination be taken as naturalistically observed. It had attained its highest development by 1913, when he painted equivocal masterpieces such as the Minneapolis *Dining Room in the Country*. Equivocal, because Bonnard works with the principle of analogy, in which outside—the luminous garden—and inside—the blue dining table—are continuous. Equivocal, because the woman leans inward, her face lost in shadow while the cat on the inside is as bright as the distant flowering tree; because in this world, light circles without obvious source or impetus, and the light is the illumination of the imagination; because the artist challenges us to distinguish between the warmth of a red wall and the warmth of identically red poppies.

If there is any doubt that the motif, for Bonnard, was a cue, or even a pretext, for the imagination, the remarkable group of paintings of nudes in bathrooms, on which he worked during the last fifteen years of his life, dispels it. In these fantasies—for they are far from being the intimist's modest observations—Bonnard suggests a universe. As in his landscapes, it is a universe animated by uncanny light—light which seems to have its sources somewhere within the paint itself and which is self-generating. It flickers softly over flesh, and stirs the still bath waters in irregular rhythms; it picks up a fiery tile here, a slithering drape there, and lodges unaccountably on the wall. Above all, the light accents the elliptical character of Bonnard's composing, stressing the closed, round poetry of cosmos.

In the bathroom fantasies, as in the Midi landscapes and in the

wonderful breakfast-table scenes, in which table extends to curtain, which extends to window, which extends to tree, and so on, there is a complicated pattern of analogy, transfigured by light. (Of his Midi landscapes Bonnard related that it is "that southern light during certain hours which—over great spaces—becomes the principal subject of a sensitive artist.") In the bathroom scenes, the "great spaces" are brought into the interior in a thoroughly contemporary concept, parallel to that of Matisse.

2

The Wheel of Space

The dialectic of cosmos and chaos may seem a disproportionate philosophic tool when applied to something so simple as a Bonnard interior or a Matisse studio view. Both painters, after all, dealt with aspects of common pleasure: color, the harmonious dispersion of intimate objects, the tender observation of human presence. But always we are brought back to the meaning, for Bonnard and Matisse did not doubt that a painting always speaks of *something.* Clinging to the nineteenth-century revolutionary theory that a painting is first of all a plane surface covered with forms and colors, Apollinaire wanted to make clear that Matisse's eloquence "comes first of all from the combination of colors and lines."[1] But he sensed, as we sense, that this combination had a meaning that went beyond a quick perception of colors and lines.

Matisse's "Notes of a Painter" must have created a lively discussion of meaning beyond ornamental appearances when it appeared, since in it Matisse makes a point of clarifying his attitude toward expression in a tone that is somewhat defensive. Noting that he is accused of not being able to proceed "beyond a purely visual satisfaction such as can be procured from the mere sight of a picture," he defends himself by establishing the principle that the whole arrangement of a picture is expressive. "The place occupied by figures or objects, the empty spaces around them, the proportions, everything plays a part."[2] Meaning, for Matisse, is embedded in the whole space of the composition, and not merely in salient details.

The meaning is not necessarily expressible in words. *Dance,* for instance, contains more than words can convey, for the shock that

Matisse himself experienced from it is also our shock, and we know that it is something essentially separate from whatever we may say about the picture. In words, we could only say: It has three colors; it has five figures which become one in an elliptical garland, a green hillock for a groundline, and an infinitely blue, flat, skylike background, pressing the circlet of figures forward. That is all that can be said in objective descriptive language, all that exists in a plastic sense.

Matisse, however, arrived at this composition only after a number of prior experiments. It has a history, one that has been absorbed by the final picture but that is nevertheless there, part of its richness, just as the aspect of the human face reflects something of where it has been and through what circumstances it has passed. What leaps into our imagination from *Dance* is not the simple combination of line and color but the deep original sense of life that inspired it. To receive from a painting, as certain contemporary critics advocate, a mere awareness of its plastic quality, or even of its power to move us into its world, is to cut short our experience with it. It moves in other directions as well, directions that have to do with history and the general currents of thought. The painting culture out of which Matisse grew was important to him, and it is important to us as his interpreters.

Dance, in its historical context, can be seen as the epitome of a theory of art formulated but not realized in the nineteenth century. That century pondered certain esthetic problems, among them the role of imitation in painting. Decade by decade, nineteenth-century thinkers moved toward a conception of painting as independent of the subjects depicted. Gradually, the painter assumed the conscious position that what he was painting was not so much the particular still life or nude as an analogue of the whole within which the still life or nude exists.

Delacroix, who was probably the first painter to give an eloquent form to the ideas that had already been circulating in the early nineteenth century, phrased in an oblique way his premonitions of the future of painting. Perhaps the most pertinent of Delacroix's observations was his allusion to the "musicality" of painting. In various texts and in notes in his journal he alluded to a

quality in a painting that resembles music more than conventional painting. The music of a picture, Baudelaire later elucidated, is felt when you are far enough away so that you do not see the sharp outline of particular details. He was an attentive student, and it was from Delacroix that he took this notion of "melody" in painting. In his "Salon of 1846," Baudelaire defined his terms: Melody is unity within color. Melody calls for a cadence; it is a whole, in which every effect contributes to the general effect. Baudelaire declared,

> The right way to know if a picture is melodious is to look at it from far enough away to make it impossible to understand its subject or to distinguish its lines. If it is melodious, it already has a meaning and has already taken its place in your store of memories.[3]

Probably from Delacroix, again, Baudelaire adopted the notion of the arabesque—a term that threads the art fabric of the century and carries connotations beyond its simple dictionary sense as a style of interlacing ornament. Baudelaire wrote in his 1863 essay on Delacroix: "A well-drawn figure fills you with a pleasure that is absolutely divorced from its subject. Whether voluptuous or awe-inspiring, this figure will owe its entire charm to the arabesque which it cuts in space."[4]

The arabesque, as Baudelaire used it, and as painters such as Gauguin and Gustave Moreau, Matisse's teacher, were to use it later, is an abstraction from the chaos of the many disparate elements in existence. It symbolizes philosophically the rhythms of the universe. Matisse, as a student of Moreau, must have known Moreau's idea that "art is dead when, in the composition, the reasonable combination of the mind and good sense come to replace in the artist the almost purely plastic imaginative conception—in a word, the Love of the Arabesque."[5] The arabesque, then, was not only a direct emblem of the painter's spirit, but also an abstract conception of space—the space in which the imagination summarizes our *sensations* of space. Matisse was certainly well aware of the prior theories of musicality and arabesque when he painted *Dance*, and in the bluest of blues, which he worked diligently to achieve

there, he expressed the unity of sensation, the single world that eliminates the schism between the observer and observed.

Matisse knew Mallarmé's poetry and years later was to make one of the most beautiful books ever printed of Mallarmé's collected works. In describing his working procedure on this project, Matisse refers to his arabesque:

> The problem was then to balance the two pages—one white, with the etching, and one comparatively black with the printing.
> I obtained my goal by modifying my arabesque in such a way that the attention of the spectator would be interested as much by the white page as by his expectation of reading the text.[6]

Dance, in its emphasis on rhythm in the main line which forms the tilted ellipse in a narrow midplane, as well as in the intervals between the figures, shows an accretion of inherited attitudes toward musicality, or rhythm, in painting. Matisse echoed Delacroix, Baudelaire, and the train of Symbolists when, one year before painting *Dance*, he wrote in "Notes of a Painter": "A work of art must carry in itself its complete significance and impose it upon the beholder even before he can identify the subject matter."[7]

In simplifying his colors and eliminating all distracting detail, Matisse was obeying an injunction implicit in the theories of late nineteenth-century Symbolists, and more particularly of Gauguin. (Although Matisse's son-in-law Georges Duthuit has stated that Matisse was never particularly interested in Gauguin, we know that, very early in his career, Matisse purchased a small drawing by Gauguin, and we are aware as well of the testimony of Alfred Barr, who tells us that Matisse was indeed interested in Gauguin, Gauguin who said, "Why embellish things gratuitously and of set purpose? By this means the true flavor of each person, flower, man, or tree disappears.")[8] Matisse said:

> I do not insist upon the details of a face. Though I happen to have an Italian model whose appearance at first suggests nothing but a purely animal existence, yet I succeed in picking out among the lines of his face those which suggest that deep gravity which persists in every human being.[9]

Matisse was in the line of the idealists, certainly, and his concep-

tion of painting was more in harmony with that of the Symbolists than of the Impressionists. His leaning toward the Symbolist esthetic is visible in his break with Impressionist color principles. Contrary to Impressionist practice, he used black, considering it the summary of light. His *Open Window* of 1914 is an emphatic demonstration of the symbolic value of black, for there can be no doubt that this is a bright picture, painted in a bright place. When Matisse took some of his paintings to Renoir in 1918, he astonished the aged Impressionist with the way he used broad planes of color and, above all, the way his blacks and his blues held the plane. By all Impressionist principles, these elements should have fallen out of the composition.

Yet Matisse greatly admired Cézanne, whom he set apart from the Impressionists when he remarked that "a Cézanne is a moment of the artist, while a Sisley is a moment of nature."[10] He studied Cézanne religiously, particularly his compositions. He owned a small *Bathers* by Cézanne, cherished it, and obviously was interested in the way the artist had posed his group and its environment close to the picture plane, so that the painting reads as a continuing, intricately articulated fusion of figure and ground.

Like many European painters, Matisse was a man of "painting culture." The artistic discourse in the history of European painting found a sympathetic student in him. He told Apollinaire that he had never avoided the influence of others. His work reflects his intelligent perusal of painting history. He was interested in Near Eastern art, taking note of the azure grounds of miniatures and their purity of high-keyed color. "Inspiration has always come to me from the Orient," he said. "Persian miniatures . . . revealed to me all the possibilities of my senses. Because of its dense detail, this art suggests a larger space, a truly plastic space, and it helped me to go beyond intimate painting."[11]

If defining a new sense of space largely in terms of color was Matisse's revolutionary contribution, his attitude—inherited from nineteenth-century speculation—that all painting comes from and expresses the self must not pass out of focus. Despite the seemingly objective character of his work, its classicism, and sometimes its rigorous pictorial logic, Matisse was conditioned to think of his art as an expression of his "self." He told Apollinaire that he had

scanned his early works, seeking the permanent traits of his painting personality, and that he had consciously developed those characteristics he felt were true of his "self," or his painting personality. He later spoke less of self-revelation, though he never abandoned the idea that art is primarily the summary of sensations of a particular self. In the well-known 1942 radio broadcast he told the interviewer that he painted "to translate my emotions, my feelings, and the reactions of my sensibility into color and design."[12] His preoccupation with his emotions and feelings, and above all with his "self," never led Matisse into the kind of psychological excavations favored by more expressionistic temperaments. Yet, it is the psychological bias pervading the late nineteenth century which is transmitted in his attitude: the bias reflected in painters (Delacroix), in writers (Rimbaud, Dostoyevsky, Flaubert), and even in composers (the whole Wagnerian group).

In the conviction that there is a reality that the painter can seize "underneath this succession of moments which constitute the superficial existence of things animate and inanimate and which is continually obscuring and transforming them,"[13] Matisse accepted the orthodox Symbolist position, the idealist position. But when he insists that the "self," and more particularly the "inner feeling" or "intuition," of the artist will determine this reality, he moves into the twentieth century. It is no longer the "idea in mind" to which the Symbolists faithfully adhered which motivates Matisse. Rather, it is the idea as it evolves in the working, as it expresses itself while Matisse is condensing his sensations.

Space, then, is no longer that which surrounds Matisse, or that within which obstacles are scattered. It is a living medium in and through which he experiences his sensations. Matisse is the direct instrument of space sensation, just as Saint-Exupéry described his flying experiences as though he, and not the machine, were the instrument. Matisse traverses the blue sky in *Dance*, and we are drawn along after him.

He was not alone in his new awareness. At the turn of the century, everyone with curiosity and a gift for interpreting trends had discovered the new concepts evolved by science: concepts that presaged the elimination of Cartesian dualism and the erasure of boundaries between observer and observed. "Whenever we speak

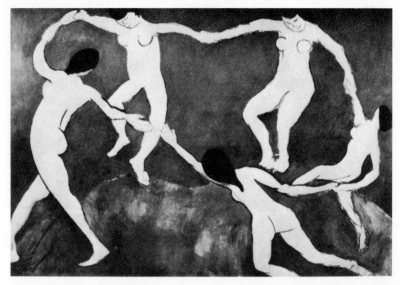

Oil on canvas, 8′ 6⅝″ x 12′ 9⅝″.
Collection, The Museum of Modern Art, New York. Gift of Gov. Nelson A. Rockefeller in honor of Alfred A. Barr, Jr.

1. Henri Matisse: Dance, 1909.

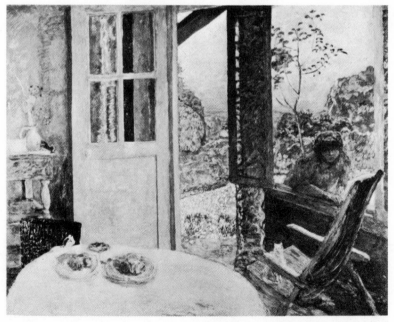

Oil on canvas, 5′ 3″ x 6′ 8″.
Collection, The Minneapolis Institute of Arts.

2. Pierre Bonnard: Dining Room in the Country, 1913.

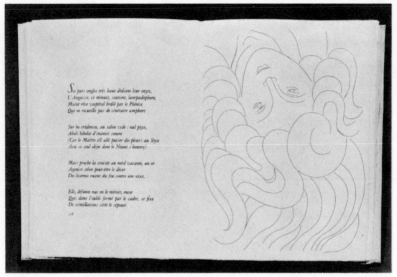

Etching, 12⅛" x 9½".
Collection, The Museum of Modern Art, New York. Abby Aldrich Rockefeller Purchase Fund.

3. Henri Matisse: Illustration for sonnet beginning,
"La Chevelure vol d'une flamme," from Poésies de Stéphane Mallarmé,
published by Albert Skira, Lausanne, 1932.

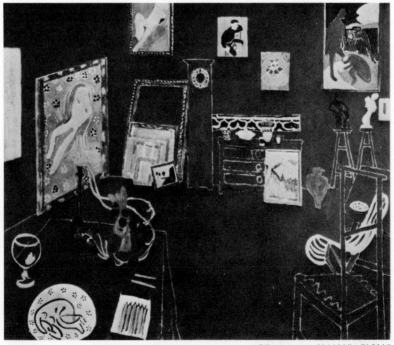

Oil on canvas, 5' 11¼" x 7' 2¼".
Collection, The Museum of Modern Art, New York. Mrs. Simon Guggenheim Fund.

4. Henri Matisse: The Red Studio, 1911.

about nature," Apollinaire had written in conclusion of his Matisse interview,

> we must not forget that we are part of it and that we must look at ourselves with as much curiosity and sincerity as if we were looking at a tree, a sky or an idea. Because there is a relationship between ourselves and the rest of the universe, we can discover it and then no longer try to go beyond it.[14]

It is this relationship that Matisse discovered, independent of science, psychology, philosophy, through putting himself in the center of his composition and eliminating conventions, so that a wall no longer constitutes a separation between two worlds.

One of the brilliant paintings reflecting Matisse's radical new conception of picture space is *The Red Studio* of 1911. This picture, which I believe has played a traceable role in the evolution of modern painting, was first exhibited in the United States in the 1913 Armory Show. It was widely reproduced and, though not purchased by the Museum of Modern Art until the late 1940s, was familiar to many American painters. In painting a space that, because it is entirely in a single hue, seems uniquely self-contained, Matisse extends the ideas broached in *Dance*. The composition of forms assumes the same elliptical shape around a central void. This circular sensation is reinforced by Matisse's arabesque, the coiling line of the vine flaring out from the green vase and the twist of the wicker chair. The off-center green vase is the nearest thing to a vertical axis around which objects (images in Matisse's own paintings) glide in a circular movement. Red from floor to ceiling, the room is at once flat—a marked plane surface—and deep. It is a room. A room in which Matisse, and we the spectators, reign calmly from a central, invisible position. The wheel of space, carefully punctuated with forms that in their similitudes echo and re-echo, turns and creates a totality that goes beyond room, studio, or inventory of pictures and objects. It becomes the universe, the one-world perceived first in its mysterious harmony and only later as a subject. ("Often I put myself in my picture and am aware of all that exists behind me. . . .")

But despite its appearance of simplicity, it is a complicated unity Matisse envisions. He has placed objects in new and daring relationships. He has invoked asymmetry and posed riddles of large and small. The idea of simultaneity is expressed in the relatively

equal sizes of things very differently allocated in space. Here Matisse enters the discourse, so much emphasized lately, of the place of things in man's universe and even of man's own stature in his "situation."

Already in *Dance*, Matisse had reversed the conventional conception of man's stance, for the figures below—presumably closer to us—are smaller than the figures above. The difference between Matisse's *Dance* and Rubens' *La Kermesse* is fundamental, for Rubens still tells of a specific place, marked off by a specific perspective, in which figures wind away from us in a clear progression from near to far.

Matisse already sensed the idea of total situation which was to overtake modern psychology. He had already stated the interaction of man and his environment in his *Piano Lesson*, in which a strip of color is gently hollowed below to echo the head of the boy, clearly stating the existence of the boy only in terms of a spatial and psychological situation. The "ambiance" is thoroughly taken into account. Cézanne, Kandinsky said, had the gift of divining the internal life in everything, and the same intention, he went on to say, actuates Matisse; and, in an observation formed perhaps with Matisse's influence, he declared, "The new harmony demands that the inner plane of a picture should remain one, though the canvas may be divided into many planes and filled with outer discords."[15] This, written perhaps while Matisse was painting *The Red Studio*, almost describes it.

I had never seen La Musique (1910) *when I wrote this chapter. The great painting from* The Hermitage, *coming between* The Dance *and* The Red Studio *would have enhanced the discussion. But what would I have said? When I finally saw it, I realized that it is not transmissible in words. It is a stunning experience. No amount of dredging could ever reveal its sources. The way the figures in their dense, Pompeian-red integrity nest in the green hillock is unprecedented. Matisse's inspired rendering of the impact of music, with its arabesque of discrete figures, and its tremendous vibrato (no color illustration has yet captured the variations in the red, or the coruscating, minute oscillations within the green and deep blue fields) is, like all indisputable masterpieces, utterly inexplicable.*

3

Beyond the Arabesque

Just as real time, or time as we experience it, is irreversible, so is the story of painting. If the assumptions underlying the revolutionary work of Matisse are still viable, they are nonetheless different when they pass from Matisse's generation to succeeding generations. The painter who routes himself through his century, successively reenacting the illuminations that constitute the history of art in that century (and one valid illumination is that the artist must pass beyond the history of his art), carries within him the mark of his voyage. This image of what lies behind him, stage after stage, is modified a thousand times in the course of his work, fuses with the upspringing of the new, and creates an advancing context that itself is continually modified. The richest painting is the painting that draws us forward from recognizable assumptions to the new. Such painting can be seen as part of the flow, the peculiar "progress," of modern painting, and also as something distinct.

It can be said that a painter as original as Mark Rothko works from the identical principle of condensation enunciated by Matisse. But through him, the principle finds radically different expression. Rothko has said that he and all painters of his generation were trained to study the human figure but that eventually it was impossible to render the figure without mutilating it. "If I couldn't find ways of dealing with nature without mutilating it, I felt I had to find other ways to deal with human values."[1] Why couldn't Rothko and other painters of his generation deal with the human figure? Rothko implies that cultural circumstance is the explanation. The extravagant gestures of ancient art were based on a per-

ception of reality that came to be regarded as mythic. Since he feels an absence of true myth in his own period, the gestures, for Rothko, become ridiculous.

But although this is one explanation, there is another which is quite as compelling. Rothko could not render objects or the figure because he, like Matisse before him, recognized the imperatives of his moment—imperatives that descended to him from the past of painting culture and with which he was obliged to contend, once he had reenacted the experiences of modern art in his own work. Like the traveler preparing to ascend the mountain, Rothko went through his luggage carefully, throwing out everything that was unnecessary or that was a product of the successful illuminations of his predecessors. That which has already been said need not be repeated.

For all his revolutionary genuis, Rothko worked within the twentieth-century assumptions already established, but did so in order to formulate new assumptions. In a sense, Rothko's paintings would be unthinkable without *The Red Studio*. In many ways Rothko is an Orphist, in Apollinaire's use of the term. In most of his work he has dispensed with definite objects, with the human figure, with perspective, Cubist or otherwise, with line, in order to concentrate on color and light exclusively. Robert Goldwater has written that Rothko's concern over the years has been the reduction of his vehicle to the unique colored surface which represents nothing and suggests nothing else. But while this has certainly been one of Rothko's tendencies, and while it accurately refers to the aims defined in the early part of the century for a "pure art," it is only a partial interpretation of his art. Like others of his generation, he has inherited both the tradition and the contradictions inherent in the tradition, and it is the struggle with the contradictions that is interesting.

Over the years, Rothko has again and again insisted that he is a "materialist," that his painting deals with "human values," that it is the human drama that interests him. He, along with Adolph Gottlieb, declared in a much-quoted letter to the *New York Times* in June 1943 that a painting must have a subject that is timeless: Presumably this "subject" is derived from experience, from "na-

ture," and is implicit in a painting rather than explicit. This is the
same elusive "subject" described by Matisse when he spoke of the
relative unimportance of detail, and explained to Bonnard that nat-
uralistic detail could only get in the way of what he wished to ex-
press.

Rothko's subject, then, is a continuation of the idea that there is
a single medium within which all life transpires. His subject is
the expression of the condition of being moved. He has noticed,
with the painter's instinctive accuracy, that certain illusions of
color, certain manifestations of form, can be said to "move" the
viewer. Not only do the muscles of the eye move, but something
also is transmitted to the brain to communicate feeling, either joy-
ous or portentous, something scarcely utterable in words is *con-
veyed* in the language of painting.

Rothko's paintings are agents. They are agents of reciprocity.
There is light concealed within them, but it is light that is like a
flower: it opens out only when responding to light. It answers as
sensitively as the eye itself, shrinking from too much glaring light,
straining forward from too little. Rothko's paintings are like living
organisms; they have a pulse, even a soul. The pulse is revealed
clearly on contemplation, for as the light of day moves into its vari-
ous cycles, so does the light of the painting, slowly transfiguring
the canvas. These paintings breathe and exhale pure light, but they
are paintings nevertheless. Each layer of paint serves to activate
the core that will spread into visibility under the right conditions.
Each caesura of vague, smoky space between emphatic colors serves
to intensify the impression of rhythmic breathing, or organic readi-
ness to respond.

Rothko inherited the problem of the painter: to suggest a fully
spatial experience on a flat surface. His contribution: the paradox
remains (didn't he say that tension is an important ingredient in
painting?), but the space is apprehended in a new way; a new
mode of seeing and feeling is introduced. He inherited a category:
space-time. A painter of Rothko's generation takes it for granted
that space-time is a valid "subject" for a painting. Quite simply,
space is revealed in time—or rather, spaces. For in these paintings,
as light moves, so do the forms; the slow movement of the forms

(not only the large simplicity of the rectangular forms but the implicit forms that reside behind the surface as massed deep tones or massed saturated hues) makes new spaces. Rothko's paintings reveal themselves only in time.

In his work Rothko has answered affirmatively the questions posed by Matisse's generation concerning light, color, space. He added to, or rather carried to a logical conclusion, Matisse's insight that he stood in the middle of his universe and that he *sensed* the space behind him. When Rothko spoke of "intimacy" (he said he painted large pictures to induce a state of intimacy), or when he attempted to engulf us in the atmosphere of his painting, he was indicating that his paintings are not to be "read" in the conventional sense. There are no lines of perspective for the mind to sort out, no objects rhyming, no clear progression of planes. Rather, the viewer opens himself to the experience in space-time, and goes through the cycles of the paintings as Rothko himself did. This is why contemplation is the only means of discovery in a Rothko.

Discovery—one can almost use it in the Aristotelian sense, for each veil of color and each slowly transpiring mass is calculated by the artist to work toward the moment of "discovery." Rothko frequently speaks in terms of the drama, and it would not be far-fetched to analyze his paintings in terms of the categories determined by Aristotle. He himself has spoken of the ingredients of a work of art in classical terms, designating irony, for instance, as most important. The moment of discovery or revelation, then, is of signal importance in the apprehension of Rothko's paintings.

The notion of contemplation has changed with time, and it is important to distinguish between the mode of contemplation practiced by the nineteenth-century Romantics and the mode required by a Rothko painting. There were periods when contemplation was induced by a real experience with nature. Goethe's Werther, Goethe himself, probably, really did sit for hours staring at the sky, absorbing the rhythm of light as it subsided into sunset. The Lake poets were genuinely moved by the landscape through which they wandered. They tried to obliterate themselves in contemplation in order to sense the essence of the universe. A hike to a summit, a visit to a field for the express purpose of watching a sunset

were a fixed mode of inducing the elevated state of soul that con-templation engenders. There are fashions even in the ways of ap-prehending nature. For many persons today, the sunset, a rainbow fall into the category of the faintly ludicrous, suitable only for the banal conclusion of a travel film.

Rothko's classical mode of inducing contemplation is indeed quite Aristotelian in one way: he does not represent a sunset or a rainbow, or even a specific allusion to an experience with nature. Rather, he stands with the generalizing approach. Aristotle: "Trag-edy is essentially an imitation not of persons but of action and life, of happiness and misery." For Rothko, the expression in his paint-ing must be as general as possible, an imitation not of persons or landscapes or specific objects but of the action of the experiencing being, the flow of the emotions. His paintings are about the state of being moved.

Rothko's classicism is apparent not only in his paintings, which in their broad horizontals and prominent vertical axes establish the so-called classic equilibrium, but also in his general attitude toward his work. Where even Matisse reflected his Symbolist back-ground in insisting that a painting was the expression of his par-ticular reactions to the world, Rothko moves out toward the gen-eral. He once said in a public lecture, for instance, that the dictum "Know thyself" was useful, but that the problem of the artist is really to reach the point at which he could "talk about something outside of himself."

Before Rothko, Mondrian had also grappled with this problem, but with attitudes of a more rigid kind. Mondrian and Rothko have in common only some abstract assumptions, along with the will to express the general rather than the specific.

While Matisse eliminated the wall and painted a continuous space, Rothko went a step further by eliminating himself as the point of reference. Unlike Matisse, he does not cut an arabesque in space. We see a Rothko painting, that is, not in terms of any fixed point of reference, as for instance the flower vase in *The Red Studio* or the invisible pivot in *Dance*, but rather in its floating aspect. The reciprocity Rothko sets up between the light within and with-out the painting is never as determinate, as fixed, as it is in a Ma-

tisse; even his color, which expands and grows with the day, is less determined than that of Matisse. Technically, Rothko did what Delaunay saw as a logical step in modern painting: he eliminated line. But he did not eliminate light and shadow; his paintings speak through shape and color, but also through the authentic chiaroscuro he carefully preserves. In lingering between obscurity and light, Rothko's paintings achieve the growing, the emanating, the reverberating tone.

Such reverberation continues to occur, even more noticeably, in his recent work, in which he has reduced his compositions to a single form within the rectangle of the canvas and has made use of the light-absorbing tendency of black. A cursory look at one of these darkling canvases reveals only its black heart and its rather strictly defined borders. He appears to have eliminated those ambiguous regions from which the tensions used to assert themselves. But contemplation reverses that initial judgment: the blackness of a rectangular center vanishes forever, once the variations beneath the surface reveal themselves. In certain lights, in fact, there is no black at all, but only a silvery, whitish surface. The alchemy of color, and of its absence, is as familiar to Rothko as his brushes and paint pots. These austere canvases, in which the only accent is the dully lit earth red of their borders, emphasize what I think of as his classicism, using this term in the sense of passion expressed with conscious constraint.

Rothko's passion is readable in one of the most ambitious projects he has undertaken, the interior of a Catholic chapel. In painting a group of canvases to be housed in an octagonal chapel, he was forced to work schematically. His problem, as he finally articulated it, was to preserve the strength of feeling throughout, despite the necessity of holding to a jointed (and potentially disjointed) scheme. He was led to an extraordinary decision. Two of the huge canvases were to be monochromatic. By their scale, by their shape, and by the depth of chroma, they would share in the expression of a mood of deep reverie. These canvases are not the less revealing for their single dominating hue, since, as is always the case in a Rothko painting, they are given many lives, of which the final surface is only the most immediate aspect. The other canvases in the group

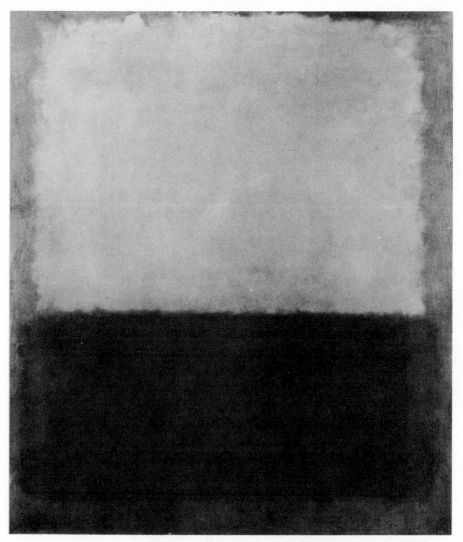

Oil on canvas, 7' 8¾" x 6' 9⅛".
Collection, The University Art Museum, University of California, Berkeley.

5. Mark Rothko: Number 207 (Red Over Dark Blue on Dark Gray), 1961.

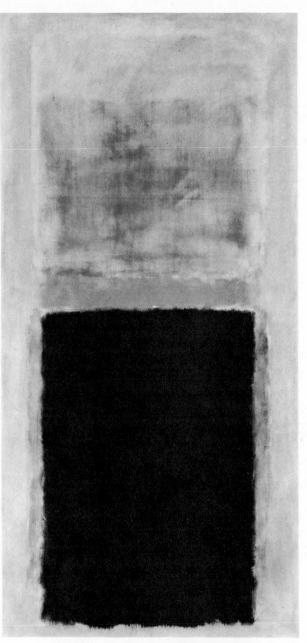

Oil on canvas, 105′ 6″ x 51′.
Courtesy, Marlborough Gallery, New York.

6. Mark Rothko: Homage to Matisse, 1953.

contain the effulgent black central rectangle within strictly defined borders. Each shape is weighed; each final edge carefully defined. Still further beneath are dozens of other rectangles that light sooner or later discovers and that add to the total effect of infinite mystery. If the lights and shadows are not as easily perceived as in his other, less densely painted pictures, the importance of relationships among rectangular shapes is stressed. The choice of proportion is as inspired as the choice of color. "The final abstract expression of every art is number," Kandinsky remarked in *Concerning the Spiritual in Art*[2]—an observation lived and confirmed by Mark Rothko.

In suggesting enclosures as a muralist, Rothko goes far toward challenging easel painting. The reciprocal interplay, the literal enfolding of the spectator by the canvases, and the emphasis on just proportion are preoccupations of the muralist. But Rothko remains fundamentally an easel painter. No matter how large his canvas, it is self-contained, autonomous, an image. It may participate in the interaction wall enclosures demand, but still remains independent if isolated.

With all its intonations, and all the nuanced accents, Rothko's oeuvre is best seen as a single grand work, "an ellipse," as he has said. From first to last he has been concerned with the disclosure of light when measured out in perfect proportions.

Rothko committed suicide in 1970. The last works he made, some on paper, some on canvas, were severely restricted in palette and mostly composed of two simple divisions of blackish-brownish gray above and dense, foggy white below. Shortly before his death I looked through the paintings, rolled out on the floor, with him and he reminded me that "the dark is always at the top." It would be too much to suggest that this was a metaphorical allusion to his moral situation, and yet I could not help seeing the paintings, devoid as they were of animation, and crepuscular in their cold light, as emblems of his despair. His generation had been intimate with Angst, he above all, and the subject of these paintings (he still believed they had to have a subject as he told me many times) could be no other than Dame Care. It would be unthinkable to see them in any other terms, least of all the literal terms of formal criticism. The dividing line between dark and light shifts, it hardens, it vacillates in these paintings, but finally, the dark prevails metaphorically.

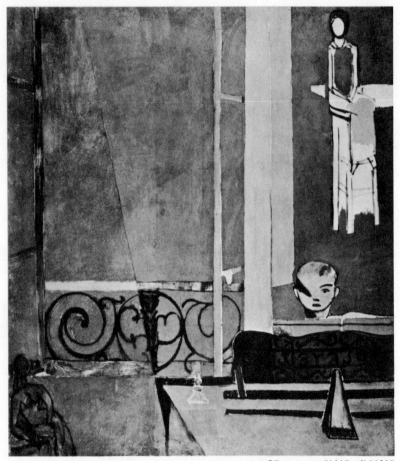

Oil on canvas, 8' ½" x 6' 11¾".
Collection, The Museum of Modern Art, New York. Mrs. Simon Guggenheim Fund.

7. Henri Matisse: Piano Lesson, 1916.

4

"A Ceaseless Upspringing of Something New"

Almost imperceptibly the new assumptions born simultaneously in the arts and sciences, and reflected in philosophy, thrust themselves into the working lives of the painters. Whether or not they had known of Einstein's first theories of relativity, certain painters working in the first decades of the twentieth century took it for granted that the fourth dimension, space-time, was self-evident.

Just as obvious to them was the principle of creative evolution expounded by Henri Bergson. Bergsonism was more than an esoteric fad. It pervaded the lives of most turn-of-the-century thinkers and made its way into middle-class publications, much as Sartre's Existentialism was skeletally rendered even in popular weeklies. Bergson's exposition of the role of creative intuition could not fail to find eager listeners among the artists who had arrived, in their own way, at a similar position.

In his writings and lectures, Bergson returned again and again to the "fringe" of intellect, the "powers that are complementary to the understanding." This fringe, this complex of powers that supplement the static process of intellect, is only now being confirmed by neurophysiologists, but Bergson's own intuitions were so remarkably accurate that he rightly posited a second system of perception, working to seize the reality in its continuity. Once the rigid, cinematographic processes of the intellect are superseded, he thought, reality appears as "a ceaseless upspringing of something new."[1] Intuition alone could give the fused image of reality, the

continuity, Bergson's *durée* (a "continuous progress of the past which gnaws into the future") of which we are all instinctively aware. Intuition, "by the sympathetic communication which it establishes between us and the rest of the living, by the expansion of our consciousness which it brings about, introduces us into life's own domain, which is reciprocal interpenetration, endlessly continued creation."[2] If Matisse and Apollinaire spoke of intuition, it was intuition as Bergson conceived it: that power which reveals "reciprocal interpenetration."

Bergson's dynamic interpretation of time vastly influenced the arts. Marcel Proust attended his lectures in 1890, only a year after Bergson's initial thesis was published, and quickly recognized the tremendous potential in Bergson's insistence that "intellect turns away from the vision of time." The fluid "fringe" around the intellectual conception of time—time that is cut up by the intellect into a series of static images like the frames of a film—captured Proust's imagination. Fluidity, thereafter, was to become an esthetic principle.

Proust's translation in literature of Bergson's *durée* and his ability to spatialize his intuitions are evident throughout his work. His most cited metaphors for this sense of *durée* are all spatialized in much the same way a painter would spatialize: the paving stones in Venice, the garden in his childhood home, the house where he dips the madeleine in tea are the sites through which flow his continuous structures of time. He had been struck by Bergson's idea of "reciprocal interpenetration," as his passages devoted to the painter Elstir in *Remembrance of Things Past* indicate. Elstir teaches the narrator to "see"; from Elstir he learns that everything is equal in the regard of a painter, even the homely women in the park. "This woman is also pretty, her dress receives the same light as the sail on the boat. . . ." The enveloping light, the universal and fluid movements which make up the cosmos of the small perception (just as water and sky had for Monet) become the medium to express the space-time entered as a condition of existence in the psyches of the early twentieth-century artists.

The apprehension of light as dynamic, all-embracing, fluid, was already implicit in the color research of the nineteenth century.

Light, or color, was no longer regarded merely as one painter's tool among others, but studied as something autonomous. Kandinsky had written, "Matisse-color. Picasso-form. Two great signposts pointing toward a great end."[3] For Kandinsky and other thoughtful artists of the early twentieth century, color assumed a capital importance. The technical interest in optical phenomena inspired by Chevreul and pursued by Seurat, Signac, and others was no longer salient. Painters were now interested not so much in what color does when received by the eye as in how it can be used to interpret the new fluid spaces of the universe. The current of painterly discourse was toward a metaphysic.

No one reflected the shift in notions of space, time, and, above all, of color more than Robert Delaunay. He speculated endlessly about the painter's problems with the enthusiasm of the born philosopher. His terms of discourse clearly mirrored the preoccupations of his time and also indicated its vast and stimulating confusion, for his observations are sometimes stammered, sometimes recondite and lengthy. They are valuable, however, as they reflect the concerns of the community of artistic spirits. He very early drew the attention of Kandinsky, with whom he kept up a correspondence for years. Paul Klee was the first to translate his essay on light into German. His friendship with Apollinaire and other writers of the "new spirit" is obvious in the amount of space Apollinaire devoted to him.

The Bergsonian world of dynamic becoming is reflected in all of Delaunay's remarks. He was seized with an insight that the static image was no longer true to his experience, and all of his work, both as a thinker and as a painter, was a struggle to find a true analogue to his experience of space. In 1912, Apollinaire recorded Delaunay's declaration "On the Construction of Reality in Pure Painting." Here, Delaunay traced modern painting in terms of its progressive elimination of all obstacles to the sole reality, light. In his view, El Greco, certain English painters, and the French revolutionary Delacroix were preparing for the Impressionists' new vision of light. "The function of light necessary for any vital expression of beauty, remains the problem in modern painting."[4] Developing his theory from Seurat, who had departed from Chevreul, Delau-

nay expanded the term "simultaneous contrast" beyond its sci-
entific designation, developing it into a metaphysical approach to
painting. If contrasts are simultaneous, they are dynamic: they are
in perpetual movement in time and space. "I had the idea of a paint-
ing that would technically have only color, contrasts of color, but
developing in time and perceptible simultaneously in an in-
stant. . . . I played with colors as one can express oneself in music
by the fugue."[5]

In his writings Delaunay also confronted the most perplexing
problem of his moment: the meaning of non-figurative painting,
and its "subject." Although he was never able to isolate clearly in
words the "subject" of his non-figurative paintings, Delaunay tried
again and again to convey the strong sense he had of the signifi-
cance of his research. He had once explained that since Cézanne
had broken the line, he, Delaunay, had to do something else, to
find "another state of mind," which he justifiably called a "histori-
cal change of comprehension, thus of technique and way of life."
Such a profound change is not easily captured in words. Yet he
tried:

> Harmony is sensibility ordered by the creator, who must try to
> give the fullest realistic expression to what one might call the
> subject. The subject is the harmonic proportion, and that pro-
> portion is composed of diverse simultaneous members in ac-
> tion. The subject is eternal in a work of art. . . . Without a
> subject, no possibility: that doesn't mean a subject literary and
> therefore anecdotic. The subject of painting is plastic and
> springs from a vision. . . . The eternal subject is found in
> nature itself. . . .[6]

Still, the clearest evidence of the preoccupations of the painters
of Delaunay's circle, called by Apollinaire the "Orphists," remains
their painted work. From the vantage point of the present, it is easy
to read Delaunay's purposes in his abstract disk paintings. The cir-
cling forms carry out his intention of activating the picture plane
and making color perform in a musical or harmonic mode.

Musicality was equated with rhythm, and rhythms were equated
with the universe. The painters concerned with the quadridimen-
sional universe revealed by science (from Kandinsky to the pres-

ent-day Matta and Vasarely) were convinced that they could create structured parallels to their knowledge of the universe. The Cubists had already voiced a concern with the "known" reality rather than the "seen" reality. The Orphists went further, and, as Frank Kupka wrote, considered seen reality false, or at least misleading.

Kupka was one of the first to act out his intimations of the harmonic universe in his abstract paintings, shown in three major exhibitions in Paris in 1912. Two paintings—*Amorpha: Fugue in Two Colors* and *Cosmic Spring*—were widely noted in the Salon d'Automne of that year. To prepare himself for the plunge into abstraction, Kupka had read widely in science, astronomy, and philosophy. He had also taken into account the new medium, cinema, and adapted the idea of successive images to the plane surface of painting. Kupka's early work, with its ornamental interpretation of the solar system and of the "known" rhythms of the cosmos (his titles, such as *Newton's Disks*, bear out his interest in scientific laws), shows interests common to many other Parisian painters of that moment. Their hope was that they could act out their intuitions of the nature of the universe, with all its radiant vibrations and infinite spaces, in the color and light on their canvases.

The direction of their discourse is inevitable: it is toward abstraction. Not all, however, were attracted by great metaphysical dreams. Léger had no metaphysical inclinations, yet he too, in his own terms, turned away from naturalism and toward an abstract vision of painting. Like Apollinaire, who quoted him in 1913, Léger knew that "modern mechanical achievements such as color photography, cinematography, the profusion of more or less popular novels, the popularization of theaters effectively replace and render totally useless the development of the visual, sentimental, representational and popular subject in pictorial art."[7] Like Delaunay, he believed that painting had to have a subject, but, as he said in 1935, "There never was any question in plastic art, in poetry, in music of representing anything. It was a matter of making beautiful, moving or dramatic—this is by no means the same thing."[8] Abstraction, he maintained, does not exist. In its place he, like Delaunay, paradoxically substituted color. "It is possible to assert the following: that color has a reality in itself, a life of its own; that a

geometric form also has a reality in itself, independent and plastic."[9]

These painters, speculating in their work, changed the terms of painting discourse. The central problem—abstraction—provoked various and differing responses, but they all, even the most rationalistic, tend to the philosophic. The assumptions such painters used and examined and amplified were rich in consequence. They remain viable today.

5

"The Reasoned Use of

the Unreasonable"

The notion of dynamic intuition was invaluable to the impatient young spirits of the first decade. On its shadowy "fringe" the imagination could exultantly expand, taking liberties that the mechanistic view could never have countenanced.

Guillaume Apollinaire, given by temperament to ebullient optimism, was an ardent proponent of the view that in the new epoch everything was possible. A marked sense of joyous expectancy, a feeling that modern life would bring unprecedented wonders to light, reads through his poetry and his prose. Apollinaire's view of the new temper of the time—the *esprit nouveau,* in his phrase— varied from day to day and was full of small contradictions. Volatile poet that he was, he cared little for dry consistency. Thus, on the one hand, the new spirit was to uphold abstract principles such as truth and purity, and, on the other, was to be exceptionally concrete, basing itself on the simple, common-sense experience of the things of modern life. In painting, the new spirit would work to bring about a great release from the bondage imposed by banal imitative theories. But it would also admit all kinds of extrinsic materials, as in collages.

When, a few months before his death, Apollinaire meditated on his own art and the manifestation of the new spirit in poetry, he focused on an issue that was to remain central both for poetry and painting:

It is by means of surprise, by the important place it has given surprise, that the new spirit distinguishes itself from all artistic and literary movements that have preceded it. It is not, it could not be an estheticism, it is the enemy of formulas and snobbism. It doesn't want to be a school but one of the great currents of literature, englobing all the schools since symbolism and naturalism. It fights for the reestablishment of the spirit of initiative, for the clear comprehension of its times and in order to open new views on the interior and exterior universe which are not inferior to those that scholars in all categories discover each day and from which they draw marvels.[1]

Surprise, that would draw marvels from the free exploration of both the interior (or psychological) universe and the exterior one (that of technological progress), remained Apollinaire's dearest ideal. He recognized the dangers latent in the passion for novelty. One might ask the poet, he says, what good is novelty? There is nothing new under the sun. To which he replies: "They radiographed my head. I saw—I, a living creature—saw my cranium, and isn't that something of a novelty?"[2]

Apollinaire was keenly aware of modern technology as a force inevitably altering the imagination of the artist. In an age of telephones, telegraphs, and X-rays, he felt time and space in new ways, and struggled to move out of conventional art forms to give voice to his pressing insights. As a poet, he followed Mallarmé's example, experimenting with typography in order to remove himself from binding traditions, to release the fantasies that lay just beneath the surface of his brilliantly creative mind. He hoped that typographical artifices, pushed very far and with great audacity, would give birth to a new visual lyricism. "It would have been strange if, in an epoch when popular art *par excellence*—the cinema—is a book of images, the poets hadn't tried to compose images for meditative spirits, more refined spirits that cannot be contented by the crude images of makers of films."[3] Modern poets, he felt, were preparing for the day when cinema and the phonograph would set them completely free, when, "conductors of an enormous orchestra, they will have at their disposition the whole world, its sounds and appearances, the thought and the human languages, song, dance, all the arts and all the artifices to compose the book seen and understood by the future."[4]

This heady psychology of abundance, which wished to encompass everything that came within the regard of the artist, and which addressed itself to a marvelous future, was typical of Apollinaire and his friends. They had a massive appetite and a massive capacity for experience. Léger, the adventurer-writer Blaise Cendrars, Apollinaire, and a host of others found an infinite number of stimuli for their fantasies. Not the least of these was modern gadgetry, which not only intrigued them but gave them occasions for the release of humor and common-sense observation. They were acutely conscious of their epoch, as artists have always been, but with them it was a magical reservoir of inspiration. Their consciousness of their time was sharp and specific, becoming an integral part of the esthetic that Apollinaire summed up in his discussions of the *esprit nouveau.*

One of Apollinaire's recurrent preoccupations was the nature of the imagination, and, more particularly, the role of the unconscious. He felt the mounting pressure of the need that began to be felt in the previous century for the recognition of the importance of intuition in creation. He stated his conviction that the artist must liberate his subconscious resources and free himself from a dependence upon reason alone. But, like his influential predecessor Baudelaire, he always reserved a place for the exercise of solid good sense and a critical spirit. Enclosed in his voluminous writings are the prophecies of two major tendencies in modern art, that toward metaphysical and fantastic speculations, and that toward the realism of objects, informed by technology.

But it was certainly in the realm of inspired fantasy that his own imagination flourished. His stress on the subconscious was insistent and was not overlooked by the Surrealists, who adopted to designate themselves the word he had coined to characterize the new spirit in his play *Les Mamelles de Tirésias.* This startling farce, moving buoyantly from the tradition established by Alfred Jarry, goes far toward the establishment of a new theater, as Apollinaire intended. But it also goes far toward the definition of a new kind of fantasy shaped by Apollinaire as a response to the deadly naturalism of his forebears. In its use of slang, of unexpected, absurd juxtapositions, of suggestive and also nonsensical props, it prefigures the contemporary absurd theater, particularly Ionesco, and

it also offers a background for the impromptu effusion of "happenings."

In his sparkling introduction to his play, Apollinaire maintains that he is offering a new kind of thesis play, designed to urge the French nation to repopulate. From the outset of his brief essay, the parallel irony twangs in accompaniment to sober words. Interspersed with his witticisms are serious esthetic observations. For instance, he points out that when man wanted to imitate walking, he created the wheel, which does not resemble the leg. In the same way, he implies, when he wished to release his creative fantasy he created Surrealism unconsciously. Aiming a sharp attack on the *tranche-de-vie* theater which dominated the boulevards of his time —and of our contemporary American counterparts, alas—he explains that he could have written a play of ideas to flatter the public, which likes to think that it thinks, but he preferred "to give free rein to the fantasy which is my way of interpreting nature."[5]

Not only does he give free rein to his fantasy but he prophesies the attitude of future theater rebels—"happenings" enthusiasts, for instance—who emphatically reject the formal symbolism of conventional theater. "There is no symbolism in my play, and it is transparent, but you are free to find in it all the symbols you want and to disentangle a thousand meanings as with the oracles of the sibyl."[6] (When asked to elucidate the film *Last Year at Marienbad*, script-writer Alain Robbe-Grillet gave a similar answer.) Defining Surrealism as "the reasoned use of the unreasonable," Apollinaire suggested that the artists capable of harnessing the energy of their intuition and fantasy "reveal new worlds that, extending horizons, ceaselessly multiplying the vision of mankind, provide it with the joy and honor of advancing always toward the most astonishing discoveries."[7]

Intuition, for the artists of Apollinaire's generation, not only freed the fantasy, as Apollinaire pointed out repeatedly, but also enabled the artist to free himself from linear history. In this abundant world of imagination and reality, the primitive could exist along with the signboards and telephones of modern life without contradiction. Spaces—or time spans—no longer had fixed boundaries. The arousal and proper use of the faculty of intuition would release

whole areas of human endeavor for appraisal. The Senufa and Oriental sculpture would take their places, along with the motor car, in the vastly expanded imagination of modern man.

The inevitable recoil from technology has taken new forms that undoubtedly Apollinaire would have sanctioned. The whole movement of "earth" artists is, in its spectacular way, directed against the organization of modern life in homogeneous patterns. Those artists who forage in the wilderness—what little wilderness there is left—cutting patterns in the forests or leveling isolated mountainous plateaus with bulldozers are self-consciously defying the mores of their society. They are bound neither by place (jet travel takes care of that) nor by institution, although they are still dependent on donors of money. If their dreams attain absurd dimensions, that is all to the good. Absurdity is all too familiar to them.

Certain of these monumentalists, such as Will Insley, move directly into the area Apollinaire most cherished. Insley's projects for extensive monuments, sometimes two or three miles square, are essentially fantastic. He is a fabulist and relates as much to Borges and Kafka as he does to his fellow earth artists. Others seem to dream more on the legendary scale of a Paul Bunyan, but are nonetheless conscious of the eccentric value their displacement from the urban art centers puts forward.

The emphasis on international communication in many sectors is another phenomenon which Apollinaire prefigured. Many of those who consider themselves artists, as a social caste, rely on international codes for the diffusion of their expression. There have been many exhibitions these past two years consisting of communiqués such as telegrams, graphs, photomontages and slide shows which serve to create a supranational art community that has forsaken forever the individualistic art object, but not the pleasure of individualistic communication. The technological aids, such as television, tape recorders and sophisticated Telstar relays, are fully exploited by this new configuration within the sanctum of art in which the most talented partisans still seek, with Apollinaire, to multiply the vision of mankind.

6

The Function

of Unreality

"By the swiftness of its actions, the imagination separates us from the past as well as from reality. It faces the future." This observation of the French philosopher Gaston Bachelard is followed by a profound axiom: "To the *function of reality*, wise in experience of the past . . . should be added the *function of unreality*, equally positive."[1]

Bachelard uses the diction of his time, for in the twentieth century the word "function" may be reciprocal, defining both the action of something and its meaning. The function of reality, then, is a moving, growing, organic thrust, unavoidably linear in quality and, like Bergson's intellect, wise in the precedents of the time gone by. But the function of unreality is a variable, erratic spiral, discontinuous, changing its pace and specific shaping activity constantly, but always mitigating reality, always reaching into an unforeseen future.

A work of art can be seen as an ineffable function of unreality. Always darting back and forth, the imagination often comes close to reality in the work of art but then veers off, faithful to its function of unreality. The fantasy of Matisse, in this sense, is as fantastic as the fantasy of Magritte or Miró. One twentieth-century assumption is that experiences that can be imagined—those that need not have been "known"—are the experiences with which the artist is primarily concerned. A corollary, in spite of strong counter-theories that take facts and things-in-themselves as non-transitive (R. Mutt's urinal, for instance),[2] is the necessity of symbol, and the strength of it as expressed in the continuing existence of works of art.

One aspect of the twentieth-century preoccupation with the meaning or function of unreality is represented by the transcending vision of Matisse, who begins situated in time and place—a hotel room in Nice, for instance—and moves outward in progressively wider circles toward forms of expression that only the imagination can originate or receive. Another aspect is exemplified in the work and thought of Miró, Klee, and other painters who have been considered as "fantasists" in the ordinary sense—painters who work from reveries of an unreal universe peopled with capricious shapes, performing unheard-of actions. Such painters make a conscious and specific effort to characterize experience whole, with its real and imagined aspects equally honored. They are not bound by clock time, by linear history, but move freely from real objects in space and time to imagined objects or invented objects in some other epoch, or in a dream. They seek a new way of viewing history, one that embraces both the linear and spiral functions. The painter who is surrounded by creation, or rather his creation, as is Matisse in his *Red Studio*, or Pollock, or Rothko, and to whom the plural spaces are a living medium as water is for creatures of the sea, has broken the linear pattern, substituting a great circular metaphor which partakes of experience everywhere.

A signal example of the artist who turns away from the linear view, and who creates entrancing fantasy, is Paul Klee. Always a thoughtful and thorough man, Klee scanned the whole of art history seeking the touchstones his imagination craved. While still a young student he had read the works of Baudelaire, Poe, and Gogol, whom he felt to be kindred spirits and who assuaged his thirst for the marvelous, the unreal. He also studied the philosophers and took up the challenge of past estheticians, debating, for instance, the much-argued questions posed in Lessing's *Laocoön* and dismissing Lessing's thesis as superfluous:

> Movement is the source of all growth. In Lessing's *Laocoön*, the subject of so much mental exercise in our younger years, there is much ado about the difference between time and space in art. Once we examine it more closely, this is really just a bit of erudite hair-splitting for space, too, implies the concept of time.[3]

Here, swiftly discovered and precisely stated, is Klee's summary of the views made possible by the twentieth-century willingness to reconsider the function of art. Klee's philosophy, garnered intelligently both from the past and from his experience as a creating artist, points always toward a definition of the raison d'être of art. His writings are exceptionally valuable because, no matter how far his mind carried him into the realm of abstruse philosophy, he was able to anchor his thoughts in practical demonstration. His observation that space implies a concept of time is not left without concrete explication, but is given substance when he goes on to point out that it takes time for a dot to start moving and become a line, or for a line to shift its position so that a plane is formed.

Klee was much concerned with a philosophical vision of time. He sensed, as did a number of other artists of his generation, that the emphasis of Western culture on clear, rational explanation for all phenomena must be supplemented by other modes of thought —modes that allow for the existence of things sensed and not seen, imagined and not tangible. For him, the so-called primitive art, and the art of the old civilizations of India and China, contain important clues to philosophical reality. His own extensive commentary is structured on the philosophical duality of cosmos and chaos. His preoccupation with cosmos, "a self-inclusive system characterized by order, harmony, and complexity of detail," was perfectly natural: an instinctive recognition that the artist does nothing other than originate self-inclusive systems.

"I begin logically with chaos," he wrote in one of his lectures for the Bauhaus,

> that is most natural. And I am at ease because at the beginning I myself may be chaos. Chaos is an unordered state of things, a confusion. "Cosmogenetically" speaking, it is a mythical, primordial state of the world from which the ordered cosmos develops, step by step or suddenly, on its own or at the hand of a creator.[4]

Announcing in one of his early lectures that the "cosmogenetic moment is at hand," Klee explained that when the point sets itself

in motion and becomes a line, "the point as a primordial element is cosmic. Every seed is cosmic."[5] Every seed, or every archetypal ovoid, is cosmic: Klee comes here close to the many ancient religious beliefs concerning the origins of life that saw the source of all creation in the ovoid shape; close to Jung's idea of the mandala; close to the conceptions of certain societies, in India, for instance, that find in the presence of man—man who has lived and constructed evidence of his presence—the character of cosmos.

Traditionally, the point, the seed, has extraterrestrial archetypes. But, as Mircea Eliade points out in *Cosmos and History*, not everything does have a prototype:

> Desert regions inhabited by monsters, uncultivated lands, unknown seas on which no navigator has dared to venture . . . corresponded to a mythical model but of another nature. All these wild, uncultivated regions are assimilated to chaos. . . . This is why, when possession is taken of a territory—that is, when its exploitation begins—rites are performed that symbolically repeat the act of Creation: the uncultivated zone is first cosmicized.[6]

Artists are attracted to chaos out of the sense that, as creators, they must know all, or because, like Klee, they know themselves to be chaos until that moment when their creations are en route. The American poet Stanley Kunitz sees chaos as "the absence of time and space"; cosmos, to him, is a world, is order. He says the imagination is always attracted to chaos because it represents "free energy." The poet, he says, invents not chaos, not cosmos, but mythos. In other words, the artist encompasses both chaos and cosmos, drawing from them the energized scheme that is the work of art.

Klee's large philosophic reference, his cosmos-chaos dialectic, brought him to the consideration of many varied phenomena, real and unreal. He made a close study of nature, of mechanics, of physics, of botany, and of abstruse philosophy, but only as they impinged on him as an artist. The artist, he said, is not interested in a scientific check on his fidelity to nature. On the contrary, the way of the artist is the mysterious way from "prototype to archetype." Klee's practical research was always directed to the illumination of

the creative processes, and always made large allowance for the
function of unreality in Bachelard's sense:

> What artist would not like to live where the central organ of
> all space-time motion, call it brain or heart of creation as you
> will, activates all functions? In the womb of nature, in the
> primal ground of creation, where the secret key of all things
> lies hidden? But it is not the place for all men. Let each man go
> where his heartbeat leads him.[7]

7

The Organic Imagination

Klee took a time-honored view of the imagination, and through experiment and reflection brought it into a fresh, viable form. When he wrote that a work is first and foremost genesis, when he insisted that no work is predetermined, when he said that every work begins somewhere with a motif and outgrows its organ to become an organism, he sponsored a view of the workings of the imagination that had a respectable and profound history. In its broadest aspect, Klee's view of the imagination is an extension of the romantic attitude as it developed from the eighteenth to the twentieth centuries. It is the so-called organic view that began to take shape when the mid-eighteenth-century artists and philosophers questioned the workings of the imagination, reacting against the prevailing mechanistic vision of the world. Far from avoiding the findings of other minds and other times, Klee found a way to assimilate them and give them fresh impetus. In this way his effect on the twentieth century was more profound than that of those artists who sought to begin from zero in a frantic effort to capture and hold the moments of "their" time.

Klee's organic view derived largely from his interest in natural philosophy. He was an assiduous student of natural forms and organic life, finding the principle of movement in nature as the essence of creation. He held, as do all organicists, that the process is more important than the product. The very act through which a work of art is brought into being is part of its reason for being. In this he held the classic organic position, a position elucidated in the nineteenth century by Goethe, the powerful current of whose

thought coursed through the nineteenth century and into the twenti-
eth. It certainly had an effect on Klee, for many of Goethe's extraor-
dinary insights are echoed in his writings. Klee was a highly literate
artist, and there can be no doubt that his own formation was "or-
ganic," in the sense that he grew from his center—that is, from his
background, which included Goethe—outward. For this reason,
and because the organic view is still a powerfully germinative force
in our century, it is well worth examining certain of Goethe's in-
sights in order to see where and how Klee and more recent artists
diverge from or augment them.

In his youth Goethe had been strongly attracted to the views of
Gottfried Herder, who was, in the eyes of his own community, a
wildly avant-garde thinker. Under Herder's influence, Goethe
studied folk art and such ancient poetry as stressed the non-rational
forces of nature. He looked to nature, in his early youth, for the
kinds of truth that are not always subject to laws. He gave himself
freely to the kind of exalted, febrile tone advocated by Herder
for poetry, but he reserved a special place for nature as the practical
touchstone for creation. Even in his Sturm und Drang period, to
which *The Sorrows of Young Werther* belongs, he was cautious
and wary of pure theory.

There is a scene in *Werther*, for instance, in which Werther sees
a four-year-old boy holding an infant.

> I sat down on a plow that was standing nearby and began, with
> great enthusiasm, to sketch this little picture of brotherly de-
> votion. I put in the fence, a barn door and a few dilapidated
> wagon wheels—everything, just as it was—and found after an
> hour had passed, that I had produced a very well-arranged and
> interesting drawing without really having contributed anything
> to it. This strengthened my decision to stick to nature in the fu-
> ture, for only nature is infinitely rich and capable of developing
> a great artist. . . .[1]

Goethe did, thereafter, stick to nature, but in a way that would
leave him great imaginative latitude. What he began to demand of
nature was what Klee later called "the secret key of all things."
He safeguarded himself against the totally abstract meanderings of
Germanic esthetics by returning always to the close study of nat-

ural science. In 1770, for instance, he was asked to take up the problem of the beautiful. Instead of offering metaphysical arabesques, Goethe answered with an example from nature: If you catch a butterfly and pin it down on a sheet of paper, no matter how carefully, you cannot pin down the whole butterfly because you have taken the life out of it and made it a corpse. "The corpse," he summarized, "is not the whole." Here, in one succinct reference to nature, he synopsized his view that only the quick, the moving, the organically growing has vitality. Throughout his life, Goethe was an amateur scientist, and used his activity in the laboratory as a governor, a check on his soaring imagination. He told Eckermann on several occasions that his studies in natural science were indispensable to him as an artist, and even tried to translate into poetry certain of his observations.

Goethe's methodical explorations of certain sciences may well have derived from his constant flare-ups of intuition, which he found disconcerting. The calming certitudes of science were important to him. An example of his startling insights, even in science, is his mysterious statement that there is no inside and no outside, that the inside *is* the outside. It appears, among his copious notes, without further explanation. Several decades later, the German scientist and mathematician Möbius confirmed Goethe when he announced his discovery of the so-called Möbius strip: the strip of paper that is twisted and its ends joined in such a way that it has only one measurable side. This premonition of the new science of topology in the nineteenth century is one of many such *aperçus* in Goethe's work. Goethe is also credited with having introduced several important terms into the study of botany. For instance, F. G. Gregory, in *Aspects of Form*, attributes to him the introduction of the term "morphology" into the study of forms in organisms in 1827.

> He regarded plants as variants of an "archetypal" form, his *"Urpflanze"* consisting of an axial structure (the stem) bearing lateral appendages, the leaves. Development he regarded as a reiteration of successive parts, thus a "time pattern" constituting the life history of the plant, in the course of which modifications of the fundamental repetitive unit occur—essentially a

"metamorphosis" of the leaf culminating in the organs of the
flower which Goethe regarded as modified leaf structures.[2]

Goethe's concept of the archetype has since been dismissed by
science, but his grasp of the vital principle of growth, of forms
metamorphosing in time, and of the onflowing nature of life made
a profound impression on generations of younger artists. More im-
portant, it helped him to shape his own view of the creative imag-
ination. In 1818 he wrote to Zelter that "no one understands that
the formative process [*die Gestaltung*] is the supreme process, the
only process, alike in nature and art."[3]

Klee came to similar conclusions from his own close study of
plant formations. One can gain much strength from naturalistic
studies, he told his students, but only to return to the original field
of psychic improvisation. Do not think of form, he urged them,
think of formation.

The psychic improvisation of which Klee spoke had interested
Goethe before him. Both artists were aware of the subconscious
and the secrets it holds inviolate. Both speak longingly of the
sources or wellsprings of creation. Goethe shows Faust in his study
reflecting that when the lamp is burning in his cell "the darker self
grows clear again / the heart that knows itself will brighten."
When the voice of reason can be heard, hope blooms, but: "We
crave to hold within our grasp / the streams of life and ah, its
sources!"[4]

According to Thomas Mann, Goethe's attitudes were based on
the Spinozan concept of the perfection and necessity of all being,
on the idea of a world free from final ends and causes in which evil,
like good, has its right to exist. "We struggle to perfect the work of
art as an end in itself," Mann quotes Goethe. "They, the moralists,
think of the ulterior effect about which the true artist troubles him-
self as little as nature does when she makes a lion or a humming-
bird."[5]

In this Spinozan world of the necessity of all being, Goethe navi-
gates in complex ways, touching both rationalism and mysticism in
the course of his enormous oeuvre. Klee, who was not averse to
mysticism, and whose allusions to the universe, or the cosmos, often

recall Meister Eckhart's famous statement, "I see God with the same eye as God sees me," would not have been ruffled by seeming inconsistencies in Goethe's philosophy. In the end, both men lived intensely by the laws of the dynamics of growing, and both men, in Klee's words, went in the direction their heartbeats led them.

The nineteenth century's dawning conviction that the imagination was not a static, fixed entity, held rigidly somewhere in the cranial region, was put forward forcefully in England by Goethe's contemporary, Coleridge. Through his vast reading and through experiments with his own mind and memory, Coleridge arrived at a clear conception of the formative imagination. It was he who insisted that poetry was not an additive practice, but rather, an activity, a vital action. He criticized previous poets for sacrificing what he called the "passion and passionate flow" of poetry.

Although Coleridge's brilliant insights range too far for discussion here, one or two pertinent areas of his thought should be mentioned. For one, he, like Goethe, was deeply interested in the process of metamorphosis. He studied technical treatises and drew from them an image of the way the natural world transforms itself. Like Goethe, he immediately translated his naturalistic studies into working parallels for artistic activity. From his study of the changing forms in nature he began to make correspondences to his own imaginative processes. The movements in the natural world were compared to the movements of his own psyche, as in the opening stanza of "Frost at Midnight," written in 1798. Here, he describes his cottage in the quiet of night and speaks of the thin blue flame that lies on his low-burnt fire and does not quiver.

> Only the film which fluttered on the grate still flutters there, the
> sole unquiet thing.
> Methinks its motion in this hush of nature
> Gives it dim sympathies with me who live,
> Making it a companionable form.

The search for "companionable forms," with their gentle motion, was typical of many Romantic poets, who stressed the "feeling into" nature and who sought to shape vital analogues. Goethe, Coleridge, and many other artists of their century scanned nature

for prototypes, seeking to isolate the forms, *die Gestaltung*, that held within them their genesis, which the artist could seize as part of his own process.

But the nineteenth-century artist's relationship to form and formation was perforce different from that of the twentieth-century artist. What Goethe could not have enunciated clearly, and what Klee could and did, was the relationship of *function* to form. Klee, a twentieth-century thinker, was able to understand the supreme importance of function. He understood that things grow according to their function, and that it is the dynamic interaction of varied functions that provide unique, arresting forms. He arrived at his understanding through experiment. He made drawings of cross-sections of the calla lily, drawings of various leaf shapes having identical inner forms and changed outer forms, drawings of seeds as they metamorphosed into plants. But he went beyond Goethe in the philosophic assumptions drawn from these studies:

> Yesterday's artistic creed and the related study of nature consisted, it seems safe to say, in a painfully precise investigation of appearance. I and you, the artist and his object, sought to establish optical-physical relations across the invisible barrier between the "I" and the "you." In this way excellent pictures were obtained of the object's surface filtered by the air; the art of optical sight was developed while the art of contemplating unoptical impressions and representations and of making them visual was neglected.[6]

The spatial organization of an object in an expanded universe— an object that not only has a visible surface but a sensed interior— can be studied in numerous Klee paintings based on his observation of plants. His 1922 *Flower-Face* can be read as a theme with variations, a playful sequence of analogies; but it can also be read as a commentary on nature's dynamic unfolding activity, its symmetry, its logic in structure. Klee here unfolds his flower and flattens it, indicating, as if in an architect's plan, its sections. He then reconstrues the flower, now as a growing column on the right, now as a simile for the human visage, now as an evolving cell (in the upper right). Not only does the flower become a symbol for growth and unceasing movement, but it also tells of time. Klee divides his sur-

face into an upper rectangle and a lower square, breaking the continuity of the central growing form, and suggesting another time register, or perhaps a mirror image.

The nineteenth-century dream of universal analogy finds expression in this and in many other Klee paintings. The circle is the seed; it is also the heart. The half circle is a moon, or a cellular section. The petals are unfurled, but they are also scrolls to be read. A calyx is a bell, sounding in the green of the environment. Sound echoes throughout the picture in rhyming forms. A stalk is an arrow, a leaf is an eye. Things rhyme and sound, and move in changing sequences, and all is related to all. The totality Klee envisioned is symbolized in this tiny cosmos of living forms. Despite his dislike of the "painfully precise" nineteenth-century approach, Klee maintained that the investigation of appearance should not be neglected. A sense of totality, however, has gradually entered into the artist's conception of the natural object, he explained. Whether this object be plant, animal, or man, whether it is situated in the space of the home, the landscape, or the world, the first consequence of this sense of totality is that a more spatial conception of the object as such is born.

Such a metamorphosis of the natural object would probably have been inconceivable to artists of Goethe's generation, as would Klee's conclusion that in art, formalism is form without function. The dynamic growth principle isolated by Goethe is here carried to its furthest consequences in relation to art.

Klee considered the limits within which the artist can conduct exact research. He noted that

> mathematics and physics provide a lever in the form of rules to be observed or contradicted. They compel us—a salutary necessity—to concern ourselves first with the function and not with the finished form. Algebraic, geometrical and mechanical problems are steps in our education towards the essential, towards the function as opposed to the impressional. We learn to see what flows beneath, we learn the prehistory of the visible. . . .[8]

Only the organic imagination can adapt itself to the notion of the prehistory of the visible, for it is in the recognition of the vital

energy that is compressed within given forms that we know "what flows beneath." Klee's opposition to formalism is an opposition to stasis, to deadness—the same deadness Goethe ascribed to the impaled butterfly.

It is unquestionable that many twentieth-century artists have had a peculiar sensitivity to the dynamics hidden within their forms, and have been aware that it is the "prehistory" of the form's appearance that gives it a meaning. Klee's cosmos, envisioned first as a seed with all the mysterious organic energy it circumscribes, has been recognized by many other artists. The hidden ways of energy, the transforming character of the organic imagination, are the sources of much modern art.

8

Stripping Down to Cosmos

When Matisse was painting *Dance*, Miró was seventeen years old. Two years later, he saw his first Impressionist and Fauve paintings and began a painstaking examination of modern art. He maintained a singularly open spirit throughout his life, eagerly examining every conceivable avenue of expression and testing his own observations against those of others. Certain assumptions posited at the turn of the century were accepted by him without question and remained with him always. The Symbolist emphasis on the indefinable function of "spirit" seems never to have left him. In 1917 he wrote to a friend, "I believe our 'school' will grasp the essentials of the painting of the future. It will be stripped of all concern for pictorial problems, it will vibrate in harmony with the pulse of the Spirit." He stated his belief that after all the modern movements, including that of the Analytical Cubist and Futurist tendencies, there would be "a free art, all interest in which will focus on the vibration of the creative spirit. These modern analytical movements will ultimately carry the spirit to the light of freedom."[1] Miró wrote this as a very young man, not long after Kandinsky had published his own similar convictions, which Miró could not have known, but which also stemmed from nineteenth-century Symbolist tenets.

Miró's ready acceptance of the exalted ambitions for art—an art of the spirit—was not unusual for the moment in which he was maturing, but his preparations in terms of working methods were. Al-

though he was already well informed about what was happening in advanced literary and painting circles in Paris, Miró followed his own course. In the letter cited, he asserted that "everything is contained in reality and it is by digging deep that we succeed in producing good painting." His confidence that a realistic approach would release the "spirit" led him to paint a number of exceptionally detailed landscapes that sound the first note of his individual genius. At this same time, he and several other painters in Barcelona were aggressively establishing their anti-romantic viewpoint in the Group Courbet (a name that makes significant allusion to a vigorous realist tradition of the past). In these landscapes, the dry, even sunlight of Catalonia etches each tiny detail. Miró's vision of a world teeming with living form—a cosmos containing abundant and ordered vitality—is at this time explicitly expressed, although later he was to rephrase his paean to the world of prolific detail in more or less abstract terms.

As early as 1916, Miró expressed his conception of the harmony of nature when he wrote from Montroig, "I have come here for a few days to live with the landscape, to commune with this blue and golden light of the wheat fields and to ennoble myself at this sight. . . . I love every tiny creature, every blade of grass."[2]

In 1918, he pursued his microcosmic exploration of nature, writing to Rafols,

> What happiness to manage to comprehend a single blade of grass in the landscape—why scorn a blade of grass?—that blade of grass is as beautiful as any tree or mountain. Except for the primitives and the Japanese, nobody has ever taken a good look at this thing which is so divine. Artists are always looking for great masses of trees or mountains to paint, never attuning their ears to the music that emanates from tiny flowers, blades of grass and little pebbles in a gully.[3]

Here again, we have the Symbolist's poetic concern with the "music" that emanates from nature, the binding harmony that can be discerned when the world of phenomena is examined in intimate focus.

This close-up vision of the universe was to occur to many artists

in the twentieth century, finding their way individually to an almost Oriental concept of detail. Mark Tobey literally discovered the small world underfoot in Japan ("While in Japan sitting on the floor of a room looking over an intimate garden with flowers blooming with dragonflies hovering in space, I sensed that this small world almost underfoot had a validity all its own, but must be realized and appreciated from its own level in space").[4] And James Johnson Sweeney reported that Arshile Gorky decided in 1943 to "look into the grass," producing a series of beautiful drawings in which the miniature world of small insects, grains of earth, and tiny grasses was characterized.

Miró had explicitly elected to ignore not only the principles of Cubism but all pictorial conventions when he set about painting his landscapes of 1918 and 1919. "What I am interested in most of all is the calligraphy of a tree or the tiles of a roof, leaf by leaf, twig by twig, blade by blade of grass."[5] Leaf by leaf, he did build up the essence of each particular tree, but he worked always toward the total harmony, the "spirit" of his subject. His paintings, even with their most meticulously handled small details, are still organized on the principle of the arabesque, that curving line that always returns, always closes off the cosmos from the chaos. Musicality and the idea of the arabesque—even the most spiritualized idea of the arabesque as expressed by Mallarmé in poetry and Moreau in his esthetic writings—are implicit in these landscapes.

A view of the cosmos as an abundant, proliferating but harmonized world, a world of myriad tiny details, is, in a sense, one side of a symmetrical dialectic, while the great wide world of infinite spaces—desert, sky, sea—is its symmetrical concomitant. Instinctively, Miró moved from the external realism of a Courbet toward that metaphysical realism described so accurately by Paul Klee. He was undoubtedly helped to find his way to his own poetic synthesis by his extensive reading. In 1916, for instance, he was reading French avant-garde magazines, and was familiar with the poetry of Apollinaire, and probably with his art criticism, as well as with that of Pierre Reverdy. By the time he left for his first trip to Paris in 1919, Miró was already steeped in the spirit of the avant-garde.

The principal twentieth-century drive toward the reduction of means, the elimination of all unnecessary flourish in painting, was conveyed to him early. Miró's statements in French abound with the word *dépouiller* (to strip, to eliminate, to render bare, and, significantly, to reap or harvest). Miró had written as a youth that the Group Courbet must "sweep away all the rotting and fossilized corpses," and had frequently referred to the process of simplification he wished to pursue. He was undoubtedly helped toward his goal by his exposure to the group of avant-garde poets and painters he met on the rue Blomet during his first long sojourn in Paris. Michel Leiris, Robert Desnos, Georges Limbour were regulars. Their exuberance, their espousal of Dada were not lost on Miró. Yet, through all the feverishly imaginative activities he witnessed, and all the queer and original ideas he absorbed, Miró continued to work in his own way toward his own already established ideals. Around 1923, he wrote, "I have managed to escape into the absolute of nature. . . . I know that I am travelling a perilous route, and I confess that I am often seized with panic, the panic of following unexplored paths to an unknown destination."[6]

"A perilous route": from the world of microcosmic exactitude to the world of the infinite, in which the groundline gives way and the spaces are no longer divided by habit and convention, but by feeling. Symbolist principles still influence him. In speaking of *The Hunter* (*Catalan Landscape*), he writes to his friend Rafols, "Monstrous animals and angelic animals. Trees with ears and eyes and a peasant in a Catalan cap, holding a shotgun and smoking a pipe. All pictorial problems solved. To express with precision all the golden sparks the soul gives off."[7] These golden sparks, not palpable but felt keenly by Miró as reality, are his entree into the world of the absolute, that same world of fantasy, essentially, that Matisse entered when he erased the walls and took in the sky on the same terms as a small Moroccan pot.

In *The Hunter*, Miró literally works with golden sparks; his forms glide in a yellow sky over a pink area suggesting the landscape. Shapes wander freely in various levels in space. Small and large are handled with great caprice, their relative sizes underplayed. Large circles and small circles, large arabesques and small

share the infinite space. The world in little is symbolized with the greatest economy—sometimes in the flourish of a dotted line alone —and each figure is stripped to its essential identity. Echoes of Picabia's machine parodies are to be found, but the real experience in *The Hunter* is of a space that knows no artificial boundaries and of forms that navigate that space illumined by what Miró called "the light of freedom."

Shortly after, Miró embarked on his characterization of the "large" vision of the cosmos. (He had just encountered the name of Paul Klee, and was moved by some of Klee's watercolors that he had seen in André Masson's studio. Their common assumptions apparently were immediately noticed by Miró.) Although Jacques Dupin, his biographer, insists that the so-called dream paintings of 1925–1927 had no metaphysical intentions, and that they are the expression of "the void," these paintings are expressed in the metaphysical language of the modern painter and can mean nothing other than their profound expression of things that exist in the human imagination virtually; things that fulfill the function of the unreal.

This was the moment of Surrealism, a moment Miró lived along with its most ardent proponents. It was a moment in which Miró himself, according to Dupin, was devouring the great rebels of poetry—Novalis, Lautréamont, Rimbaud, Jarry. Since it was neither the bizarre nor the fashionable in Surrealism that appealed to Miró (he never fully exercised the proper automatistic ritual), it was most probably the metaphysical reverberations, particularly in Novalis and Rimbaud, that spoke to him in their work.

It is worth examining the tone of Novalis. Both Miró and Klee read him. (Klee is said to have read his *Hymns to the Night* many times, and many of Klee's thoughts echo Novalis.) As Miró is a serious and assiduous reader, we may assume that Novalis' various insights reached him in full. We may assume, in Novalis' own words, that the poetry affected him magically,

> for it is not the mere hearing of words that really affects us in this magic art. Everything happens inside . . . the inner sanctuary of the mind. . . . He—the poet—can arouse these magic powers in us at his pleasure, and through the medium of words

enables us to experience an unknown, glorious world. Out of
their cavernous depths times gone by and times yet to come rise
up before us—innumerable people, strange regions and the
most fantastic happenings—and make use of the familiar pres-
ent.[8]

Novalis' poetic vision is rooted in metaphysical questions. "How
little one has applied physics to the human spirit and the spirit to
the external world," he wrote.

> Reason, imagination, intelligence—these are the bare frame-
> work of the universe operating in us. No word of their wonder-
> ful blendings, new forms and transitions. No one has thought
> of seeking out a new unknown force, to follow out their co-
> operative relationships. Who knows what wonderful new uni-
> ties, what wonderful new developments still lie ahead of us
> within ourselves.[9]

Certainly the program of the twentieth-century painters was con-
sonant with Novalis' vision of new relationships, and it is precisely
in the effort to express the possibility of "wonderful blendings,
new forms and transitions" that modern art announces itself as
"modern."

Novalis' tone is exalted, and oneiric, as Dupin says Miró's paint-
ings were in 1925, but, far from expressing a mystical "void,"
Novalis' poetry posits a cosmos familiar to the history of the imagi-
nation:

> What spirited being, endowed with senses, does not love, above
> all, the other miraculous phenomena of space that surround
> him, the all cheering light, with its colors, its rays and billows,
> its mild omnipresence, as when day is breaking? Like life's
> innermost soul, the titanic world of the restless stars breathes it
> and swims dancing in its blue tide—the sparkling eternally
> tranquil stone, the meditative, sucking plant, and the wild,
> burning, multiform animals breathe it— . . .
> But I turn down toward the sacred, inexpressible, mysteri-
> ous night. . . . Far-aching memory, desires of youth, dreams of
> childhood, the brief joys and vain hopes of an entire long life
> come gray-clad, like evening mist after sundown . . . —o ardor
> of night, o slumber of heaven, you it was came over me—the

landscape rose softly; and above it soared my delivered, new-born spirit. . . .[10]

His *Hymns to the Night* could serve as descriptions of certain paintings of both Miró and Klee. What is important is not so much the visionary aspect as the opening-out; within these paintings, which are tough, self-searching statements of both the tangible and the intangible, of both aspects of human life, are elements of widely differing character from which later generations were amply nourished.

The vision of large spaces that persists in the human imagination is recurrently expressed in Miró's oeuvre. The paintings of 1925 expressing extension ad infinitum are intimately related to the paintings of 1961—sublime statements of Miró's career.

In *Head of a Catalan Peasant*, for instance, Miró's various fantasies of the peasant are sublimated, and the poetic surge of feeling for a cosmos very like Novalis' is the content. The Catalan becomes a simple scheme—two intersecting threads against the infinite sky, fine and fragile but written with confidence, with the head symbolized only by the Catalan beretta. A moving star, and yet another, three small planets, and the red baton, a Godlike finger that floats downward or upward, depending on interpretation: a simple statement of the wide world of fantasy—as real to the painter as to the poet, as real as the world of small things.

In this painting and others of the 1920s, Miró has moved through the metamorphosis of form toward what he called the "absolute of nature." Dupin states:

> The problem of the genesis of forms has now been solved as far as he is concerned. Like nature herself, he works from the embryo, from the mother cells which grow and develop, split up, take on various fixed forms, but always according to a continuous process in obedience to laws of organic development.[11]

Even in these free cosmos paintings, the function of the form—or rather, the forms as entities functioning in spaces—are felt as conditioned dynamically by the whole. So slender a thread as the Catalan peasant rides the ether because the ether is as it is. The

enlarged dots, or planets, are formed as much by the pressure of the
blue density (underscored by the brush marks) as by the "idea"
of them. A dynamic view of form changes the relationships of
things in space:

> Les pointes rouges da ma cravate
> piquaient le ciel . . .

wrote Miró in his "Jeux Poétiques."[12] A poetic game, a fantasy,
yet a summary of a point of view which in substance is much the
same as Matisse's; here, the artist can imagine myriad relationships
between the solid that he is himself and the invisible concept that is
space, or sky, or cosmos.

Nothing reveals his attitude better, though, than the group of
paintings titled *Blue* painted in 1961. In all of these paintings, the
"point" is crucial, the point that Klee called the primordial, cosmic
element. "Every seed is cosmic." One aspect of Miró's work, partic-
ularly in these recent paintings, is his "cosmicizing." They are invo-
cations of vastness (a conception we *know* rather than experience
directly), of sensations such as flying, gazing, daydreaming, hur-
tling, invocations of the function of unreality and its absolute ne-
cessity. It is the vastness understood by Coleridge who, in a letter
concerning his youth, wrote: "From my early reading of fairy tales
. . . my mind has been *habituated to the Vast* and I never regarded
my *senses* in any way as the criteria of my belief."[13] Like Coleridge,
Miró is habituated to the vast. In these paintings it is given on the
canvas as a great, modulated field of blue—the chaos from which
will emerge cosmos.

What is cosmos in *Blue II*? It is the black irregular trail of
rounded shapes and the nearly vertical bar of earth-and-blood red
(the same finger of destiny as in *Head of a Catalan Peasant*). The
vivid black shapes, rounded like stones or seeds, stroll across the
blueness, as would a living being who must decide each of his next
steps. They are the marks of man's presence and they cosmicize the
vastness. The completed painting is the concrete result of a prior
ritual, or the conclusion of an unconscious metamorphosis.

In an interview, Miró explained that the large *Blue* canvases took
him a great deal of time, not in the painting, but in meditation. The

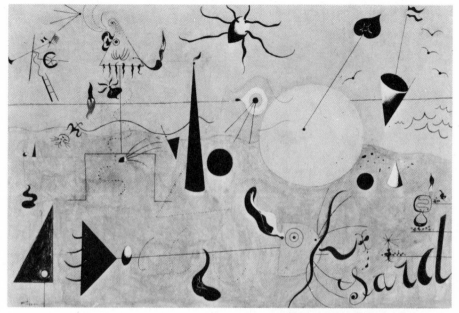

Oil on canvas, 2′ 1½″ x 3′ 3½″.
Collection, The Museum of Modern Art, New York.

8. Joan Miró: The Hunter (Catalan Landscape), 1923-24.

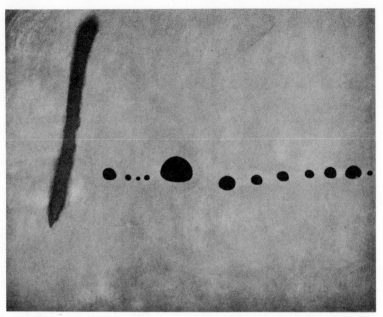

Oil on canvas, 8' 10¼" x 11' 7¾".
Courtesy, Pierre Matisse Gallery, New York.

9. Joan Miró: Blue II, 1961.

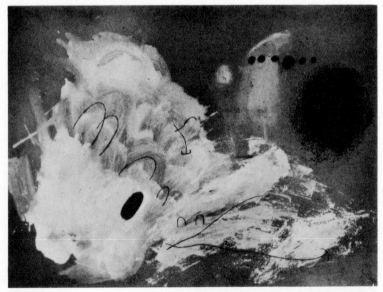

Oil on cardboard, 2' 5½" x 3' 5¼".
Courtesy, Pierre Matisse Gallery, New York.

10. Joan Miró: Solitude III/III, 1960.

first step, he said, was of an intellectual order. But then, in a surprising confirmation of the metaphysical, the "cosmicizing" aspect, he stated:

> It cost me an enormous effort, a very great interior tension, to arrive at a desired stripping-down [*dépouillement*] . . . It was as before the celebration of a religious rite, yes, like the entrance into religious orders. You know how the Japanese archers prepare themselves for competitions? They begin by putting themselves in a state, exhaling, inhaling, exhaling—it was the same for me. I knew I risked everything, a weakness, an error, and everything would have fallen to earth.

Finally, when asked what his painting orientation would be, he answered: "De plus en plus dépouillée" (More and more stripped down).[14]

In cosmicizing the uncultivated zone (in Eliade's phrase) Miró asserts his stature as a man, nothing more but certainly nothing less. He is never given to sentimental fantasies that go beyond the bounds of his own experience, his own emotion. Miró began as a realist, an aggressive, programmatic realist, willing to ally himself with the Group Courbet and to reject all the academic motifs considered acceptable at the time. He has said in a hundred different ways that his source is always nature. Dupin points out that the symbol of the foot throughout Miró's work is probably an allusion to Miró's conviction that man is rooted in the earth via his feet and everything that grows springs from this contact with terra firma. Miró is quoted somewhere as saying a man must brace his feet against the earth in order to spring upward.

(It is this deep commitment to earthly experience and the concrete world that has led Miró to protest strongly that he is not an abstract artist. "Have you ever heard of greater nonsense than the aims of the abstractionist group?" he exclaimed to Sweeney. "And they invite me to share their deserted house as if the signs that I transcribe on canvas at the moment when they correspond to a concrete representation of my mind were not profoundly real and did not belong essentially to the world of reality." Again: "For me, a form is never something abstract; it is always the sign of something. It is always a man, a bird, or something else.")[15]

To "cosmicize" is to make the unknown habitable. The familiar experiences of the concrete world are indispensable. Miró's great arcs from the earth to the infinite blue skies of fantasy and back constitute a vision of a whole world. Miró is one of the artists who have made certain twentieth-century assumptions—of prelogical concerns, of new spaces, of dynamic form—into a healthy vision. He has joined the function of the real to the function of the unreal in healthy wholeness. That "other" world of myth, archaism, and non-history which Miró understands with perfectly intuitive responses is always there. But so is the real world, with its linear history and its describable activities. The "other" world can only be expressed metaphorically (as Miró once pointed out, he wanted to go beyond form to poetry), and its proofs must lie in the realm of the sensible and the common-sense.

For instance, even if we were to resist the extravagant theories of modern philosophers and ethnographers concerning the role of myth in the collective psyche, we would have to admit that there are surges of emotion that seem utterly unprepared by an occasion. We would have to admit that colossal fury exists, that deep depressions exist, that many extremes of imaginative behavior exist without "real" explanation. When a man says, "I acted with a strength I never knew I had," or "I don't know what came over me," he is acknowledging the occurrence of a personal experience that cannot be demonstrated to others, but only understood through the imagination.

When Miró says that he wants to "rediscover the sources of human feeling," he is already taking a metaphysical position, or, rather, he is speaking of his language of signs as an instrument toward greater understanding. His language, with all its magical overtones, and probably its cultivation in knowledge of actual magic, is his philosophy made visible for all to ponder. His friends, such as Michel Leiris, probably stimulated him. Leiris, a poet and anthropologist, has made significant studies of rituals and magic all over the world as a scientist, and his conclusions invariably underline the serious sources and purposes of non-western European custom. Here again, Miró is a man of his time, and the late nineteenth- and twentieth-century willingness to "see" beyond

western European culture is expressed in him. The organic imag-
ination moves in a world of creative evolution, a world eloquently
described by Bergson, whose intuitions are supported by another
great twentieth-century anthropologist, Claude Lévi-Strauss, who
quotes a metaphysical philosophy common to all the Sioux In-
dians, according to which things and beings are nothing but ma-
terialized forms of creative continuity:

> Everything as it moves, now and then, here and there, makes
> stops. The bird as it flies stops in one place to make its nest, and
> in another to rest on its flight. A man when he goes forth stops
> when he wills. So the god has stopped. The sun, which is so
> bright and beautiful, is one place where he has stopped. The
> moon, the stars, the winds, he has been with. The trees, the
> animals, are all where he has stopped, and the Indian thinks of
> these places and sends his prayers there to reach the place where
> the god has stopped and win help and a blessing.[16]

(If a text were to serve as a parallel to Miró, what better text than
this, for Miró has "stopped" in all of these places?)

Bergson's metaphysics, which conditioned Miró's generation to
a great extent, are very similar, as Lévi-Strauss proves in his choice
of a Bergson text for comparison:

> A great current of creative energy gushes forth through mat-
> ter, to obtain from it what it can. At most points it is stopped;
> these stops are transmuted, in our eyes, into the appearance of
> so many living species, i.e. of organisms in which our percep-
> tion, being essentially analytical and synthetic, distinguishes a
> multitude of elements combining to fulfill a multitude of func-
> tions, but the process of organization was only the stop itself, a
> simple act analogous to the impress of a foot which instanta-
> neously causes thousands of grains of sand to contrive to form a
> pattern.[17]

I have said that Miró joins the function of the real to the func-
tion of the unreal in a wholesome way. Lévi-Strauss, in comment-
ing on the two texts, the Sioux and Bergson, makes a similar point
with terms of discourse that are significantly scientific. What have
the Indian wise man and Bergson in common? he asks.

It seems that the relationship results from one and the same de-
sire to apprehend in a total fashion the two aspects of reality
which the philosopher terms *continuous* and *discontinuous*;
from the same refusal to choose between the two; and from the
same effort to see them as complementary perspectives giving
on to the same truth.[18]

The need to apprehend "in a total fashion" the two worlds that
are continuous and discontinuous is probably the central philo-
sophical question of our time. Miró has consistently woven back
and forth between the two realms, knowing instinctively that they
exist as two aspects of reality. But Miró is a painter, and his lan-
guage is the language of a painter. Forms, no matter how many
times he has questioned their importance, are the flesh and blood
of his paintings. Forms, or, in a different sense, symbols. Vege-
tables, hats, feet, skies, winds, seas, hair, and blood symbolize both
worlds in a poetic reminder of their ineffable capacity to stir emo-
tion at levels we hardly discern in our everyday existence. The
moon, stars, the ladder inevitably resound poetically.

Ceramic, 3' 2½" x 1' 9¼" x 1' 1⅜".
Courtesy, Pierre Matisse Gallery, New York.

11. Joan Miró: Femme, 1962.

Ceramic, 10′ 6″ x 1′ 11⅝″ x 1′ 6″.
Courtesy, Pierre Matisse Gallery, New York.

12. Joan Miró: Femme et Oiseau, 1962.

9

Form as Function

Miró's ceramic pots and sculptures are invested with the implicit energy that Klee called "a sense of totality when dealing with the object." Form in its most vital aspect is assigned the major expressive role. But it is not only outward form that interests Miró. He is as much aware of the "functions" that force the wall of an amphora to belly out as he is of the outer curved wall.

When he began working with Josep Llorens Artigas, a master ceramic technician, one of the first things Miró did was to study the forms of vegetable marrows, feeling out the secrets of their often asymmetrical bulks, touching their smooth or bumpy surfaces, englobing their fullness in his hands. Miró, like Klee, has always been interested in natural forms and has studied them closely since he was a boy.

Jacques Dupin notes that from 1945 on, however, Miró's approach to objects and sculptures has changed. "He no longer searches for bizarre combinations, but for significant moments that reflect an organic vision of natural forms."[1] This vision of natural forms is then heightened and transformed so that the "function of unreality" is fully satisfied. Miró was not merely drawn to the natural form vaguely, but was specifically and concretely interested. When he began working with Artigas in his country atelier, Miró was exhilarated by the discovery of the savage character of the rocks recalling the mountains of his home in Montroig. The second day he was there, Artigas recounts, Miró ran out and began painting directly on their rough surfaces. Reverting somewhat to his Surrealist days, when the *objet trouvé* provided such a spur to the

imagination, he began to reflect on how he could produce the casual appearance of the objects. He decided to make Artigas' 19-year-old son his apprentice "because he had never studied drawing or esthetics and is free of all artistic prejudice." He set the boy to work making replicas of natural objects. When they were complete, Miró would alter them, or, if they suggested something else, would add or subtract forms. Sometimes they were joined with fragments of metal, plaster, and wood.

In his first series of sculptures made between 1953 and 1956, Miró was still given to ornamental or symbolic flourishes, relating more to his painting than to sculpture itself. But in the second group a majesty announces itself that far surpasses anything Miró has fashioned before. Nietzsche had said that there is no such thing as pessimistic art. Art affirms—it affirms even as it hints at the terrors of existence and symbolizes the dark and unfathomable strains in man. Miró's ceramics are pure affirmation, supremely evident not only in the plenitude of his shapes, but in the recurrent themes of fertility rites, sexual felicity, natural growth, and rootedness: rootedness in the sense that Miró's fantasy goes beneath the surface, expressing itself almost exclusively in the sculptured shape which grows from within and is not dependent on surface commentary. It is as if these sculptures grew beneath the sculptor's hand with hardly a thought intervening, as if the millennial dreams of potters and ancient sculptors had found their natural expression through this man working with earth and fire. In their firm contours, in their much-traversed, coruscating surfaces, Miró's ceramics offer a vision of cosmos in its purest sense.

Not that Miró created factitious primitivism. Rather, he came to the simplicity and stark effects of the primitive artist via the principles implicit in his total oeuvre. Klee always protested when his drawings were likened to children's drawings or to the pictographs of primitives. He pointed out that they were a reduction to an essence, arrived at through sophisticated means. The same is eminently true of Miró. He found that the rocks and gourds and animals and bones, which had served ritualistic artists of so-called primitive societies so well, could be used as the source of his own metaphorical language. In making their shapes his own, he re-

possessed the earth for which a part of him had always longed. It is plenitude, well-being, that these pieces emanate, despite their allusions to violent ritual or even tragedy. His great amphoralike vases, for instance, with their swelling sides and roughened surfaces, are vital reminders that man has always symbolized well-being in the fullness of his pottery.

From the expressive vessel to the symbolic sculpture is a brief step. Miró, who has always maintained that he admires poets more than plastic artists, is never content to make beautiful shapes for their own sakes; he is also a poet, seeking direct contact with the mysteries of existence. From his craving to be rid of the conventional logic of Western thought—a craving that asserts itself throughout his later work, and which is based on the assumptions of the early part of the century—he has moved steadily toward a most elementary, or perhaps elemental, symbolism.

Although they cannot be called primitive, his ceramic sculptures abound with allusions to mothers, goddesses, fetishes, and temple-like edifices. Woman and goddess, however, are metaphorically linked. They are equal; they are also round-walled enclosures, housing the generative seed; they are edifices; they are animals; they are pictographic symbols. They can be built as if of masonry, like pedestals reminiscent of Aztec walls, or fashioned as slender columns, smooth-walled drums mounted atop one another, culminating in lunar horns. Miró seeks and finds a mythos, but a modern mythos.

One element which distinguishes the work of Miró from the studied primitivism of certain modern artists is his humor. Even when he speaks of magic and august mystery, Miró preserves his smile. It is found in the way a woman's head seems to grow from a conch, or in a round, tublike citadel, crusty and indestructible.

Miró, then, has gathered his creative forces into a stupendous, energetic expression of an innate sense of dynamic form. Each of his pots has both an internal energy—a structure—and an outer guise, which come together as a moving whole. His capacity for suggesting magic, and for reminding us always of the dark side of the moon, the forces that work within us without our knowledge of what they are, is unique. And it fulfills the prophecies of earlier

twentieth-century artists who understood that the world of appearances was scarcely large enough for the new terms. Ever since Nietszche, who believed that art was "metaphysical solace," it has been difficult for a great many artists to regard the works of an artist's imagination as mere outer phenomena whose significance is strictly esthetic. Form, itself, takes on a metaphysical significance, a "life" which is understood to be autonomous and organic by many artists. Chaos, or formlessness, is overcome not by the imposition of a static formula, but by an area of energy that charts itself as form. This is not primitive animism; Miró's found objects, the way he sees rocks and shells and sea debris, are more in keeping with the twentieth-century vision of the continuum of energy, of the unity of life. It is akin to Matisse's erasing of the wall.

10

"A Mobile Life in a Changing World"

Both Miró and Klee were constantly preoccupied with the changing life of forms, in other words, with metamorphosis. The twentieth century, no longer able to see metamorphoses in their narrative symbolism as could the Renaissance, made metamorphosis into a detached process, not connected with stories of Leda, Zeus, and other remote legendary personages, but directly experienced in life itself. For definitions, one dictionary gives: 1. change of form, structure, or substance, esp. by witchcraft or magic. 2. transformation of any kind.

It is natural for a generation steeped in the dynamic view of the imagination, as well as the Bergsonian view of creative evolution, to concern itself with "transformation of any kind." The emphasis on metamorphosing forms has been more or less constant for almost two centuries. The simple statement of the Romantics, *becoming*, not being, epitomizes it. The world of becoming is the world of structural transformations. The roots of such thought are deep in the nineteenth century, in the insights of Goethe and Coleridge as well as many others. In his poem "Psyche" Coleridge pointed out that the Greeks used the word to mean both the soul and the butterfly and made an analogy between the metamorphosis of the butterfly and the metamorphosis of human relationships. Life is viewed by Coleridge and Goethe as a progression, ordered, if possible, of unceasing changes.

Metamorphosis, then, is not merely a preoccupation of the Sur-

realists, who emphasized its magical aspect, but has been seen by
many twentieth-century artists in an objective, structural sense as a
definition of life. The twentieth-century artist entered the dynamic
world of becoming and hardly had to give it a second thought. It
was one of the assumptions he could take for granted.

Often the degree of acceptance of certain assumptions can be
tested by the diction of texts accompanying the history of recent
art. In early avant-garde publications, there were frequent allu-
sions to the metamorphosis of language, with reference especially
to Joyce. When Roger Fry collected his essays in 1926, he grouped
them under the title *Transformations*, and explained that he
wished to suggest "all those various transmutations which forms
undergo in becoming part of esthetic constructions."[1]

Henri Focillon, in his brilliant and influential essay *The Life of
Forms in Art*, first published in Paris in 1934, referred again and
again to the metamorphosis of forms. His thesis is apparent when
he writes:

> Form, it is true, may become formula and canon; in other
> words, it may be abruptly frozen into a normative type. But
> primarily form is a mobile life in a changing world. Its meta-
> morphoses endlessly begin anew, and it is by the principle of
> *style* that they are above all coordinated and stabilized.[2]

The "mobile life in a changing world . . ." Kandinsky, Arp, Pi-
casso, and dozens of other artists worked, consciously or not, to-
ward the realization of mobility, while others, such as Mondrian,
sought via abstraction to express the precarious moment of equilib-
rium in which both the mobile life of forms and the changing
world meet for a moment in a "stop."

The assumption of change as the character of existence underlay
Picasso's Cubism. His juxtaposition of interacting planes and his
view of objects as many-sided would be unthinkable if the assump-
tion of change were not there. A Cubist painting is specifically
about the changing structural qualities within forms as they are
perceived in mobile spaces. Kandinsky had predicted that Picasso
and Matisse would revolutionize painting, Matisse with color, Pi-
casso with form. Picasso's accent on transformation, on the dynamic

interpenetration of inside and outside (a guitar appears to us from all sides, and from within as well), puts him in the organic tradition.

Throughout his essay on Picasso, Alfred Barr refers to Picasso's "metamorphic style." Of a 1927 painting of a figure, for instance, Barr writes: "The human form has undergone a metamorphosis so radical that foot, head, breast and arm are not readily recognizable."[3] He speaks of Picasso's passion for metamorphosis, and of his interest in the classic stories on the subject (his illustrations for Ovid, his preoccupation with the Minotaur). He reproduces *An Anatomy*, a page of metamorphic studies for sculpture dated February 22, 1933, and published in the magazine *Minotaure*, and adds a footnote:

> A series of etchings dated 1624 and showing metamorphic variations of human figures composed of carpentry, ribbons, solid geometrical shapes and pieces of furnitures by the Genoese mannerist painter Bracelli were published in *Formes* in 1931. They may be compared with Picasso's fantastic *Anatomy*.[4]

Barr illustrates Picasso's abiding interest in metamorphosis when he discusses a *Bull's Head*, assembled from parts of a wrecked bicycle. He quotes Picasso:

> Out of the handle bars and the bicycle seat I made a bull's head. Thus a metamorphosis was completed; and now I would like to see another metamorphosis take place in the opposite direction. Suppose my bull's head is thrown on the scrap heap. Perhaps some day a fellow will come along and say "why there's something that would come in very handy for the handle bars of my bicycle . . ."[5] And so a double metamorphosis would have been achieved.

In practice, Picasso's passion for metamorphosis is concentrated on the reduction of his painter's means to expressive forms, forms that necessarily are mined from his own visual experiences. Unlike the Surrealists, Picasso was not interested in the extra fillip, the extra increment of oneiric meaning. In both his *Bather* series and his *Sleeping Woman* series, usually considered the closest he ever

came to the Surrealist spirit, Picasso always concentrates on estab-
lishing the characteristic gesture in its essence. Playful elaborations
are avoided.

The magnificent slumber picture *Nude on a Black Couch,* dated
1932, is not merely a voluptuous essay in arabesques, but has the
"disquieting" overtones familiar to the mind of the Surrealists. The
philodendron leaves are fleshy, powerful; they spread against the
white door like predatory hands, and suggest the thick and sinister
herbiage of the jungle more than the leafy decor of bourgeois
interiors. The atavistic overtones are given in a flare of red at the
right, and in the yellow area beneath it—unquiet intrusions into an
atmosphere of torpor. The Surrealist propensity for disturbing
metamorphoses and queer illusion is echoed in the reverse image of
the head. Picasso grays the violet of the face very slightly, while
the violet outside the profile is perceptibly deeper, hinting not at
one but two images. The mirror and the theme of narcissism were
not far from Picasso's mind at this time.

Picasso's many pictures of sleeping women, with their fierce in-
tonations and suggestions of violent dreams, indicate his deep
affinities with certain of the Surrealists, but particularly the Sur-
realist poets. His intense friendship with Paul Eluard is under-
standable. Eluard wrote ceaselessly of illusions and dreams, and
often the objects and the dreaming subjects were metamorphosed
or fused. Picasso's own writings reflect the bond between the two
men. He kept strange diaries that read like Surrealist exercises.
Here is a random translation from his 1941 notebook:

> Chasuble of blood thrown on the nude shoulders of the green
> wheat trembling between damp sheets symphonic orchestra of
> torn-up flesh hung on flowering trees of the wall painted ochre
> agitating its great apple green wings and white mauve tearing
> its nose against the windows . . .[6]

Or, consider this excerpt from 1942:

> It was not for nothing that the three bodies made of mud and
> light remained enveloped in shadow and sadness the quarter of
> the century past . . .[7]

These jottings without punctuation, often of interest only because
of the euphonious associations, are characteristic of a certain tend-

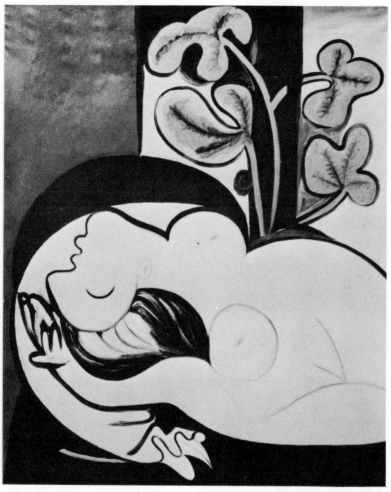

Oil on canvas, 5' 3½" x 4' 2¼".
Private collection.

13. Pablo Picasso: Nude on a Black Couch, 1932.

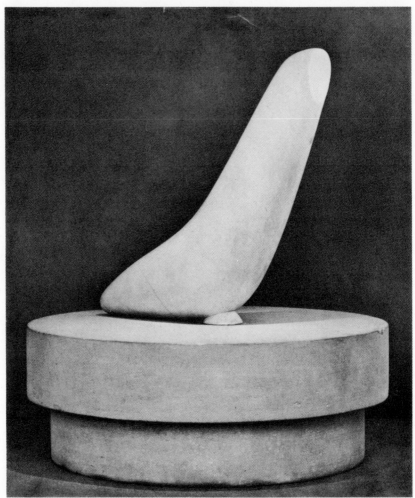

Marble, height 3′ 7″ (excluding base).
Collection, The Solomon R. Guggenheim Museum, New York.

14. Constantin Brancusi: Miracle, 1936?

ency in Picasso to seek the same dislocated, disordered forms that the Surrealists identified with the notion of metamorphosis. But while Picasso may be said to be interested in "transformation of any kind," the orthodox Surrealists were more interested in the "change of form, structure, or substance, esp. by witchcraft or magic"—or by dream. They looked back to the medieval images of a Hieronymus Bosch; to the deranged dream drawings of Grand-ville, to Redon's work, to Gustave Moreau (whose favorite themes included Daedalus, Phaethon, and Galatea, all associated with mi-raculous metamorphoses).

A sample of the kind of intelligence which would have thrilled a Surrealist is the following:

> The new vision of Original Man was most grandly expressed by an Italian contemporary of Bosch's, Pico della Mirandola, the Florentine Neo-Platonist, in his exultant praise of Adam, whom he regards as a Protean expression of the universal proc-ess of transformation and whose nature he places between the animal and the divine. "Hence," says Pico, "Asklepios of Athens had good cause to say that this ability to transform one-self into all kinds of different beings is represented in the mysteries by the symbol of Proteus. And hence, the Pythagor-eans, too, as well as the Jews, celebrate a festival of the Meta-morphoses."[8]

The Protean, or, as it is sometimes translated, the biomorphic possibilities of form were exhaustively studied by Hans Arp, whose poems and cryptic writings on art provide an unfailing gauge of the temper of the Surrealist epoch.

"In art," he wrote,

> man loves what is vain and dead. He cannot understand that painting is something other than a landscape prepared with oil and vinegar, and sculpture something other than a woman's thigh made out of marble or bronze. Any living transformation of art seems to him as detestable as the eternal metamorphoses of life.[9]

His various translations of what he means by "concrete" art—art that grows like a fruit—reinforce the organic view. In 1958, he wrote in the Museum of Modern Art catalogue for his exhibition:

> Concretion signifies the natural process of condensation, hardening, coagulating, thickening, growing together. Concre-

tion designates the solidification of a mass. Concretion designates curdling, the curdling of the earth and heavenly bodies. Concretion designates solidification, the mass of the stone, the plant, the animal, the man. Concretion is something that has grown.[10]

What better or more naturalistic description of metamorphosis?

In the work of Constantin Brancusi, form was consistently used to symbolize becoming, and on this account he has his place in the history of modern art as a revolutionary. Although Brancusi resolutely defied the estheticians and warned them not to look for "obscure formulae or for mystery" in his works, his sculptures can be read as definite statements concerning the vitality of forms and their mobility. "When you see a fish, you don't think of its scales, do you?" he is quoted as saying by Malvina Hoffman. "You think of its speed, its floating, flashing body seen through water. Well, I've tried to express just that. If I made fins and eyes and scales, I would arrest the movement, give a pattern or shape of reality. I want just the flash of its spirit."[11]

The difference between Brancusi's interest in mobility of form and that of the Impressionists, or of Rodin's, for example, lies in his typical twentieth-century sense of an imperative to strip form to its essential function. A bird soars, and its body is fashioned for soaring. Brancusi, in his brass and marble sculptures particularly, reduced organic forms to their perfect function. The light that skims up the curving walls of his brass birds is a vital effervescence from the shapes of the walls themselves. Brancusi entitled one of his bird sculptures *Project Before Being Enlarged to Fill the Vault of Heaven*, and in his light forms, skimming on polished surfaces, he found the means to fill the vault.

The incantations used by the Surrealists to induce their imaginations to floriate automatically might be considered magical. They were not concerned with essential form. Certainly, the Surrealists could not leave the idea of magic alone. Their view of transformation, which works well in written poetry and less well in painting, was summarized by Max Ernst:

> It was discovered that the more arbitrary the juxtaposition of the elements, the more certain it was that a complete or par-

tial transubstantiation of things by the flying spark of poetry
would take place. The joy of every successful metamorphosis
does not originate from a miserable poetic urge for distraction.
It rather stems from the ancient vital need of the intellect for
emancipation from the chimerical and stultifying paradise of
fixed memories, and from its urge to explore a new, incompar-
ably large sphere of experience, where the borders of the so-
called inner world and the outer world . . . overlap more and
more. . . .[12]

Metamorphosis, or transformation—the process of moving and
shaping—is, then, at the heart of the Surrealist credo, but is not
exclusively theirs. Barr could write of the unrecognizability of ana-
tomical features in Picasso's metamorphic style of around 1927;
he could have written the same observation of deKooning's ab-
stractions of the late 1940s, and again of the late 1950s. DeKoon-
ing has consistently utilized the principle of the "mobile life in a
changing world." When he first began to paint romanticized vi-
sions of angels, he had already freed the line from any descriptive
function and used it to suggest the mobility of anatomical shapes.
Later, when he returned to the recognizable female form in the
Woman group, he transposed rhyming parts—muscles and breasts,
cheeks and hips—in such a way as could be read either as ab-
stract continuations of the aggressive atmosphere that envelopes his
figures, or as independent organs. His whole vision is fraught with
the disjunctions that metamorphosis implies. He, too, sought what
Ernst termed the "emancipation from the chimerical and stultify-
ing paradise of fixed memories," and when he came to do his land-
scapelike abstractions, with their blue horizons leaping forward
and their inverted perspectives, he made a paradise of his own,
one in which movement is not constructed, but occurs in the nat-
ural onflowing of his brush over the surface of his yielding canvas.
The spaces he describes in many of his later abstract landscapes are
large and unencumbered: spaces that offer curious vistas for the
imagination. They are tinctured with the knowledge that subject
and object have a thousand invisible links, and are perhaps one af-
ter all.

What was viable in Surrealism for deKooning and others was

specifically the vision of the organic and the inorganic intermingled in constant transformation.

As a working principle, metamorphosis is present in almost all the arts practiced by men of deKooning's generation. Poetry, too, flowered in the climate of metamorphic elasticity. One of America's major poets, Theodore Roethke, was, as Stanley Kunitz wrote shortly after Roethke's death, a "poet of transformations." Writing from the sympathy and understanding generated by his own dedication to the principle of transformation, Kunitz clearly enunciated the poetics of his generation through his analysis of Roethke's work.

"A lifework that embodied the metamorphic principle was abruptly terminated on August 1, 1963," Kunitz begins. "If the transformations of his experience resist division into mineral, vegetable, and animal categories, it is because the levels are continually overlapped, intervolved, in the manifold of tissue."

The overlapped, the intervolved is always in a state of becoming. Roethke's personages, as Kunitz remarks, are always Roethke. "And he encounters death in a thousand rotting faces—all of them his own," and "we must remember that it is the poet himself who plays all the parts." The poet feels his way into all manner of things and states of being, and becomes them as he moves restlessly back and forth in space-time. Growth—the organic principle—is the very essence of both his quest and his journal of the quest in the poems.

> Roethke's passionate and near-microscopic scrutiny of the chemistry of growth extended beyond "the lives on a leaf" to the world of what he termed "the minimal" or "the lovely diminutives," the very least of creation including "beetles in caves, newts, stonedeaf fishes, lice tethered to long limp subterranean weeds, squirmers in bogs, and bacterial creepers." These are creatures still wet with the waters of the beginning. At or below the threshold of the visible they correspond to that darting, multitudinous life of the mind under the floor of the rational, in the wet of the subconscious.

The motility of the spirit geared to thinking of existence in terms of transformations is stressed in the opening section of "The Lost

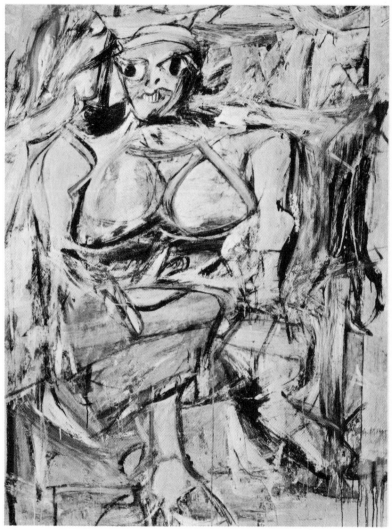

Oil on canvas, 6' 3⅞" x 4' 10".
Collection, The Museum of Modern Art, New York.

15. Willem deKooning: Woman, I, 1950-52.

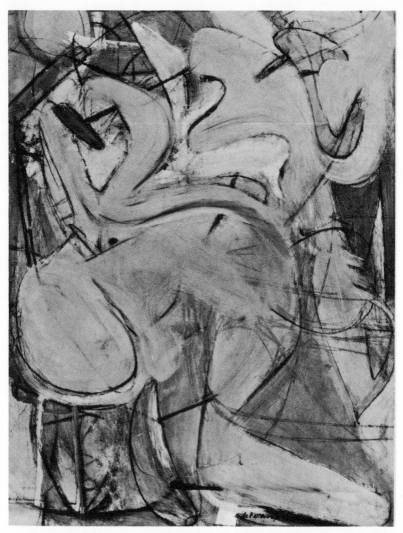

Charcoal and oil on composition board, 2′ 8⅞″ x 1′ 11¼″.
Collection, The University Art Museum, University of California, Berkeley. Gift of Julian J.
and Joachim Jean Auerbach.

16. Willem deKooning: The Marshes, 1947.

Son." Of this, Kunitz says, "The hallucinated protagonist, regressing metamorphically, sinks down to an animistic level, begging from the sub-human some clue as to the meaning of his existence." (Miró and later Gorky begged from the sub-human or the "minimal" the same clues.) Later, Kunitz comments on the poems in Roethke's last book: "As always, in these soliloquies, the poet sinks through various levels of time and of existence," and "tries to relive his selfhood back to its mindless source, so that he may be born again, meanwhile proclaiming his faith in the inexorable wheel of metamorphosis."[13]

Kunitz's own poetry is nearly always the song of the poet sinking through various levels of time and existence. His own transformations are not as "minimal," as vegetable and close to the moist organic beginnings as Roethke's, but are cast, rather, in a grand, oracular tone. Ruminations on time and history are offered in certain of his poems in the same Jungian pattern of regression and progression that he discerns in Roethke. The spiralling of a man's life is felt throughout his oeuvre and, in a sense, Kunitz, Roethke, and all the metamorphic poets of the twentieth century realize the dream of the One, the dream of the single work that comprises the all of what must be sung; their oeuvre, like a symphony, must be heard to the end so that the spiritual and kinesthetic reverberations form and re-form their patterns beyond the poem, or collections of poems. The metamorphic principle extends itself mysteriously into infinity.

Kunitz writes, in "The Way Down,"

> Time swings her burning hands.
> The blossom is the fruit,
> And where I walk, the leaves
> Lie level with the root.[14]

In this and countless other condensations, Kunitz puts the metamorphic principle to work, evoking images that in their allusiveness resound through time and space as the strong breath of the Norseman resounds in the conch.

What Kunitz calls "that darting, multitudinous life of the mind under the floor of the rational" has been the object of many ex-

cavations undertaken by both poets and painters. For the painter it is more elusive, more difficult to symbolize perhaps, but throughout the twentieth century painters have returned again and again to the vision of existence sponsored by the metamorphic principle. The Surrealists isolated the principle of metamorphosis, and raised it to unprecedented importance. Since their energetic exploitation, there have been various approaches to transformation in the plastic arts, often less pure, less intensely centered in an idea than the works of Surrealism's prime.

In much contemporary work, metamorphosis is treated with varying degrees of abstraction, sometimes adhering to the orthodox Surrealist principle of unprepared juxtaposition, sometimes to the organic principle of growth, in the way Miró studied organic form, sometimes more closely to the structural principle of what Klee called the "pre-existing" form.

In the work of Robert Rauschenberg, for instance, the high-spirited Surrealism broached by Apollinaire finds an heir. Rauschenberg's thrust into the discourse of modern painting is in the direction of paradox. He uses the "real" to initiate experiences of the unreal, to use one of John Cage's favorite phrases. To initiate experience: in this concept, the romantic notion of becoming rather than being is fully honored. Cage and Rauschenberg accept the basic premise that the imagination is organic, and, just as the late nineteenth-century Symbolists stressed suggestion rather than description, so they stress initiation rather than completion. In this way, they hope to remain true to their vision of existence as perpetual flux.

It is natural for Rauschenberg to annex the metamorphic principle. In his paintings—compendia of photographed images, painted passages, rubbings, and silk-screened images, sometimes called "combines"—a street sign passes quickly into a tower; a crate of oranges converts easily into city lights; human faces become a crowd; hats stand for people. Any number of imaginative experiences are available in the openness of his transforming process.

The orthodox metamorphic approach is most salient in his illustrations for Dante's *Inferno*. Dante's medieval horror of metamorphosis directly conditions Rauschenberg's imagining. To the medi-

eval mind the demonic has no consistency. It appears to be one thing and becomes another, producing a terrifying sense of the indefinite. Dante's awe in the face of transformation is felt in Canto XX, where he describes a woman "whose unbound hair flows back to hide her breasts," and in Canto XXV, where he recalls tales from Lucan and Ovid and boasts that his own inventions are the more horrible. His vision of the most terrifying loss of consistency through metamorphosis is expressed in the description of sinners "who fused like hot wax, and their colors ran together until neither wretch nor monster appeared as he began."[16]

Rauschenberg could easily adapt his style to his subject, for the preceding Surrealist psychology had saturated his formative years, and he could take it for granted that there is something darkly magical in metamorphosis. His fugal style enabled him to merge one image with another, changing both. He could illustrate directly, without too much difficulty, some of Dante's most hallucinating passages. The constant movement in the flow of the *Inferno* was congenial to Rauschenberg's additive imagination. One image superposed on another; a symbol thrown into an indeterminate chaos of atmosphere; a fragment of lettering or a fragment of a human physiognomy inserted in a wilderness of marshland are part of the ongoing process of imagination that Rauschenberg naturally adheres to even in his single canvases.

Of course, the mocking heritage of Dada is not left behind. In many of Rauschenberg's "objects" there is an intention to shock into acute awareness sensibilities that have lost a foothold in the mundane world. Rauschenberg, like many painters who were shaped after the Second World War, was impatient and critical of romanticism, and stated, through his work, an insistence on things as they are. But things as they are, for Rauschenberg, are things in perpetual transition, things seen in the continuing tradition.

Transfer drawing, watercolor, wash and pencil. 14½″ x 11½″.
Collection, The Museum of Modern Art, New York.

17. Robert Rauschenberg: Dante's Inferno, Canto XXVI, 1959-60.

11

Transforming Assumptions:

Surrealism

into Existentialism

Writing in the 1930s Max Ernst envisioned an experience "where the borders of the so-called inner world and the outer world would overlap more and more."

To the artists of Ernst's generation, the world of Freud was the inner world—a world of inner life histories, woven by the unconscious largely in terms of dream. It was still the world of mechanistic cause and effect: the terrible experience of a child registers and causes a dreadful effect in the adult. In all Surrealist painting and writing, there is a distinguishable division between waking reality and the hallucinating work of dreams.

The Surrealists had remained, for the most part, devoted to the Freudian tradition which had been turned to such brilliant account by André Breton. As a medical student, Breton had studied mental disorder and was alert to the radical implications of Freud's theory. Freud's emphasis on the role of dreams was congenial to Breton's temperament. Without the wild verbal impulse impelling him, perhaps Breton would never have launched Surrealism. But in Freud he found a confirmation of his own need to escape the deadly effects of what he considered utilitarian realism in literature. Freud, as Breton said in his *First Surrealist Manifesto*, made it possible to escape from logic. Specifically, he made it possible for Breton to escape a hoary European tradition and lay the firm groundwork for another tradition. Much has been said of Breton's theories, his inconsistencies, his dogmatism, his implacable nature. Too often the

fact that he was an artist of immense endowment is obscured. Anyone who doubts should read his *First Surrealist Manifesto*, not for the theory, but for the verbal magic, the savor of the words, the flow and the implicit, if odd, logic of his thoughts, the flowering of his fantasy. More than his programs and principles, his art carried the day. In this manifesto, his Freudian dualism is more emphatically stated than in later writings. "I believe in the future resolution of these two states, apparently so contradictory, which are dream and reality into a sort of absolute reality, a *surreality* if one can put it that way."[1]

But Breton's reality, as it appeared in his poetry and his novel *Nadja*, was far to the side of the dream. He spoke early of his loathing for the materialist mind with its "hatred of the marvelous"; and the marvelous, as he kept asserting through his exalted imagery, exists in the dream. Surrealism to him was a source of almost religious revelation. He refers again and again to the "voice" of Surrealism and once spoke admiringly of Robert Desnos, who, he said, "could *speak Surrealist* at will." Here, the break between waking, commonplace reality and the marvelous is sharp. The absolute reality, for Breton and many Surrealists, was to remain the reality of the dream.

Yet Ernst, when he foresaw a moment when the borders of the so-called inner and the outer worlds would overlap, and Aragon, when he recognized the necessity of the concrete reality of the here-and-now, were removing themselves from the sharp dichotomy of the ancient heritage of reality as normal and commonplace, and irreality as demonic. Both suspected that this duality had been superseded by modern life.

It was during the second wave of Surrealist activity in the 1930s that the works of Kierkegaard, Husserl, Heidegger, and others began to hold the attention of such thinkers as Jean-Paul Sartre, Jacques Merleau-Ponty, Gabriel Marcel, and of a new generation of psychiatrists in Europe who deviated radically from the Freudian approach. Out of the ferment of the 1930s arrived the emphasis on Existentialism in the 1940s. No sharp breaks can be traced in this evolution. In some ways, Bergson prefigures Sartre startlingly. Take this passage, for instance:

> For reason does not proceed in such matters as in geometry where impersonal premises are given once and for all, and an impersonal conclusion must perforce be drawn. Here, on the contrary, the same reasons may dictate to different persons, or to the same person at different moments acts profoundly different, although equally reasonable. The truth is that they are not quite the same reasons, since they are not those of the same person, nor of the same moment. That is why we cannot deal with them in the abstract, from outside, as in geometry, nor solve for another the problems by which he is faced in life.[2]

The whole emphasis in the new philosophic inquiries is now on the "phenomenal field," on the complex relations existent between man and man, man and object, man and time. In the writings of the 1940s and 1950s, we find a stress on the word "situation." A situation contains many elements, and any change in any element changes the whole. Man, as an isolated, thinking being, is no longer simply a subject. He exists always in a situation, and although no one can die for him, or, as Bergson said, no other person can solve the problems by which he is faced in life, it is taken for granted that he does not exist unless he exists in the world.

Existential psychoanalysis, as practiced by contemporary European analysts, follows Heidegger's designation of existence as being-in-the-world. This has opened various new paths, according to an essay by Ludwig Binswanger, such as studies of various existential dimensions—height, depth, width, thingness and resistance, the lighting and coloring of the world, the fullness or emptiness of existence. In the same essay, Binswanger clearly defines the phenomenological, or Existentialist, post-Freudian concept of the dream. Existential analysis, he says, understands the dream as specifically one of being-in-the-world: in other words, as being of a specific world and a specific way of existing. "This amounts to saying that in the dream we see the whole man, the *entirety* of his problems in a different existential modality than in waking, but against the background and with the structure of the *a priori* articulation of existence."[3]

Dreams are a continuation of waking life in a different manner, matter-of-factly bringing the two worlds of which Ernst spoke

closer than ever before in a natural continuity. They are no longer a realm for creative retreat, as they were for Breton.

The principal stress, with existential psychoanalysts, is always on structure. "I only ask you not to imagine existential structure as something static, but as something undergoing constant change," writes Binswanger.[4] He is concerned with "the structures, structural articulations and structural alterations" of man's existence; hence, he says, it is not consciousness alone which interests him, but the whole man prior to any distinction between conscious and unconscious, "for the existential structures and their alterations permeate man's entire being." Or, as another existential analyst puts it: "In phenomenological psychology man is considered as existing. All mental experiences—perception, remembrance, thinking, dreaming and also feeling—are relations of an existing human being and his world. They presuppose both the human being and his world."[5]

All of these approaches to the definition of man and his world deviate from nineteenth-century Romantic notions of empathy. Shelley, "feeling into" the nature of Mont Blanc, is having one of many possible experiences of an object in the world and his relationship to it. Coleridge, feeling at one with the universe, *is*, for a moment and *in a certain situation only*, at one with the universe. But there are so many other situations.

In many Existentialist writings it is conceded that we "transcend" this world through the things in the world. The artist's moment of transcendence—that moment which Nietzsche recognized as the moment when he is no longer the artist but *becomes* the work of art—is arrived at through being absorbed by the things, real or imagined, of this world. But the old, simple subject-object dichotomy has been complicated a hundredfold, and it is complicated by a view of the universe that is compounded by thousands of inexplicable temporal and spatial relationships. Change, metamorphosis, structural variation are no longer simple cause-and-effect affairs. For the artist of the postwar era, the assumptions added to the modern tradition are agents of incertitude.

The nature of daily experience is subject to change, and with it, any scientific deductions made concerning it. Think, for instance, of

the psychiatrically studied cases in which the subject's problem was traced back to the existence of the wet nurse, the so-called second mother. Wet nurses are now passé, and with them, the neurosis once described as the effect caused by the substitute mother. Many contemporary psychiatrists have noticed that the nature of neurotic disorders has changed and that new sources of anxiety have appeared. Whether these are true changes, or only changes in superficial content, is not important.

The language of the Existentialist and phenomenological thinkers is unfortunately far from clear. To appraise the validity of their thought requires the perspective of time, and, probably, the work of many future scholars. Yet, many have sensed the importance of their amplifications of the Freudian approach. The Surrealists assumed their feverish dreams to be separate—a part of a dream life which was another reality. But the dreams of latter-day fantasists in the arts are not. The world—usually summarized in works incorporating the dream contents—is taken into the dream rather than the other way around.

When the phenomenological psychologists talk about case histories, they tend to talk about the "landscapes" through which their subjects pass. A patient is seen, not as an isolated entity beridden with obsessions, but rather as an transient in a world of objects. A child, then, would be examined in his own world, the world of unreasonably cherished toys, of playrooms, cellars, gardens, and schoolrooms. He would be examined as though all of the objects of his life were so many signals. How he lives amongst these things is more revealing than his behavior to this or that person.

The distance between the world of objects and the interior or psychological world is thus diminished in the new psychology. How would it have been possible for Pop Art, with its emphasis on objects, to have evolved had not this new mode of thinking saturated us? There is a vast difference between the Surrealist object of 1930, prized for its suggestive strangeness, and the Pop object of the 1960s, prized for its *un*strangeness. The Surrealist object is an excrescence of the subconscious, taking on meaning only because Freud had established a rhetoric to deal with the unconscious. The Pop object is "in-the-world" on the same level with the man who

conceives it. His relations to it are what count, not the dreaming allegories it stimulates in his imagination.

While philosophical constructions rarely inspire artists directly, they seem, in practice, to parallel artistic trends. The Existentialist psychologists too are significantly parallel, in their research into the nature of man's seeing and feeling of his world of objects, to the ways in which artists have come to treat the phenomenal world.

The much-discussed "care," or anxiety, the basis of the "crisis" psychology on which the Existentialists founded their speculations, is there; it exists; it is an experience widely noted and widely shared. While there are fashions in illness, just as there are fashions in art—in Italy, for instance, it is the rare individual who does not suffer from *fegato*, or liver disorder—these fashions do take their pretexts from the world. Thus, the anxiety, enunciated by Kafka and symbolized by Beckett cannot be separated from the moment in time in which it appeared: a moment of extreme social distress, of genocide, of betrayal, of postwar exhaustion.

The new assumptions and the pervasive sense of radical change which confronted the young artist of the 1940s evoked strong responses. For many, the world of things no longer seemed so clear and tangible. The painter could no longer be as certain of making order out of chaos. The deliberate disassociation practiced by the Surrealists was ineradicable, and made the assumption of a coherent whole, waiting to be discovered and realized, a most unlikely one.

The Surrealists had had some premonitions on this score. Paul Eluard, writing in 1936, offers exceedingly modest terms to the artist:

> For the artist as for the most uncultivated man, there are neither concrete forms nor abstract forms. There is only a communication between what sees and what is seen—an effort to understand, an establishment of relationship, almost a determination, a creation. To see is to understand, to judge, to deform, to imagine, to forget or forget oneself, to be or to disappear.

And even Breton himself, depressed probably by the Second World War, began to speak with less ebullient confidence of the

artist's possibilities. The first sentence of an essay written in 1942 is: "Man is perhaps not the center, the focal point, of the universe." Even seen in the light of Breton's irony, this statement is inescapably debilitating to Breton's own earlier pronouncements, in which he envisioned a great surge of creative power that would engulf humanity, change its values, and restore a primeval harmony. The romantic in Breton, heir to Rimbaud, to Lautréamont, had been vitally attacked by the scientific alterations of the cosmic view, and would never again be so certain of that surreal absolute. The assurance that there might be a "musicality" in the created work that could bind together perceived and imagined elements was no longer there. Dissonance and extreme mobility seemed to destroy the orderly elucidation of space.

With the multiplication of psychological points of departure and the loss of cause-and-effect simplicity came malaise. Out of this malaise the artist sought ever more urgently for "self," with less and less confidence in finding an integral, identifiable self. In short, there were seemingly innumerable moral and psychological factors troubling the consciousness of the modern painter. Neither the clear sense of spaces from the horizon to the self which Matisse enjoyed, nor the Surrealist assumption that there is an unconscious realm that has only to be tapped for the work of art to issue forth, could support the painter of the post-World War II period.

The strongest response to the alteration of almost half a century of painterly discourse based on the principle of metamorphosis came in the Informal, or Abstract Expressionist, movement which dominated esthetic exchange for more than a decade. The painters who evolved in this period responded, in their own mode, to Sartre's Existentialism (and, of course, to Sartre's antecedents). They seemed to agree that man is, as Heidegger claimed, "thrown into the world." The violence of this diction was commensurate with the violence of changes, both sociological and moral, in the life around the contemporary artist. A sense of tragedy pervaded much Abstract Expressionist work, and a struggle to shape a metaphysical language in terms of plastic articulation became apparent. This struggle, which is still a vital and continuing challenge to many painters, is best understood when examined individual by individual.

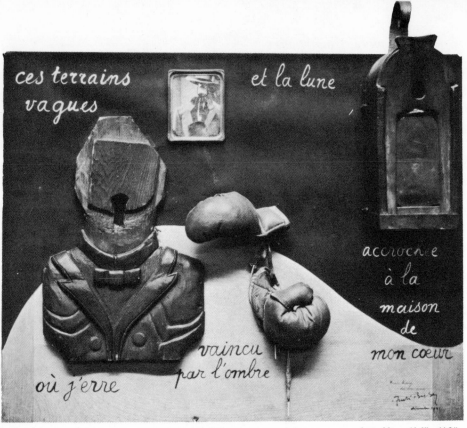

Assemblage, 1′ 6″ x 1′ 9″.
Collection, The Museum of Modern Art, New York. Kay Sage Tanguy Bequest.

18. André Breton: Objet-Poème, 1941.

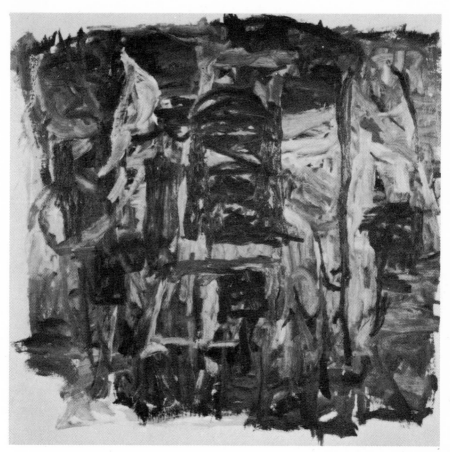

Oil on canvas, 5′ 10″ x 6′ 0″.
Collection, Mr. & Mrs. Lee V. Eastman. New York.

19. Philip Guston: Close-Up III, 1961.

12

The Physiognomy
of the Mind

Philip Guston is one of the principal painters to have carried certain of the assumptions deposited in the course of the twentieth century to fruition, and beyond. Like the phenomenologists, he works from "the whole man prior to any distinctions between conscious and unconscious." He has accepted the chief assumption, that painting is an interpretation of experience on all levels, psychological and spiritual as well, in order to open a way to another language in painting: the language of metaphysics.

Temperamentally, Guston belongs to the romantic flow of discourse from nineteenth-century Symbolism through twentieth-century metamorphic speculation. When Miró observed that "in the work of Leonardo I think of the *esprit* and in the work of Paolo Uccello it is the plasticity and structure which interest me,"[1] he set out the two main directions in modern painting. The two directions have often been pursued together (most painters of Guston's generation, for instance, have taken Mondrian as part of their heritage, and so does he), but ultimately the artist gravitates to one pole or the other. Guston's paintings, particularly his most recent, are strongly on the side of *esprit*. They indicate that for him, painting is a mode of inquiry and a mode of stating an intuition concerning the meaning of existence.

Supposing we could list, as if on a bill of lading, all the items that go into a painting by Philip Guston; it might read something like this:

 Item: Traditional oil paint from tubes (rose, ocher, blue, gray, black)

Item: Stretched canvas, normally no higher or wider than the
reach of a tall man
Item: Strokes (long, loping; short, staccato)
Item: Textures (opaque, dense; transparent, thin)
General Description: Grayish strokes weaving in and out
with occasional flickers of silvered highlights, forming a re-
silient webbing, or a thickish atmosphere, which supports, sur-
rounds, forms, and corrodes two or three major shapes. Shapes
are composed of strokes, usually closely articulated, more
densely painted. Suspended in the "medium," they move in-
ward or outward. Roughly rectangular or arclike in design.
Largely tonal but sparse indications of non-naturalistic color,
rose, blue, ocher.

This is a lifeless series of words, yet it is a fair verbal transcription
of the visible facts of a recent canvas by Guston. A catalogue of his
characteristics, his reflexive gestures, says nothing of the moving
efficacy of the paintings, or of the vital questions they pose. But
Guston's paintings are more than a collection of visible facts. They
are intentionally endowed with meaning, for, as the Zen master
says, as soon as the questioner poses the question, he already has an
intuition of the answer. The questions posed in Guston's paintings
emerge from a long life of painting and from the answers to other
questions he has asked himself at different epochs in his painting
life.

When, for instance, he first began to study the "structural" paint-
ers, such as Uccello and Piero della Francesca, he worked in their
aloof mode willingly, putting distance between his emotion and his
execution, seeking an equilibrium of clear volumes in space. After
a time he came to question the Renaissance world, in which every-
thing was assigned its eternal place. He then began to think about
"the total picture plane." His compositions—allegories of urban
life for the most part—became intricate plays of forms in strangely
imagined spaces. Certain painterly ambiguities began to take pos-
session, undermining the static Renaissance harmonies.

As Guston's thought turned to the symbol, or at least to the ab-
breviated form that admits of broad interpretation, his vocabulary
changed. More and more, the atmosphere within which the figure
moved became his subject. Finally, he was constrained to ask him-
self whether his subject was in fact a readable allegory, and, in

answer, at last swept aside the conventional human figure and all
recognizable aspects of his environment. At this point, moving be-
yond external nature, Guston began to paint the pale, calligraphic
abstractions which were then compared with Mondrian's plus-and-
minus paintings and with the late Monet. Although neither of
these comparisons is accurate (the measured rhythms of Mondrian
were never Guston's, and Monet's late paintings were still attached
to their physical motifs), they indicate a specific question posed by
many artists: May a painting not be about the known but *not visible*
forces of nature, as well as about other things?

By eliminating classical perspective, then linear composition,
then color as a local agent, and, finally, even the cues to external
phenomena, Guston arrived at the new questions which character-
ize his metaphysics of painting. To begin with, the dim, palpable
atmosphere of his new paintings is no place known to the eye. But it
is known to the imagination; hints of sea-washed air, of distant sil-
vered lights, of buoyancy, of inhalation and exhalation stir the
mind. From remembered sensory experiences, the imagination con-
strues its own universe, a universe that is illusion.

Illusion: a word almost lost to us through obfuscation. *Illudere*,
Latin: "to play against"; it is the play against the immediate quality
of "real" experience which is the painter's strength. To form a
many-dimensioned experience on a limited, two-dimensional sur-
face is his pride. By the initial paradox he plays a personal game
against the commonplace and establishes his domain—the domain
of the imagination, or the metaphysical domain. Not necessarily in
the tragic mode of Nietzsche, who spoke exaltedly of illusion when
he claimed that art was metaphysical solace; no, more in the mode
of Bachelard, who, in insisting on the reality, the entity of the imag-
ination, held that the function of the unreal was just as vital in the
human psyche as the function of the real.

Within the throbbing environment of a Guston painting, the
forms take on various functions. At times, they come near to being
merely accents, slightly varied rhythms within the whole. At times
they are like creatures, burrowing into safe recesses or pressing ag-
gressively forward. Mythical overtones are in the nesting sugges-
tions and the birth struggles. A form can ride like a forlorn raft on

the high seas, or it can struggle violently in the claustrophobic twilight. Not known to the eye, but familiar and stirring to the imagination, these forms gather up the forces of the whole. They are not based on direct observation, either in color, which here is largely neutral, or in outline, which is generally equivocal. They are the quintessence, rather, of the artist's imaginative experience as he works. The drawing is not based on any classical function of drawing. Lines jerk or glide, interrupt themselves or wind themselves into tangled skeins. They are significant movements and arrive at that point, described once by the artist, at which "the hand and the mind know each other."

In his paintings, Guston's soliloquy is not muffled, but clear. The strokes which before were somewhat wayward and confused now lie serene. Some have coalesced into firm bodies suggesting heads, masks, iron objects. These, although still nervously active like the human organism, maintain their equilibrium in a chaotic universe.

Guston has gone through the capital experience of the century, that irreversible thrust into the sources of creation in which the instrument is reduction. He aims not at formal simplicity, but at the true formulation of his lifelong question: What, after all, is a painting? If it is not representation, his hand and mind speculate, then perhaps it is presentation. Presentation of what? Of summaries or reductions, of an overwhelming intuition of the nature of existence.

Guston's insight, which can be expressed solely in painting, concerns a view of the cosmos. Without conscious comparison, he arrives at a position close to that of philosophically inclined contemporary scientists.

The unique quality in all his recent paintings is this: that out of the unequal but rhythmic stroking, a physical analogue of the *sense* of space-time is drawn. The beings within this space-time are nothing other than a dynamic concentration of that which surrounds them; they are composed of the very same matter. They are rhythms, but rhythms that are accented and accelerated—intense concentrations of energy. When the strokes coalesce, suggesting solids that displace space, they compel illusion to come into being. In seeking what he has called "an experience more remote than

what I know," Guston has found a view of form as shaped by total energy. His forms, like the forms of many major twentieth-century artists, live by virtue of their contexts. They are homologues. Their very existence depends on what passes through and around them.

The long, loose, silvered strokes that come into being like slow surf, or that weave deep behind the picture-plane, touching earth and depths, are also a direct expression of self, or of a particular imagination. The many shifts in distance, in direction, in pace, in emotional climate sensed on the canvas, and the various roles of the figures, now assertive, now volatile, are not merely ambiguous. They are multiplicity itself, a direct projection of the working imagination. The painter is saying, "If painting is this, it is that also." Swept by forces and mysterious energies, the forms in Guston's paintings, like his human organism, resist. Their resistance, their stubborn defiance of conflicting forces, assure their dynamic equilibrium.

Where is the citadel of this almost-human resistance? In the artist's imagination, that power that moves beyond the range of brute forces, beyond the range of matter and anti-matter, that moves forward in the grand ocean of time. For only the imagination can realize the onward flow, the *élan vital* which is what Guston's paintings are about.

Guston's experience, read in the paintings, is a continuous juggling act of difficult terms. He extends the most serious aspect of the Romantic tradition, for his view of the organic imagination remains orthodox: it is through the conjunction of imagination and hand that ideas gain body. Process against product: ideas become dense, pulsating, readable "things" as the artist's imagination labors.

Style, said Schopenhauer, is the physiognomy of the mind. It is this physiognomy, rendered with mirrorlike fidelity, that is portrayed in Guston's paintings. Physiognomies change, and thousands of nuances pass over them like clouds on a windy day, and Guston starts again and again to trace the true physiognomy. "I think often of Whitehead's definition of philosophy," he has said: "philosophy is the long way around. Painting begins in one place and, in a way, winds up in the same place."[2]

The events in the painting occur without warning, even to Guston, who awaits them like a seasoned trapper. "Sometimes I think of the Zen koan. I know very little about Zen, but I think somehow I am undergoing the koan."[3] (The koan, says D. T. Suzuki, is a non-logical exercise given to Zen initiates:

> Ta Hui was never tired of impressing on his disciples the importance of having satori which goes beyond language and reasoning and which bursts out in one's consciousness by over-stepping the limits of consciousness. . . . As your concentration goes on you will find the koan altogether devoid of taste, that is, without an intellectual clue whereby to fathom its content. . . . When all of a sudden something flashes out in your mind, its light will illumine the entire universe.)[4]

With the events comes the question. No painting is unreasoned, unchallenged. Each is a clarification of the last. The metamorphoses implicit in abstract painting are of central importance. We might say that in his oeuvre, Guston has gone from form to meta-form. A vital discovery is the similarity of spaces and forms. The continuity of matter, though, is not the final statement, for Guston believes in evolution and envisions, with Teilhard de Chardin, a great apotheosis of mind. He is a painter of *esprit*, and also a painter of intuition, "overstepping the limits of consciousness."

In 1928 Breton had written, "The plastic work, in order to respond to the necessity of an absolute revision of real values on which everyone is in agreement today, will refer to a *purely interior model*, or it will not be at all."[5]

Guston is a modern painter who has inquired incessantly: What can be done without in painting? Or, conversely, what is essential? He is a modern painter, who can have only the modern experience; the "real" experience for Werther, of gazing for hours at a mountainous prospect, cannot be his. He is a modern painter for whom painting is authentically a way of life, a way *to* life—he touches on the metaphysical edge of existence with a painter's rhetoric.

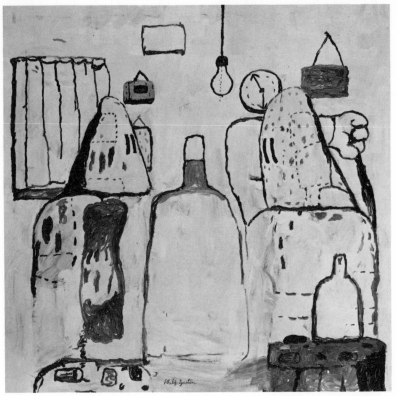

Oil on canvas, 73' x 78'.
Courtesy, Marlborough Gallery, New York.

20. Philip Guston: Bad Habits, 1970.

Soon after this book appeared, Guston told me one day that he was no longer a "seasoned trapper," and that he wasn't waiting any more for insights. His new work had swerved sharply into another mode, he felt, as did most of the critics who reviewed his startling exhibition late in 1970.

When I saw the work, however, I recognized Guston's old conviction that "painting begins one place and, in a way, winds up in the same place." It was not only that he had once begun with the image of the same Ku Klux Klansmen that appear caricatured in the new paintings. Rather, Guston followed his old reflex of recapitulating themes and experiences at long intervals, bringing to them the accumulated insights of some forty years of painting. These new works, in which he establishes a cast of characters—those red-handed yahoos who don the mask of the Klan but can stand for bloody yahoos anywhere, anytime—are still questioning the nature of painting. The enacted crimes of the Klansmen recall the crimes of the early Renaissance paintings with all the eschatological commentary they brought forward. They reach for the increment of meaning that narrative painting supplies, but they do not relinquish the meanings Guston had discovered in his abstractions.

A close appraisal of the 1968–1970 paintings reveals how much the modern tradition has informed these paintings; how much the vacillating, struggling formations of his previous paintings recur here in subtle contexts. Though the balletically gesturing hands of the Klansmen are masterful caricature of hands, they are also forms relating agitatedly to other forms—forms that are very much indebted to the abstract paintings. The palette remains constant, with the same oranges, apple greens, reds, blues and numerous tonal grays that have always characterized Guston's canvas. They work, as they have always worked, to dissociate surface forms on the one hand, and to bind the whole picture into the unreal ambiance that is Guston's peculiar domain. The social commentary which is undeniably salient is encased in a still broader commentary. Holocausts, whether stamped with the American trademark, or with German or French, are holocausts nonetheless.

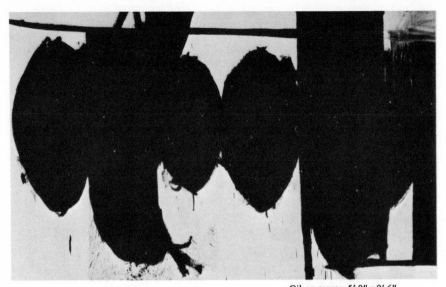

Oil on canvas, 5' 9" x 9' 6".
Collection, The Metropolitan Museum of Art, New York. Anonymous gift, 1965.

21. Robert Motherwell: Elegy to the Spanish Republic, 70, 1961.

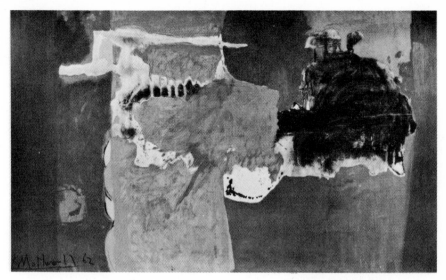

Oil on canvas, 7′ 0″ x 11′ 9″.
Collection of the artist.

22. Robert Motherwell: Chi Ama, Crede, 1962.

13

A Fusion of Modern Assumptions

The fusion of modern assumptions of the early part of the century with the new philosophic insights evolved after the Second World War can be read in the work of Robert Motherwell. He was intimately shaped by the preoccupations of the Existentialists; but he also confronted problems implicit in the immediate past of painting.

His willingness to participate in order to clarify himself made Weldon Kees write of his work in the 1940s: "Fathered, curiously enough . . . by Mondrian and continuously nourished by Picasso, from whom Motherwell 'lifts' objects and passages with complete acknowledgement . . . Motherwell assumes the full consequences of the furthest tendency of abstract art."[1]

Although Motherwell has talked about a great many things, both in print and in conversation, he always returns, almost unconsciously, to certain preoccupations that can be called approximately Existentialist. He is concerned with the basic proposition that a man "chooses" himself, and he is deeply concerned, in the classic Existentialist sense, with death as the termination of possibility. At all times, he speaks of painting as an ethical act, stressing choice as its signal component. Art, he has said, *can* be purely esthetic, but as such is not enough for him. "Sometimes I have a painting which is esthetically beautiful, and I pause. But then I go on because it doesn't really correspond to my judgment of the world."[2] He refers to Kierkegaard's concept of "the despair of the esthetic." The world is full of beautiful things; if there were no further grounds on which to judge, this knowledge would foster total despair, es-

thetic despair. To elude the toils of esthetic despair, the artist forces himself to choose. "Whom we call great is always he who chose. The great looked at everything, decided on the importance of certain things, and then did them."[3] Since every choice and decision involves the risk of loss, and since painting is nothing other than a series of decisions, painting is of necessity an ethical act. The importance of the spiritual aspects of his picture-making is revived each time he approaches a canvas. The high standards for the act of picture-making set by Wassily Kandinsky and Piet Mondrian are respected by Motherwell.

Not only is painting an ethical act for Motherwell and certain others of his generation, but it is also intimate, personal, and transcendent. He has always pursued parallel lines of development; he has experimented widely with the intimate, the casual, the unpremeditated, in small paintings and collages. In his other line— his grand line, so to speak—he has pursued the monumental, the transcendent, attempting to confront in abstract terms all that is bracketed between life and death.

Motherwell began while very young to experiment with collage. It represents for him, as for his Cubist predecessors, a link with the casual world with which he has never wanted to lose touch. Louis Aragon has remembered Braque speaking of what was then called *"une certitude."* This was the pasted element, around which the picture had to reconstitute itself. "For the Cubists, the stamp, the newspaper, the box of matches which the painter pasted on his picture had the value of a test, of an instrument of control of the very *reality* of the picture."[4] Motherwell benefited also from later uses of collages. The lessons of Dada, and later those of Surrealism, were not lost on him. He used collage in all its possibilities, not neglecting the more literary and magical transactions of the Surrealists.

Although Motherwell says he has always thought of modern art as intimate, graceful, personal—as are his own collages—and not geared to what he called the institutional aspects of life, he is also attracted to things that never change. He follows the Surrealists in a quest for the primordial, unchangeable basics, symbolized in timeless objects such as bread. His interest in primitivism involves

a certain monumentality, and ultimately concerns that which transcends the intimate and personal. Like Klee and Miró, he walks between these two realms, now visiting the one, now the other.

In a brief chronology he once prepared there is a note that as a child he suffered from chronic asthma. That he deemed this significant enough to include suggests a great deal—a boy, dreaming on the furthermost littoral (he was brought up in the state of Washington), suffocating with asthma, turning away from the immediate locale toward the wide world of the imagination. In this case, the turn was toward the culture at the other end of the continent, and, even more, across the Atlantic.

At 22, Motherwell spent a year at Harvard studying philosophy. At 24, he had a year at Columbia under the art historian Meyer Schapiro. In 1940–41, at 25, he studied engraving with Kurt Seligmann. Here, Motherwell was finding his way to the world already dreamed as a boy. Seligmann was an unorthodox Surrealist, a man of wide interests and great civilization. He was also the author of a significant book on the history of magical practices. Seligmann's scholarly interest in the occult must certainly have charged Motherwell's imagination.

At the same time, Motherwell began to meet the many Parisian artists in exile, and notes that he was "greatly influenced by the surrealist theory of 'Automatism.'" This theory was imported by its author, André Breton, whose effect on the community of New York painters was considerably more forceful than many historians suggest. Breton's theory of automatism, in all its elaborate rhetoric, was not fully comprehensible to many of the painters, but the idea was quickly sensed. Aside from Breton's obvious effect, via automatism, on the painting of Jackson Pollock, whose adaptation of it to purely plastic ends was to alter the course and discourse of modern painting, there were the more subtle, lasting touches. Breton brought the kind of literary word-play which had already occurred during the Dada period into a new kind of context in the United States. His use of poetry and written aphorisms in "objects" was to influence many younger painters interested in the pictographic sources of painting. Many of the so-called calligraphic painters were as much interested in Breton's transposition

of the word and the image as they were in Oriental calligraphy.

In 1941, for instance, Breton created an "object." This was enriched with the writing:

> ces terrains vagues
> et la lune
> où j'erre, vaincu par l'ombre
> accrochée à la maison de mon coeur.

A young painter such as Motherwell would not be indifferent to the possibilities inherent in Breton's "object." Later, he was to use snatches of poetry, often in French, in his paintings.

Even before his direct encounter with the Parisians, Motherwell had already made his way to Apollinaire, Jacob, and Mallarmé— the spontaneous, the casual, the absurd, and the profoundly mystifying. The edge of absurdity lingering in the periphery of all modern vision was to lead him later to edit a definitive anthology on the Dada movement. But automatism, to Motherwell, was not related to the absurd. It was not merely cerebral play, but a true touchstone, a way of releasing images that lay concealed beneath habits of thinking, layers of education, and sieges of discipline. It was not a Freudian open sesame either, for Motherwell felt a greater affinity for the mode of the postwar thinkers, who had an inclusive approach in which the dialectic of cause and effect was often left behind. His vision was closer to the Ernst prophecy of the intermingling of unconscious and conscious worlds; of the continuity implicit in all phases of existence.

In 1941, Motherwell went to Mexico with Matta. Aside from Matta's intimacy with the Surrealists, there was his detachment from tradition, his way of extending his frontiers and reaching for cosmic, supra-personal images. Breton had written in 1939 that after Einstein, "the need of a quadridimensional universe was particularly affirmed in the work of Matta (landscapes with several horizons). . . ." His representation of the modern spirit, the spirit that would no longer regard itself as outside nature watching, but rather as being within a threatening cosmic situation with no neat boundaries, interested young Motherwell and influenced him. But Matta, like many of the Surrealists, was partly an illustrator, and

the plastic needs sensed by Motherwell as a way to issue out of the tight corners imposed by Surrealism had to await fulfillment until the following year when, back in New York, Motherwell made his first collages. In New York he exchanged views with older painters, Rothko, Baziotes, Newman, Tomlin, Still, and others, and became one of the participants in a new movement, Abstract Expressionism.

This movement was not really a movement, but rather a philosophical attitude toward painting, and, in some ways, according to Motherwell, a veritable social revolution. This point of view stressed two principles, asking first, how it might be possible to make a picture that is humanly moving without representation, and secondly, how it might be possible, as Rothko once put it, to avoid the opposite of modern art, which is nostalgia for the past. To Motherwell this meant that the intelligent painter would have to ask himself what was *possible*, would have to recognize limitations, his own as well as those posited by the history of modern painting. His illustration of this: to develop a powerful engine, the engineer must observe size limits in a racing car; he must concentrate the greatest power in the smallest engine. "My sense of limitations in painting is not technical," Motherwell explains. His choice of limitation includes the rejection of illusionistic depth and the rejection of the idea that an artist is a prophet or a seer.

His whole preoccupation with limitations, then, is a logical extension of the assumptions of the century. More particularly, of Miró's concern with "stripping" his painting of all but the essential. He transposes Miró's way of thinking to his own generation's tenor of thought when he says, "I am interested in the skin of the world, the sound of the world. Art can be profound when the skin is used to express a judgment of values."[5] Motherwell need never have read the classics of phenomenology to arrive at this instinctive retention of interest in the "skin" and the "sound" of the world. It is his assurance against the enveloping and potentially suffocating mists of romantic transcendentalism.

During the middle-to-late 1940's the morphology of Motherwell's forms was visibly derivative; Picasso's linear male and female signs of the late 1920s, the black straight lines, triangles, and

circles, were used in strictly planar sequences. But even then, it was not only the world of paint that interested Motherwell. His interest in automatically mined imagery carried him beyond the simple abstract formulae of early abstract tradition; he sought through his forms to evoke anthropomorphic echoes. The strange fullness of metamorphic gesture, as seen in Picasso's Surrealistically conditioned bathers, began to appear in abstract terms. From Miró, Motherwell learned to make forms speak specifically of abstract experience—of experiences such as flying, loving, dreading, which are not attached to specific occasion. Like Miró, Motherwell was concerned with the two realities, the continuous and the discontinuous. Like Matisse, whose grand spaces were assimilated by all younger painters almost without their being conscious of it, Motherwell felt no estrangement from the world that extended all the way from the horizon to himself. I write here of Motherwell, but in this case it can be said of almost all the serious painters who became engrossed in the attitudes sponsored by Abstract Expressionism.

How is it possible to make a picture that is humanly moving without representation? is a question that finds no easy answer. Perhaps through what Gerard Manley Hopkins called the "inscape," through the cosmic view, through the intimate turned monumental, through the journal, through the subconscious reeling-off of past and future.

In the mid-1940s, Motherwell began to explore the surfaces of his canvases in their temporal aspect. In order to read the compendia of symbols in certain of his large paintings, they had to be received in time like the spiritual journey they always embodied. Motherwell accepts the Dante tradition. His major paintings seem to be the result of a journey from the *selva oscura* into light. At first they were classical, clear-edged, flat compositions. Later they became fugal, elliptical, complex like his life itself, and like the vision of life launched by the Existentialists.

It was around this time that Motherwell initiated a series, now numbering in the hundreds, grouped around the title *Elegy to the Spanish Republic*. In this series (the very fact of a series implies an organic vision of creation) the morphology is exceptionally revealing. The former victim of asthma speaks of time and its anguishing

mortgage on the individual in the way the full black forms are con-
strained by strong white fields on the one hand, and in the way they
read as they march dirge-like across the surface in slow motion. He
speaks of the absorption-unto-death (doesn't black absorb all light
and doesn't the artist fear above all the loss of his vision of color?).
He speaks in the drawing of incipient choice and dread as well. His
lines move out as they describe each oval black form, suggesting
movement into the white of nothingness.

Alongside of the *Elegies* are their complements, paintings ex-
pressing life as a ravishing journey, full of delights, surprises, and
vexations. Improvisation and the sudden shock of perception are
noticeable. "Ninety per cent of my painting is correction," Mother-
well has said. Correction or selection, a life after all is not easily
reducible into symbol. To trap a life in its moment of supreme self-
awareness is no easy matter. Those who, like Motherwell, extend
the vitalistic tradition of the organic, abstract movements in the
twentieth century take on a stupendous and morally taxing task.
The morphology of his forms reveals Motherwell travelling in his
inscape, identifying so closely with the pregnant, wandering forms
that they take on a magical life. In their plenitude, their movement
across vast surfaces, these forms drawn from a psychic automatism
but altered by the artist's judgment suggest the "I" at its most inti-
mate level in the process of joining a whole. Here Motherwell and
Guston have much in common, and what they have in common, to
paraphrase Eliot, is their past—the past which includes Picasso's
metamorphoses, Breton's and Miró's, and the psychological trans-
formation of spaces wrought by Matisse and Mondrian.

In 1961—again from his own chronology—Motherwell took as
a studio 5,000 square feet of a former billiard parlor. There, with
the shadows of the phantom billiard tables marking off the floor,
he unrolled his canvas and literally pursued the journey from one
huge composition to the next, from small improvisations pinned
on the wall to the floor, where the image swelled to monumental
proportions, sometimes to grandeur.

When forms touch, or barely touch, as they do so often in
Motherwell's paintings, there is tangible evidence of an erotic mo-
tif. The sexual and amorous aspect of his work is insistent. From

overt allusions in the *Je t'aime* group to the covert, as in *Chi ama, crede,* to the symbolic, as in the Spanish elegies, Motherwell explores the boundaries of human contact. He does it in complicated terms, in terms expressed by the Mexican poet Octavio Paz:

> If eroticism belongs to all epochs and all civilizations, love is an exclusively Western passion. Like everything that we have invented, it conceals a contradiction; a fatality voluntarily assumed, it can only resolve itself in destroying itself or in transfiguring itself, in making itself into an image. Images of love, transfigurations of passion: poems.

Motherwell's paintings are exemplifications of Western culture, of its contradictions and its abiding philosophic assumptions. His work moves with the assurance of the onward flow of history, of the imperatives implicit in the modern tradition. "I do not see how the works of a Mondrian or a Duchamp can be described apart from a description of what they refused to do," he once wrote.[6] In his own case, it is not so much what he refused to do—for he recapitulated many modern painting experiences before he settled into his own idiom—as what it was no longer possible to do. Motherwell, and, of course, the other painters of reputation at the same time and place, felt the onward flow of painterly discourse in the twentieth century. Their time and space is evolved from the very visions that initially departed from the late nineteenth century.

It is quite possible that the experience of Motherwell, and of a number of his generation, is yet to be rounded out into a full realization of all the possibilities released through the idea of modernism itself. Motherwell has a tendency to backtrack, and to indulge in superfluity. If his series paintings were seen side by side in a single viewing, they would doubtless merge into a single motif at a single moment of the twentieth century. His redundancy is in itself an extension of the kind of experimental obsession modernism tolerates; yet out of the repetition of experiments (closer, by the way, to the alchemical than to the rational scientific tradition) Motherwell has derived a firm vision of the kinds of spaces to which he belongs, and this is an achievement of considerable distinction.

The radical change in the experience of space as exemplified in Matisse's reference to the aviator traversing the sky is incontestable. Similarly, the role of the symbol has altered radically, largely through the work of Miró's fertile imagination. While it is superficial to base discussions of painting on some sequence of "influences," it is unavoidable to talk in terms of the forward thrust in painting dialogue. Few painters would deny that painting is a long conversation throughout history that develops unforeseeably, but that does develop. Without Matisse there would have been a Rothko, but he might well have been a different Rothko. In a sense, a great painter becomes a way along which all must pass in order to come to the light of their own genius. Matisse, Miró, Picasso, Klee, Mondrian, and all the other signal figures in twentieth-century painting are part of a young artist's experience. In one way or another he must route himself through Matisse's "condensation of sensation" and Miró's "stripping," just as Matisse and Miró routed themselves through Cézanne.

The assumptions of the great twentieth-century painters have been augmented; much can now be taken for granted. Many of the painters of the modern pantheon have stated that the subject, in its literary identification, is less important than the whole. However, the tension between subject and composition has remained salient, even in the work of the Abstract Expressionists. (By "subject," I take into account the double connotation, for the subject as "I" and the subject as "motif" are ambiguously meshed in the modern painter's psyche.) For younger generations, however, abstraction is a mother tongue; the subject-object conflict is no longer urgent. A young abstract artist simply takes it for granted that the space which Matisse saw as continuous, and which artists for more than a century have felt to be a medium within which both they as subjects and their art as objects exist in much the same way, is an enveloping, elusive, but all-inclusive space.

Even an artist concerned with specific symbology—I think of Stephen Greene—cannot paint symbols as distinct from the milieu in which they take form. For all his preoccupation with the dreadful, with the crippling in human experience, Greene has not been able to illustrate specific instances as if they were isolated events.

Instead, he paints a continuing atmosphere, sometimes an atmosphere of day merging into twilight, which cannot be seen as distinct for the memory of symbols embedded in it. The ladder, which Miró had used in one way and which Greene was to use in his early Crucifixions, recurs, but it is never a thinglike entity. It is part of a drama that has no finale. The small red eyes, the faint hints of organic forms, the sharp highlights occasionally thrust into prominence—none of these compositional elements can really be dissociated from the spherical space, with its infinite possibilities, that has been invented by the twentieth-century imagination.

Helen Frankenthaler has spoken specifically of how it feels to imagine in these new spaces. Her paintings are directly descriptive of the new space experience in a literal way. When she saw how Jackson Pollock spread his canvas on the floor and worked above it, as though he were Matisse's aviator traversing the sky, she instantly grasped the essential novelty of the ensuing sensation of being within the painting—something that had already been set as a goal by Kandinsky and the Futurists. Pollock's new relationship to the picture was more than a mannered device; it was a synthesis of many incipient sensations that had been experienced by artists earlier in the century. For Frankenthaler, to drop infusions of pure color onto the unprimed canvas from above was not unnatural, for she, like others of her generation, was shaped by the postwar multiplicity of spatial conceptions. To put a painting below, to bend over it, to trace forms with the whole arm and body: all of these gestures changed the spatial concept. There is an enormous difference between standing within and overseeing one's image and standing without, looking at eye level at an object perpendicular to the floor.

Out of the flowing technique came the flowing images from one canvas to another. If these are "inscapes," they are inscapes in which no undue torment is visible. Process is free, the imagination is deemed worthy of independence; color is taken for the vital matter that it is, given an ever wider range. Space and time are indistinguishable. If there is a saturated blue field, pressed forward by the final vertical of the stretcher on either side, it vibrates through its constriction, but it is an expanding vibration, one which takes

the viewer necessarily into some kind of virtual blue continuum. Even where the emphasis on process has ceased to be so compelling, as in the case of Al Held, the assumptions established by the generation of Abstract Expressionism are largely intact. For Held, the vast surface of his canvas extends horizontally and the figures, often roughly geometric, serve to push the extension further. Movement and even metamorphosis are essential to his vision. The quasigeometric forms are for him convenient symbols, but they do not symbolize the assurance and fixity of meaning associated with geometry. Rather, they move, they are given full walls (a circle bulges with interior force, as a free-form abstract symbol in Miró seethes with its interior energy). The throbbing insistence on texture, on movement, takes into account the charged atmosphere of plural changes. If at times he seeks a splendid equilibrium invoking symmetry, he cannot succumb fully to his impulse. Some irregularity, either of form or texture, will always recall his basically organic vision of existence.

The whirlwind pace of developments in painting—or at least, in directions in painting—provides an amusing commentary here. When this book appeared, the legacy of abstract expressionism seemed completely used up. In its stead, the legacy of Newman's and Reinhardt's planarity was supreme, modified by many young artists into a vision of repetitive motifs that they called "serial" art. Holding the plane was the thing, as long as there was lots of plane to hold. Within two years, however, the freedoms implied in the Pollock branch of abstract expressionism, and the more contained freedoms of the Rothko branch, were resurrected. It is true that the spray gun reigned supreme, even in the hardiest free-form abstract experiments, but the look of the paintings definitely related them to the abstract expressionist progenitors. To be a painter was once again to be a lyrical painter. Miles of dripped, sprayed, scumbled and loosely figured canvases have appeared, and among them, a few really serious explorations of the ample spaces suggested by the old generation.

14

"Negative Capabilities": The Argument Between Purity and Heterogeneity

The art-for-art's-sake doctrine implicit in the arts since the mid-eighteenth century has been simplified almost beyond recognition in our century. In the vital stream of modern art, the principle that the value of a work of art lies in its autonomy has led to repeated efforts to purify, to "strip" all that is inessential. The decision as to what is alien to a specific art changes with the times, but the principle remains: to clear away all that is extrinsic to the work itself. This principle can be traced in all the arts during the first half of the twentieth century, applied vigorously to remove all vestiges of nineteenth-century impurities. Debussy reflects it in *Monsieur Croche the Dilettante Hater*, published around 1901, in his discussion of Beethoven's Ninth Symphony: "Beethoven determined that his leading idea should be essentially self-developing and, while it is of extraordinary beauty in itself, it becomes sublime because of its perfect response to his purpose. . . . Nothing is superfluous in this stupendous work."[1]

Federico Busoni, in his "Sketch of a New Esthetic in Music" of 1911, identifies feeling with economy, and thereby parallels Kandinsky's thoughts on "silence" (Kandinsky likened the white spaces in his compositions to silences in music):

> That which, within our present-day music, most nearly approaches the essential nature of the art is the Rest and the Hold (pause). Consummate players, improvisers know how to em-

ploy these instruments of expression in loftier and ample meas-
ure. The tense silence between two movements—*in itself mu-
sic* in this environment—leaves wider scope for divination than
the more determinate, but therefore less elastic, sound.[2]

And in 1920, Busoni noted, "I feel the idea of Oneness in music as
one of the most important of these as yet uncomprehended truths.
I mean the idea that music is music, in and for itself, and nothing
else, and that it is not split up into different classes."[3] In 1922, he
clearly reflects the new essentialist taste when he writes:

> In the editions I possess of Poe, there are many carefully ar-
> ranged, good and characteristic portraits of the poet to be
> found. But a picture of Poe by Manet, etched with a few
> strokes, sums up all the other pictures and is exhaustive.
> Should not music also try to express only what is most impor-
> tant with a few notes, set down in a masterly fashion?[4]

(Busoni, by the way, was Edgard Varèse's master.)
 Here is the cry for reduction, an appeal for an unerring return to
sources, an unveiling of the true emotional horde lying within the
individual, unfortunately obscured by habit and by false, extrinsic
concerns.
 Similarly, vigorous stripping operations were undertaken in lit-
erature before and after the First World War. The sharp thrusts of
Ezra Pound's spirit demolished rhetorical conventions. He looked
back approvingly to Flaubert, who had cast away traditional orna-
mental flourishes and proclaimed a literary era of tremendous con-
densation. Matisse's condensation of sensation was paralleled by
Pound's condensation of image and his obsession with the "vortex"
of poetic action. The image is not an idea, he maintained, but rather
a "radiant node or cluster."
 The cluster into which and through which everything passes and
is strained to an essence subsumes the principle of multiple per-
spectives. The superposition of experiences leads to the image. Vor-
ticism, the movement with which Pound and Wyndham Lewis
drove forward toward simplification on all levels, advocated a con-
densation of emotion and thought that would go beyond analogy

and similitude. It would ultimately render the work of art independent of secondary allusions. Behind the Vorticist movement was a general rebellion against the niceties and needless complexities of artistic language. Wyndham Lewis and the other artists who associated with Pound considered the art impulse as inherently primitive, and spoke with obvious rebellious pleasure of the "savage" nature of art. By "vortex" they seem to have meant simply an elemental concentration of energy and image that could be compared to the heart of a maelstrom. The sculptor Gaudier-Brzeska, an intimate friend of Pound, wrote in *Blast* in 1914 that vortex is energy, vortex is the point, one and indivisible. Speaking for the group, he said: "We have been influenced by what we like most, each according to his own individuality, we have crystallized the sphere into the cube, we have made a combination of all the possible shaped masses—concentrating them to express our abstract thoughts of conscious superiority. Will and consciousness are our VORTEX." As Pound advocated a new grammar which would derive all its energy from concrete, simplified language, divested of the inflation of endless adjectives and extended similes, so the artists attempted to divest their plastic language of description, anecdote, linking passages (the gradual diminution of light, for example), and unnecessary detail. The heart of the vortex was the great condensation of all emotion and formal experience into what Gaudier-Brzeska lyrically called the point, one and indivisible.

Admiring Oriental economy, Pound sought to adapt the haiku to his own needs, to the needs of his moment. By its sparseness of language, the intenseness of its effort to locate the right moment of coinciding events, the work would express the sense of simultaneity and space-time which had come upon the far-seeing artists with the turn of the century.

Pound's suspicion of the elaborate flurries in poetic diction, the "shallow frothy excitement of writing, or the inebriety of a metre," may be compared with Matisse's or Kandinsky's suspicion of the rituals of academic painters. Sincerity and economy of expression was the ideal for painters and poets alike in the first decades of the century. Pound summed all this up admirably in a 1916 letter to the young poet Iris Barry:

The whole art is divided into:

a. concision, or style, or saying what you mean in the fewest and clearest words.

b. the actual necessity for creating or constructing something; of presenting an image, or enough images of concrete things arranged to stir the reader.

Beyond these concrete objects named, one can make simple emotional statements of fact, such as "I am tired," or simple credos like "After death there comes no other calamity."[5]

(In practice, Pound was open to many approaches in literature. His defense of other writers was unstinting when he felt they were intelligent and gifted. His insistence on purity did not exclude certain Baroque poets from his admiration, but, like Kandinsky, he insisted on the passion that made of creation a necessity. One of his favorite criticisms of the poems sent to him by younger poets was that there wasn't enough "urge" in them.)

Since the turn of the century, the drive for purification has taken many forms in painting and sculpture, and is practiced both by those who wish art to be judged by its internal relations alone and by those who are wary of this ultimate decision. Purity has been one side of a dialectic. Heterogeneity has been the other. In the works of the artists still confident that the romantic tradition is vital, and who are concerned with process, the purifying strain is held in balance along with the drive toward heterogeneity. (The romantic tradition, it should be noted, works both ways: "art for art's sake" can lead to formal purity, but also to extreme diversity in range of subject, to exoticism, etc.) Matisse told us of pure spaces, it is true, and he ruthlessly cut off certain customary associations, but his spaces are still habitable spaces, spaces known to us circumscribed beings. They are dreamed-of spaces, but not entirely divested of their sources in intimate everyday things. Miró moves off into fantasy, but never gives us spaces known only to the mind or senses; they are inevitably dreamed in heterogeneous terms, terms which are not pure in the sense that a geometric figure is pure.

In the generations following these modern old masters, the balancing problem becomes more complicated, for not only have two world wars intervened, changing the sociology and psychology of

art, but certain experiences have been cyclically repeated, indicating the authentic crisis. (Dada returns repeatedly; reduction to nothingness keeps turning up, as in the monotone paintings that are exhibited periodically; "action" art in various guises appears over and over again.) The argument between purity and heterogeneity is carried on not only in the works themselves but in the greatly enlarged diffusion of printed words.

The continuity of essential painterly discourse is thus interrupted time and again, but in the deepest waters, the current moves swiftly on. Certain artists, such as Motherwell, Guston, Rothko, to mention only three, have been through the reductive experience of the epoch (Motherwell admired Mondrian, as did Guston, and Rothko himself offers an image of reduction which is so often misinterpreted as "pure" painting), and have set themselves the task of putting *back* certain impurities in order to leave their imaginations breathing space. These artists work with themes that have psychological specificity—that is, that relate to specific apprehensions of experience—and these apprehensions are limited, frankly, to single canvases. Guston can reduce his means, his palette, his forms, but he leaves ambiguities that can only be considered impurities in the paradoxically fruitful sense. To interpret his paintings, the mind and the emotions are simultaneously invoked, with neither gaining precedence. Motherwell carefully preserves both tendencies even within a single picture. It can be seen in certain of his recent paintings where there are double forms, one painted in a positive, unequivocal way, pure and patently structured, and the other, in a fugitive, amorphous way, a wavering shadow that is not "fixed" in the picture space, but unsettled and unsettling. Guston in his latest works is working toward the *mooring* of the wayward stroke, toward the suggestion of a stable infrastructure, but it is the *working toward*, with all its admissions of heterogeneous experience, which remains salient.

The spaces which their paintings elucidate are not "objective" spaces, since the assumption of the interpenetration of man and nature is maintained. These artists have accepted the notion of the total movement of natural forces; they assume that every shape is mitigated and made to function by its surroundings, and that all ex-

perience transpires in spaces that are the product of interaction—both physical and imaginary. They are not concerned with natural forms as were Klee and Miró, however. They have at times gone beyond the laws of functional form and pressed onward, toward the mysterious formlessness revealed in microscopic studies of matter. There are man-made structures in their paintings, and commentaries on them, as well as organic movements. They strive to define both the continuous and discontinuous, and they acknowledge the increasing information about the workings of the subconscious. It is no longer the Surrealist's simple faith in the mining of the subconscious. Nevertheless, these painters, sometimes called "painterly," remain firmly committed to the romantic ideal of process and heterogeneity. They are prepared to live with what Keats called their "negative capabilities." Keats observed,

> It struck me, what quality went to form a Man of Achievement especially in Literature and which Shakespeare possessed so enormously—I mean *Negative Capability*, that is when man is capable of being in incertainties, Mysteries, doubts, without any irritable reaching after fact and reason.

Edgar Wind has commented, in *Art and Anarchy*, on the romantic tendency toward dissociation—that is, the tendency toward fragmentation—in the general reductive movement. Certainly, fragmentation was carried to its apogee in modern painting, where, once the object was removed, spaces admitted any number of fragmented forms. Kandinsky's early improvisations epitomize this idea. But the fragment eventually attracted to itself its total form, either literally or by association. The principle of eliciting a whole from a fragment, so effective in archaeology, has not, as Mr. Wind suggests, left us with fragmentary, unfinished works of art and hopelessly anarchic thoughts; rather, it becomes a method suitable to contemporary experience.

15

Objectivity, A Twentieth-Century
Chimera

In his kaleidoscopic vision of the new spirit, Apollinaire made note of several vital tendencies born in his epoch and milieu and still maturing in our own. He took into account the accomplishments of science, speaking of the radio, the telephone, the X-ray machine, warning the artist that he must not neglect the significance of these technological advances. On the other hand, he was heir to the Symbolist view of a world beyond the world, and believed that the artist could find truth behind appearances. Again, he had a healthy love of the world and advocated its material incorporation in the work of art. Along with Max Jacob, he borrowed motifs from popular culture for his poems, lustily developed the Toulouse-Lautrec type of interest in the music hall and the boulevard, and highly approved of the Cubists' use of postage stamps and bottle labels in their collages. On the other hand, he had faith that intuition would reveal undreamed-of marvels. In him, the dawning conflict between artists seeking an objective touchstone in the world and artists seeking a subjective revelation was epitomized.

The years before the First World War, sometimes characterized as insouciant and blind, were, to the intense minds of such artists, years of great intellectual and spiritual turbulence. Science was at once suspect and feared, and welcomed as a source of stimulation and hope. For Kandinsky, the discovery of the disintegration of the atom was a crucial experience. "The discovery struck me with a terrific impact, comparable to that of the end of the world," he wrote,

and, thereafter, he turned toward a kind of metaphysical spiritualism. Yet, the same discovery fired him with tremendous hope. His ambitions for his art were immense; he envisioned nothing less than an apotheosis of the human imagination, leading him to characterize painting in 1918 as "the vast, thunderous clash of many worlds, destined through a mighty struggle to erupt into a totally new world which is creation."[1] At the same time, a vision of Nietzschean power—esthetic power—led Kandinsky to formulate the program for the new Soviet state workshops, where the artists were to plant the explosive seeds of universal culture. His proposals for the newly established Institute of Art Culture included a vast study of every known art form, and of possible extensions of them. He advocated research into the interrelationships of different forms of art; included an outline of studies on monumental art, or what he called art as a comprehensive whole; foresaw a collaboration of visual artists, musicians, dancers, and architects, and suggested a special project for workers in the positive sciences, who, he believed, could find common ground with the artists. Kandinsky believed that while the artist was at work, the probable effect of his work on others did not interest him; but that, once the work was ended, the question of its effect and influence became supremely important to him. The Utopian dream of Kandinsky was of a state of general culture in which the profound meanings proffered by artists could be received by the many rather than the few.

Beginning from the same zero point—that of "stripping" art to its essentials—two "families" of artists diverge. For Matisse, Miró, and scores of organic artists, stripping is the result of a purifying process largely governed by intuition. For the long line of purists from Malevitch to Vasarely, it means the incarnation of an intellectual act of will, intended to reveal the "objective" character of forms and spaces.

The will to find the objective touchstone was consciously propagated by the Cubists, above all by Braque and Picasso. In their studio talk, as overheard by critics such as Apollinaire and Reverdy, they referred often to the "objective" nature of their inquiries concerning form and space. The idea of a "conceptual" art is present when Picasso, for instance, says that he paints what he knows, not

what he sees. The idea of pure forms, not distorted by subjective, emotional vision, turns up again and again in early reports of dialogues among the Cubists.

Neither Picasso nor Braque, however, could accept a completely purist position, although many successors, such as Ozenfant and Jeanneret, took their purist theories from the Cubist esthetic. Both originators of Cubism insisted on their freedom from system, and when the time came for others to rarefy their principles of form, they themselves jumped in the opposite direction of heterogeneity. They may have sired the Purist family, but they remained aloof from family aspirations.

The purists, and the objective family in general, seek a "constructive" attitude toward art, an attitude open to modern science and technology, aware of man as a maker and builder, and concerned with finding laws in art equivalent to the laws in nature. Nearly always, the purist temperament is attracted to dreams of social utility for the arts, or at least to ascetic programs designed to minimize the artist's idiosyncratic bearing on his work. By temperament the purist is generally given to axiomatic thinking. He is intent on organizing matter, on relating to an assumed esthetic sensibility common to all mankind. He is impatient in the extreme with the equivocal utterance of the "tragic" artist, and briskly turns away from excessive speculation. As Mondrian said of the new spirit, "It is characterized by certainty, it does not question, it offers a solution."

The history of the various solutions offered by great purist imaginations crosses the history of individual solutions (or perhaps it would be better to say non-solutions) at many points. The divergences, at least in theory, are not nearly so acute as they appear. It is conceivable that in the future, when the twentieth century is assessed, the art of a Mondrian and the art of a Miró will be seen as springing from similar sources, arriving at parallel if not contingent results.

The men of the purist revolutions spoke repeatedly of a "new" order, a "new" sensibility, "new" harmonies, "new" ways of being in the world. Nature, as experienced by the nineteenth-century Romantics, no longer existed for them. There was a "new" nature,

which could be discerned behind the awkwardly ambiguous shapes of visible nature. Theo Van Doesburg had already stated it succinctly in 1912, when he said, "Strip nature of its forms and you will have style left." It was style alone that could serve as a universal language—style uncontaminated by the transitory and quixotic emotions of the "modern baroque" artists.

Van Doesburg's written program, developed some years before it was published in the first issue of *De Stijl*, which appeared in June 1917, throbbed with impatience. "The really modern artist, i.e., the conscious artist, has a twofold mission," he proclaimed.

> In the first place, he must create the purely visual work of art; in the second place, he should make the general public susceptible to the beauty of such purely visual art. . . . As soon as the artists in the various branches of plastic art will have realized that they must speak a universal language, they will no longer cling to their individuality with such anxiety.

When they learned that "purely visual" art—i.e., art based on the straight line—could become universal, there would be "a new relationship between the artist and society."[2]

In his first manifesto, in 1918, Van Doesburg specified that "there is an old and a new consciousness of time. The old is connected with the individual. The new is connected with the universal."[3]

This principle is implicit in all purist statements. It suggests not only that there were certain temperaments given to optimistic, constructive theorizing, but that the circumstances of the moment demanded certain responses. The accent on the collective nature of creation, which occurs again and again in the twentieth century, is certainly a symmetrical response to the revolutionary character—both political and technological—of its history. Mondrian, Kandinsky, Tatlin, Van Doesburg, Gropius, and similar artists were not alone infected with the collective vision; Breton, Aragon, and other artists whom Van Doesburg would have called scornfully "blind instruments of intuition" asserted that the evolution of art was the result of collective actions. Collectivity is, for better or worse, one twentieth-century mode of existence.

Along with the passion for the purist reduction to the universal,

evident in the articles published in *De Stijl* (where Mondrian's chief theoretic writings were published), there was the insistence on the "spiritual" values of art—the legacy of the art-for-art's-sake period. De Stijl artists, said Oud, were seeking "not the more sensual values such as tone, ornament, etc., but the more spiritual values such as relations, clear forms and pure color." Pitting themselves against the "caprices of nature" and the "weakness of the hand," the Neo-Plastic artists set themselves the task—by no means new to the history of art—of finding the unchanging laws, the universals existent in nature. The subject of their paintings, as H. L. C. Jaffé points out in his book on De Stijl, was nothing less than the transcription of "universal force." By aligning himself with the universal, the artist can look forward to the day when the world will be free of his small personal concerns, when "free painting" and "free sculpture" will disappear in favor of a vaguely adumbrated universal art.

Although Mondrian was to remain essentially a symbolist thinker, in whom the metaphysical reigned supreme to the end of his life, Van Doesburg was more rigorously "modern." Only thought, or intellect, creates, he wrote in his "Manifesto of Concrete Art" in 1930, and at a speed unquestionably greater than that of light. "The evolution of painting is nothing else but an intellectual research into truth by optical culture."[4] For all his faith in the intellect, however, Van Doesburg showed himself to be a complex person, not exempt from the conflict of the time. The straight line and the intellect were his initial ideal in painting, but for poetry and literature he showed himself a welcoming host to irrepressible movements of wild intuition. He associated himself with the Dadas early, published their writings in his magazine, and himself wrote Dada poetry under various pseudonyms. The renewal of the word, he felt, could only be accomplished by the destruction of the old rhetoric, by the abolition of all worn-out syntax. Stripping, here, becomes a stimulating act, an act that will free the new, the unexpected. This apparent contradiction is one of many. The two "families" were at this time much less clearly divided as to method than they became in later years.

The Bauhaus, for instance, which could countenance the presence of such markedly individualistic temperaments as Klee and

Kandinsky, was not nearly as strict and functional in its outlook as its historic legend pretends. A look at the various invitations to parties, at the incidental photographs of the students at work and play, at the photographs of theatrical productions quickly proves that the Bauhaus was an open center of activity that gathered up spirits ranging from the purely Expressionist and individualistic to the rigorously purist. The Dada movement, the Russian Constructivist movement, De Stijl, and other more ephemeral moments in avant-garde art history were all freely discussed at the Bauhaus, along with the art of the past. Still, as it is registered in history, the Bauhaus stands for a Utopian, collective principle similar to that outlined by Mondrian and Van Doesburg for De Stijl. Gropius, in his initial proclamation for the Weimar Bauhaus, indicated the same irritation with the tradition of the solitary *artiste maudit*, so dear to the nineteenth-century bourgeoisie, that Van Doesburg expressed so vigorously in his first issue of *De Stijl*. Writing in 1919, Gropius begins sketching a Utopian program: "Art is not a 'profession.' There is no essential difference between the artist and craftsman. . . . Let us create a *new guild of craftsmen* without the class distinctions which raise an arrogant barrier between craftsman and artist."[5]

While Gropius' initial statement of the aims of the Bauhaus seems to extend the tradition of William Morris, even of Ruskin, who believed that art applied in industry would radically alter society, the development of the Bauhaus was quickly turned in the direction of modern industry, where even the "craftsman" or "master," as the teachers were at first called at the Bauhaus, was subordinate to the collaborative principle. As G. C. Argan writes, the initial courses at the Bauhaus, in the last analysis, were "an instrument created to produce a new class of supervising technicians whose work could be projected on an international level."[6]

Gropius developed his theory of social amelioration through the collective activity of artists and artisans in his article, "The Theory and Organization of the Bauhaus," written in 1923:

> The old dualist world-concept which envisaged the ego in
> opposition to the universe is rapidly losing ground. In its place

> is rising the idea of a universal unity in which all opposing forces exist in a state of absolute balance. This dawning recognition of the essential oneness of all things and their appearances endows creative effort with a fundamental inner meaning. No longer can anything exist in isolation.[7]

Here, the differences between individualists, such as Matisse and Miró, and universalists, such as Mondrian and Van Doesburg, emerge. The diction, the assumptions are the same: No longer can anything exist in isolation. Universal forces are greater in sum than opposing forces. A fundamental inner meaning can be drawn from the recognition that there exists a complex but unified cosmos. Yet, for a man with a need for logical clarity, for "pure" solutions, the very assumption of the modern conception of existence, that nothing can exist in isolation, leads to dreams of a collective, anonymous integration of art and life, while for the dreaming organicists it leads to metaphysics and a heightening of illusion.

Gropius speaks pityingly of "the great art proletariat, lulled into dreams of genius and enmeshed in artistic conceit." For this army of ungifted, self-deluded artists he proposed a useful life in collaboration. "The ultimate, if distant, goal of the Bauhaus is the *collective work of art*—the Building—in which no barrier exists between the structural and the decorative arts."[8] The realism Gropius injected into Bauhaus pedagogy was summed up by Alfred Barr, writing for the catalogue of *Bauhaus 1919–1928*, an exhibition at the Museum of Modern Art in 1938. One of the main principles Barr singled out was "that most students should face the fact that their future should be involved primarily with industry and mass production rather than individual craftsmanship."[9]

This, from Gropius' point of view, was the purpose of the new school. In practice, the Bauhaus was flexible enough to provide nourishment for many different inclinations. Paul Klee's thought, Kandinsky's, were not geared to "the Building," but rather to the philosophical implications of contemporary life. When Klee developed his first course at the Bauhaus, he presented his students with materials which were not associated with "art." Rather, they were the everyday, often worthless, objects that we handle unconsciously time after time: mounds of rags, papers, pieces of tinfoil,

glass, cellophane. For Klee, these bits of anonymous remnants of the actions of the unreflected daily routine were to be the source of imaginative flight. For Kandinsky, who joined the Bauhaus in 1922, the elements isolated in preliminary Bauhaus courses were to be used toward the constructive end of formulating the laws of what he called "energy-tension." In other words, the same methods were applied by the various masters to arrive at very different results.

For Josef Albers, the commonplace materials used by Klee had another purpose, that of inspiring new constructional forms by stimulating the student to invent new ways of handling these materials. Albers worked with what he called the "inductive method" of instruction. In his preliminary course, students were to experiment with "studies in transformation in one plane," with "transformation of a cylinder through cutting and bending paper," and with "three-dimensional effects achieved by two-dimensional elements: circles and parts of circles." Through coolly applying the inductive method, the student would emerge with a knowledge, informed by science and all modern developments in optics, of how to transform basic plastic elements into constructions which were self-contained, non-romantic, realistic, and opposite to all that an organic temperament such as Klee's proposed.

When László Moholy-Nagy set up his new Bauhaus, the Institute of Design, in Chicago in 1937, he adhered faithfully to Bauhaus principles, announcing that "the Institute does not aim at the education of geniuses, or even of 'free artists' in the old sense." Rather, he aimed at producing superior designers and craftsmen who would in turn raise the levels of understanding in the community around them. The principle which emerged from early Bauhaus experience he formulated as follows: "Not the single piece of work, nor the highest individual attainment must be emphasized, but instead, the creation of the commonly usable type, development toward 'standards.' "[10] He was interested, he said, in the ABC of expression itself and not the personal quality of expression which is usually called "art." (Years later, we still find a great exponent of this ABC view in Vasarely, who also seeks an alphabet —standardized by himself—of basic elements.)

Moholy-Nagy's writing about his didactic principles; his illustrations with his own work and that of his students had an incalculable influence in the United States. Much of the discourse today, based on the new "objective" art, sounds very much like Moholy-Nagy's discourse originating more than thirty-five years ago. Moholy's breadth of interest and his own indomitable experimental impulse broadened the basis of Bauhaus ideology considerably, but the method Albers called "inductive" took precedence in his educational method.

16

"Truth by Optical Culture"

Many artists have found exaltation in the contemplation of number. Kandinsky's ultimate conclusion was that number is everything. Like many dreamers of constructive "solutions," he sought the laws, the steady, consistent underlying structures of the universe, in order to make an analogue in terms of painting. Now, any artist who dreams an analogue to the harmony of nature must assume, with Kant, that there is an inherent esthetic response to harmony and rhythm: that a man contemplating a well-wrought, well-proportioned object is shot through with some peculiar satisfaction that can only be called esthetic. The satisfaction found in the discernment of abstract harmonies is known to musicians, physicists, and geometers. It is also known to painters of a certain temperament who search for the "right" proportions with as much passion as painters of other temperaments have in exploring the ephemeral interactions of things and emotions.

Victor Vasarely is a grand and passionate seeker of the "right" abstract solutions. "I choose two quantities of forms-colors, I determine their topography, their scale, their rapport, and I prove that in a given place with given lighting, these quantities become qualities."[1] This seemingly cool, rational, mathematician's approach stems from the tradition in which Renaissance painters experimented with arithmetical proportions, and Leonardo claimed that "painting is a thing of the mind." To what intense, arduous lengths such dreams of objective rightness of form led these rational painters! And to what admirable aspirations: to achieve nothing less than perpetual solutions, rather than questions. But solutions reside

only in the ideal future, which, with all his will and ardor, the artist of the Constructivist family strives to reach.

The family history that bears on Vasarely's formation is the history of the Constructivists. Born in 1908 in Hungary, graduated from college in 1925, and an art student until 1929, Vasarely stepped into an already mature modern tradition of abstraction. For him, as for many artists of his generation, the battle for the legitimacy of abstract painting was past history. They never doubted that modern art was abstract art. They could take everything so painstakingly postulated by Malevitch, Tatlin, Mondrian, Kandinsky, Van Doesburg, Moholy-Nagy, et al., for granted. Vasarely was particularly susceptible, given his natural penchant for axiomatic thinking and precise working habits. His early training was in the Hungarian version of the Bauhaus set up by Alexander Bortnyik in 1927 when he returned from his own Bauhaus initiation. Bortnyik was a staunch disciple of Gropius, Moholy-Nagy, and Herbert Bayer. According to Vasarely, he based his instruction on a rigorous geometry. "We had to express in form, color, and materials the plastic equivalents of such notions as sharp, dull, distended, sulky, calm." There was no question of a recapitulation of modern art history in the enthusiastic modernity of the Bauhaus colonials. Bortnyik's students plunged readily into a full-blown abstract rhetoric. "When I left Hungary in 1930," Vasarely recalled in a monograph written in 1952 by his friend, the abstract painter Jean Dewasne, "I had already absorbed all the abstract culture that had been created until that moment."[2]

Much of Vasarely's abstract culture was based on the kinds of "objective" problems set by masters such as Albers and Moholy-Nagy. Some of his early works strongly recall the student illustrations of Bauhaus problems in Bauhaus publications. For instance, his portrait of a zebra, done in black lines warped into a third dimension, could easily be a model of the problems set by Albers under such dry titles as "studies in transformation on one plane," or "three-dimensional effects achieved by two-dimensional elements." The zebra, it is true, is there—a figurative pretext. But clearly Vasarely was not interested in its nature, in "expressing" it. He was intrigued, rather, by the paradox of lines which, when

warped, produce the illusion of both movement and depth. The line, not the zebra, interested him, and only as a vehicle to express a kind of unitary space envisioned by most abstract theorists.

The straight line from which such erstwhile purists as Vasarely had begun, was more than a prop for such thinkers as Van Does-burg and his successors. "The straight line of the geometer," Julien Alvard has written, "is a trajectory of an invisible curve, as good as saying it doesn't exist. The truth is, it is only present in the world of art, and there, it is the most insolent manifestation of the irreal."[3]

Vasarely's abstract culture rests only partly on the tough, purely plastic experimentalism advocated by Albers and Moholy-Nagy. He also encompasses and extends the idealistic, exalted optimism broached so insistently by Mondrian and Kandinsky. The artist, he told Dewasne, must one day "have a revelation that he is identical with the material universe that surrounds him. He must one day feel the right pulsation of the spiritual world which, in spite of its multiple visages, rests constant."[4] Although there are certain con-tradictions in Vasarely's writings, and although he likes to speak and think like a brusque rationalist, he has persistently referred to that "spiritual" world sensed so poignantly both by Kandinsky and Mondrian. Like them, he is an optimist believing that everyone —peasant, worker, and professional alike—is open to rhythms, sounds, forms, and colors. Like them, he builds upon the nine-teenth-century principle of art-for-art's-sake, of Beauty as an in-controvertible existent in human affairs, and like them he veers into vague and somewhat inconsistent sentimentalism when he ut-ters the word "beauty": "Because the shock of the beautiful is pro-duced in our emotive being and not in our intellect . . . the dream of the painter is to produce good works, to put them among men and mix them in life in order that they can constitute a presence."[5]

The Utopian hopes of the earlier generation are sustained to this day by Vasarely. Like Gropius, he insists that the collective prin-ciple, increasingly active in twentieth-century life, must be accepted by the artist. "I dream of a social art. I suppose a profound plastic aspiration in man. . . . Art is the plastic aspect of the community."[6] Or, "Each work must have two lives: its life appropriate to the scale of the individual, and its multiple life on the scale of the

human community."[7] Like his predecessors, he sees a "new" world, utterly different qualitatively and quantitatively from all that has preceded. For such temperaments as his, modernity is a passionate religion, identified with seemingly incompatible principles of spirituality and technology. The "new" world Vasarely lauds is a re-creation of the new world envisioned by Apollinaire and the early modernists. Vasarely is given to the kind of proclamation that begins with the words, "Our world is . . ." or, "The time in which we live is . . ." "Our epoch," he notes in his fragmentary journal for 1954, "with its invading techniques, its speed, with its new sciences, its vertiginous theories, its discoveries and unpublished materials, imposes on us its law."[8]

Along with this exhilaration in the face of modern life, he has an almost reflexive suspicion of individualism, a contempt for the nineteenth-century bourgeois image of the artist as a quixotic, velvet-clad entertainer. "The title 'artist' is gratuitous, detestable, only covering appetites and thirsts. Will we go toward anonymity to find again the honor of the métier?"[9] Echoes, here, of Gropius' first statement in his Bauhaus proclamation. Echoes of a long tradition of revolt against sentimentalism and exacerbated individualism. Echoes of the often hysterical diatribes against the tragic, the subjective, and all that is associated with nineteenth-century Romanticism. Mondrian, Van Doesburg, Vantongerloo, Kandinsky, Arp, and even Breton: they had all wondered, like Vasarely, whether anonymity would not be more honorable, truer to artistic ideals.

This tradition of irritable reaction against the overstress on individual emotional tremolos is worth examining. Like certain other modern traditions, it finds its roots in the nineteenth century, and is renewed with each generation, particularly by the family of purists. It is implicit in Courbet's central position: "Show me a soul and I will paint it." It is implicit in the revolt of the artists and writers against *fin-de-siècle* Symbolism. Writing in 1895, Maurice Le Blond, in his "Essai sur Naturisme," cries: "Enough! Enough Baudelaire and Mallarmé. Our elders preached the cult of unreality, the art of the dream, the search for the new *frisson*. They loved venomous flowers and darkness and ghosts. . . . As for ourselves, the Beyond does not move us. . . ." And Gide, writing in

his mature period, renounces his early poetic symbolism, insisting
that art is born of constraint, thrives on struggle, dies of freedom.

Personalities given to anti-Romanticism easily find justifications
when they search for past prototypes. A striking instance is cited by
Vasarely's colleague Jean Dewasne. Dewasne cunningly goes back
to the master most admired by his esthetic rivals, the Surrealists,
in order to find a startling contradiction to their position:

> Do I dare suggest that madness, sickness, anguish, indeci-
> sion and tarot cards seem to me suspect? . . . Lautréamont in a
> letter of the 12 of March, 1870, wrote—and he had acquired
> the right dearly—:
> "The poetic sighs of this century are hideous sophisms. To
> sing of ennui, sorrows, sadnesses, melancholies, death, shad-
> ows, etc. . . . is to want to see only the puerile reverse of
> things. . . . Always whining. That is why I have completely
> changed my methods in order to sing exclusively of hope, calm,
> happiness, duty. . . ."[10]

This is a splendid illustration of the theory that surfeit is the main
source of esthetic change. Out of a surfeit of emotional maunder-
ings and sickly preoccupations with the tragic rises the construc-
tive response, the exasperation of the moderate, rational spirit.
Whoever experiences this rising in the gorge, this surfeit, usually
seeks and finds a kindred spirit in the past to support him. When
Cyril Connolly fastened his acerbic gaze on Rimbaud—another
idol of the Symbolists and Surrealists—what did he see? He saw
that Rimbaud had had a sense of repulsion after his visionary,
fevered flights, and envisioned a work which would be cooler, more
realistic in tone. Connolly points to Rimbaud's project to write a
long poem with the opening scenes called "Photographies des
Temps Passés," and says that *photographies* is the "operative
word."

Connolly, like Vasarely, was a man whose most powerful
thoughts were engendered during the 1930s. At that time there
was a visible effort on the part of writers and artists to pull back
from metaphysics and to relate the artist to the events—all tragic
and disturbing—in political life. Hemingway was one of the chief
exponents of the lean, matter-of-fact attitude which regarded with

derisive distaste all metaphysical excesses, all flights into the Abstract Beyond. Malraux was putting the artist into the position of artist-warrior in his work and his own life. (Apollinaire, in his burlesque, *Les Mamelles de Tirésias*, had also protested romantic cant, and had, he claimed, a practical social end in mind.) The pure esthete came under suspicion, along with all gravely phrased theories of the artist as demigod.

Vasarely's uncompromising disdain for romantic excess rings through almost all his written statements. "What remains of the Muse inspiring beautiful souls . . . under the crude lights of biochemistry, genetics, and bionics?" he asks rhetorically in his 1960 journal. "The genius, the illuminated poets, the sensitive soul: so many fairy stories. We regret it, of course, but they are only souvenirs. We know now that by successive steps, in the process of the complexification of the unit-particle-wave, we arrive at a human phenomenon. The *art phenomenon* cannot any longer have a divine explanation, but well-and-good materialist."[11]

(The recoil from abstract metaphysics is not limited to the purist artist. Mark Rothko, for instance, insists, and has always insisted, that his is the art of a materialist; he would respond sympathetically to Courbet's "Show me a soul and I'll paint it.")

The suspicion of self-illuminating, self-referring romanticism recurs consistently in the twentieth century, often spurred by disastrous events. Writing a measured and sober article immediately after the Second World War, Stephen Spender, whose poetry was far from naturalistic, launched an appeal to his fellow writers: "The inner world of personality is certainly the most important reality we know, but unless it can be related to the outer world, all attempts to develop it only reveal its isolation and weakness."[12] This statement is not so different from Vasarely's often repeated statement of the necessity of the dual life of a work of art. The inner world of personality is not foreign to Vasarely; it is only too narrow, and dangerously enclosed.

Through the force of his personality and his great talent, Vasarely emerges as a major artist. It cannot be denied, even by Vasarely himself, that he evolved his unmistakable style through working intensively over the years, in the same isolation as that

of the romantic artist. When he arrived in Paris in 1930, confidently possessed of all the abstract culture to date, he began by continuing the kind of plastic research with forms and materials familiar to him through his Bauhaus experience. To Dewasne he related that he used as many different materials as he could, and even made a brief incursion into automatic drawing, which he scornfully dismissed immediately as of interest only to psychiatrists. He described how he soon began to seek already-covered surfaces—scraps of old paintings or newspapers—in order to give himself an "external point of departure": in order, in other words, to insure the "objective" character of his businesslike research. This could be compared with the establishment of Cubist "certitude," the quality of absolute reality inserted via collage into pictorial art. After investigating these painted or otherwise already covered surfaces, Vasarely began to research the uses of cellophane, to lay down transparent planes that could move him in the direction of multiple perspectives and free him from the rigors of Neo-Plastic dogma.

As crisp and workmanlike as his experiments were, Vasarely, like any other painter, experienced the kind of organic, mysterious development, the kind of irresistible, inspired impulsion generally associated with artists of process. When Dewasne asked him how he elaborates one of his paintings, his answer was more in the character of the romantic painter than the purist:

> I see, I imagine, I sense a mounting in me, I desire, or impose upon myself a color—an obsessing and tenacious color. This color must present itself in a form. I search, I fumble in myself until I can define it clearly, more or less round here, pointed there, open at left, balanced in this sense around an ideal center of plastic gravity. . . . Waiting, I carry that form around in me like a baby.[13]

Vasarely's earlier experiments with the form which has such a slow and inexplicable genesis tended always to confirm the unspoken law of the plane, the law which the early purists had established and which insisted that the two-dimensional carrier not be controverted by illusion. Most often, he would work in few colors, adjusting them instinctively so that the "ideal center of gravity" would remain undisturbed. As Dewasne observed, Vasarely's con-

trasts are not contrasts of colors but of luminosities. By balancing
one luminosity with another, he achieved the kind of equilibrium
consistently advocated in the purist tradition.

Vasarely, however, had circumvented the Mondrian theory of
the right angle. Even in his earlier abstractions on canvas, he had
persisted in experimenting with various perspectives. The familiar
lozenge shape, the square with one sloping angle, the circle trans-
formed into an ellipse, all served to suggest another dimension, an-
other area of movement for his colors. In manipulating these
forms which invariably imply the third dimension, Vasarely found
himself moving far from Neo-Plastic conceptions. By the early
1950s, he often used only scissors to determine his forms. The rich
colors—deep ochers, blues, sometimes a marvelous range of grays,
sometimes high-intensity reds—worked in concert with the sharp
definition of edge to produce the kinds of ambiguities that haunt
Vasarely.

For it must be emphasized that although the very notion of am-
biguity is anathema to a man of Vasarely's turn of mind, his work
reveals an absolute fascination with the ambiguous. A form that
he searches out in himself is eventually forced to assume a shape
that can be read in various ways, and in which the determination of
its place in the world is complex and often equivocal. By means of
the queer and original perspectives in which he casts his forms,
Vasarely reveals the questing nature of his talent, and its vital
interest in the conundrum. Even his choice of velvety, deep colors,
which seem to have nine lives behind their surfaces, is lyrical, geared
to stirring vague, sometimes melancholy emotions. There is even a
reminiscence of de Chirico's nostalgia in certain of Vasarely's can-
vases—those in which mirror grays set off reverberating move-
ments into infinity; in which lines twang like the strings of a cello.
His belief in his first sketch, which he says he always keeps, since
all later work is only a purifying of the first statement, indicates his
romantic confidence in the moment of inspiration. These sketches
provide an index of hundreds of plastic notes which he keeps and
ponders, notes that resemble the musical scores of avant-garde
composers, and from which all his works evolve.

From his persistent attack on varying perspectives, Vasarely grad-
ually evolved a new esthetic which he explained in his *Notes for*

a Manifesto, published in 1955. What he called "pure composition," he explained, was still, as it had been for Mondrian, a planar theory in which rigorous abstract elements—few, and expressed in few colors—possess on the whole surface the same quality of complete plasticity. But Vasarely goes a step further; by introducing opposing perspectives, the same elements found in a Neo-Plastic work surge forward and subside in turn, bringing a new kind of "spatial feeling." The illusion of movement and time is conveyed in a single moment of observation. Unity, made of contrasting form-colors, "is at once physical and metaphysical. It is the comprehension of the material, mathematical construction of the Universe. *Unity* is the abstract essence of the BEAUTIFUL, the first form of sensibility."[14] The painting which rests on the initiation of the new spatial feeling of movement he called "*cinétique*."

There is a double root for Vasarely's clarification of his new esthetic as a kinetic art. On the one hand, it derives from an inevitable necessity contained in the Neo-Plastic method; an adventurous young artist could not remain within the rigid boundaries established by the previous generation. Inevitably, in the play with forms on a plane surface, movement would assert itself, since from the moment the geometric forms are warped into perspectives that lead the eye inward from the plane, movement is generated. With all the formal experiment undertaken at the Bauhaus, all the "inductive" procedures, it was preordained that a Vasarely would seek a new complexity in terms of movement.

On the other hand, the mind that takes pleasure in abstract harmonies, that finds esthetic satisfaction in the justness of a geometrical proposition, seems to tend always toward a tectonic vision. While nearly every sensitive viewer can be moved by the graceful repetition of a Renaissance arch, moving steadily and inexorably to its perfect containment in a well-planned arcade, there are certain sensibilities which are particularly attuned to the rhythms, the exact measures that produce the effect of total grace. This peculiar sensibility to the constructed, to proportions conceived by a precise mind, is always attracted by the tectonic potentials in the art of painting. It is natural for a formal instinct, a constructive mind like Vasarely's, to veer toward the large, the public, the "constructive" schemes. This natural penchant is complemented by a philo-

sophical tendency to seek "solutions." Formal and social aspiration combine without difficulty, to the purist mind.

Kinetic art, then, was a movement in the direction of fulfilling Vasarely's philosophical aspirations as well as his needs as a creator. In order to follow his philosophical development, it is essential to recognize that it springs from the twentieth century's profound change of attitude toward man and nature. Apollinaire had already stressed that man is a part of nature, not a spectator looking on. Scores of other writers and artists echoed this view, either verbally or in terms of their methods of work. Vasarely is not unique in claiming that his "nature" is that of Einstein and Heisenberg; that in his epoch, contemplation transforms itself into participation, and that the artist realizes that he himself is nature. He has much in common with Arp when he tells Dewasne in 1952 that the artist now participates directly in nature like a tree or a cloud. And he does not differ greatly from a host of artists of opposing approaches when he senses the enormous significance of the changing experiences of space. "Space, the new site of form-color, is physical, but it is above all this new dimension of the universal conscience. Art is the plastic image of the community."[15]

As a man of his generation, Vasarely shares in the emerging vision of man as no longer the center of the universe, the vision verbalized by personalities as different as Breton and Van Doesburg. He also shares in the working elaboration of early twentieth-century assumptions, and in their radical transformation. While artists in the first half of the twentieth century were still concerned with natural forms, albeit abstracted to a high degree, and while certain artists were even aware of different forms revealed by microphysics (Varèse could explain his music in terms of the crystal), the artist of the second half, particularly the purist, is not concerned with specific form, but with universalizing abstractions of movements. For Matisse, there was a "state of the soul" influenced by objects. For Vasarely, the objects are nearly non-existent. He is completely convinced that the dimensions and movements of the new sciences are part of the individual's living experience, are, in fact, his central experience.

It is not, then, a difficult step from the natural to the constructed, from *homo sapiens* to *homo faber*, from the private to the public,

from individual to community. "Painting and sculpture," Vasarely
wrote in 1955,

> become anachronistic terms: it is more correct to talk of a bi-
> tri-multidimensional plastic. . . . Our knowledge of space, en-
> ergy, matter—inert, organic, living—makes us believe that the
> physical constitution of man is the prolongment of the physi-
> cal constitution of the universe. From here, the creative act
> ceases to be fortuitous! . . . Contemplation by the exterior is
> thus transformed into participation through the interior.[16]

If the physical constitution of man is a prolongment of the
physical constitution of the universe, Vasarely implies, then there
is a natural condition in which any man, not only the elite, can be
illuminated by works of art. It is toward great social projects, or
at least great projects exposed to society, that he conceives of "in-
vention and recreation."

> If Art wanted yesterday to be *Feel and Make*, today it can be
> *conceive and have made*. If the conservation of the work resided
> before in the excellence of materials, the perfection of their
> technique and in the mastery of the hand, today it finds itself
> in the awareness of a possibility of *recreation, multiplication*
> and *expansion*. Thus, through technique, the myth of the
> unique piece will disappear, and the diffusable work will tri-
> umph thanks to the machine, and through it.[17]

From this ambition of diffusion, already entertained by the early
Constructivists, Vasarely immediately envisions a new polychrome,
geometric city. And with this dream of saturating the city (was it
so different from Tintoretto's voracious dream of saturating Venice
with his work?) comes work of increasing architectural viability,
above all work in which the optical inducements to movement are
produced by the mere fact that the passers-by in large places are
moving, and, in moving, are peripherally aware of the movement
within the colored surfaces encompassing them.

Certain of Vasarely's multiple works are in relief—structures in
various materials, in which the measured intervals of depth and
color accent produce an almost mechanical movement of the optical
nerves. Others, executed on huge steel plates on which the color

is engraved, require prolonged study for the full and complicated effect of the rhythms.

The tough, rationalist side of Vasarely's personality is satisfied by his essays into large-scale architectural designing. When, in 1963, the Musée des Arts Decoratifs in Paris held a large exhibition of his work, its director, Michel Faré, in his selection, seemed to remember Vasarely's earlier pronunciamento (so reminiscent in tone, and even in diction, of Breton's dicta), "Art will be a common treasure or it will not be." And Vasarely himself adopts his sharpest tone in his own introduction to the catalogue, which is devoted largely to a fierce polemic, a kind of salvation-through-technology sermon. In it he reiterates his view that the polychrome city, in which "the unity of the construction will be also the esthetic unity, giving an intrinsic plasticity, not an added plasticity," is the sole valid goal of the creative worker. The climax of his statement, once again in the priestly polemic tone that is one of Vasarely's several voices, is an appeal for that nostalgically yearned-for anonymity: "Let us kill above all the egocentrism in us. Only teams, groupings of entire disciplines can from this point create; cooperation among savants, engineers and technicians, men of industry, architects and plasticians will be the first condition of the work."[18]

For all the hardness of tone, for all the determined will to be clear, constructive, and without illusions concerning the role of inspiration and talent, Vasarely does not escape some of the central preoccupations more often associated with the organic, individualist artist. His salvation-through-technology program is clear enough, but the philosophical or esthetic problems he confronts are often the same ambiguous, troubling, and unanswerable problems faced by the artists who have not scorned the unique piece and who are not given to sociological temporizing. The strange ambivalence residing in Vasarely (which I regard as his saving grace, the very element which preserves him from the dry, mechanical solutions of purist epigones) is remarkably revealed in an article he published in 1960 on what art criticism should be.[19] This article begins with Vasarely's description of his own reactions before the works of a young artist, Morellet. With the interpretive vocabulary common in contemporary criticism—the very criticism he is attacking—

Vasarely waxes poetic about "near and far stars, spaces seen from the Sputnik, carbon in its ultimate state of crystallization like millions of diamonds." He describes a vision of "an electromagnetic field emitting rose and green rays of light, of the interior of the atom," and of "the unimaginable image of a place in which a thing is at once a real object and mathematically pure."

His poetic transport before "this extreme voyage from galaxies to electrons" makes him think of Cézanne, whose structure, he says, was almost mathematic, and from whom later plastic theory derives. Cézanne, in turn, makes him reflect upon the universe, and, in a tone which decidedly recalls the metaphysical tone of Mondrian in his more mystic writings, Vasarely explains that since Cézanne, the "restrained Nature of our predecessors" has infused itself into the universe of "infinitely large" and "infinitely little." At this moment, Vasarely says, the operational theatre of the plastic artists also needs to enlarge itself, in terms of both its sources and its functions.

Moreover, Vasarely sketches an idealistic future, in which a "common language" or a "plastic genetics" can be determined, and a "science of art" finally realized. But this "science of art" is oddly conceived by Vasarely, who calls upon the thoughts of Teilhard de Chardin about the ultimate "noösphere," and the concept of Robert Oppenheimer, who hopes for an ultimate "common language" of science which will bring spiritual and political unity to mankind. He cites Wiener, Dauvillier, and Heisenberg, who, he says, "trace optimistic paths for man." What Vasarely dreams of is nothing less than "planetary unity."

Not unlike the artists enthralled by Bergson, Vasarely says,

> I have always professed the necessity of evolutionism in plastic art, not in the historic mode, but in the manner of Darwin or rather, Teilhard de Chardin. . . . The enlargement of the artist's thought toward the sciences—exact and human—gave him the comprehension of great ensembles and their structures.[20]

The dream of a metaphysical language of form, it is obvious, is not limited to one family or the other in modern art. Vasarely's source, Teilhard de Chardin, is also Guston's, who, as I have pointed out, moved in his work from form to meta-form, and envisioned an apotheosis of mind along the lines proposed by Teilhard. Vasarely's conviction that "we cannot admit any more an

'interior world' and another, exterior, world separately, the within and the without are in osmosis,"[23] is an affirmation of the principles discerned by European phenomenologists who stress the idea that there is no within or without for the human psyche, but only a physical continuity.

The artist who sees himself in the tradition of materialism and reason, as Vasarely does, often pushes beyond to the point where the extremes touch. The dream of psychical force as the unifying principle in existence is surely a dream of the idealist, yet hard-headed artists in the materialist tradition have been among the most exalted visionaries. Maxim Gorky, in a reminiscence of the poet Blok, deplored the "decadent" cast of Blok's thought. He, Gorky, was a firm believer in the supremacy of reason. Yet, when he came to explain his belief, the idealist hidden behind the materialist bursts free:

> I myself believe that at some future time all matter absorbed by man shall be transmuted by him and by his brain into a sole energy—a psychical one. This energy shall discover harmony in itself and shall sink into self-contemplation—in a meditation over all the infinitely varied creative possibilities buried in it.[21]

The extremes touch, then, when Vasarely—who can stand for a host of purist painters—proudly proclaims that he has succeeded in fleeing from the ordinary landscape, that he has found the way to "the inapproachable, the stars, the invisible. . . ."[22] Whether on the waves of electromagnetism or on the wave of reveries of great spaces such as sea and sky, the contemporary artist persists in the dream, already described at the turn of the century, of an abstract analogue to natural experience.

While Vasarely's rhetoric still rings true, the result of his commitment to industrial esthetics is a horrifyingly visible decline in quality. He has inundated the world with glittering Vasarely objects and reproductions, but the loss of immediacy and urgency in these manufactures is fatal.

23. Victor Vasarely: Naissances, 1952-60.

17

Man in the World

On May 17, 1965, the *New York Times* carried a front-page account of Dr. José M. R. Delgado's unprecedented encounter with a fighting bull. Dr. Delgado, the reporter recounted, merely pressed a button on a small radio transmitter and the raging bull trotted obediently away in the opposite direction. "The bull," wrote the reporter, "was obeying commands from his brain that had been called forth by electrical stimulation—by the radio signals—of certain regions in which fine wire electrodes had been painlessly implanted the day before."

On May 21, 1965, readers of the *Times* saw a top headline on the front page: "Signals Imply a 'Big Bang' Universe." This story announced that scientists had observed the remnants of what may have been the explosion that gave birth to the universe.

On Sunday, May 23, the week's spectacular scientific news was summarized on a single, closely written page which also carried a letter signed by scores of leading specialists on Latin America protesting President Johnson's intervention in the Dominican Republic.

Three vital areas of human endeavor, three items of information with vast implications covered in a single week.

Dr. Delgado's adventure, detailed in the Sunday *Times*, was based on extensive animal research aimed at "the understanding of the biological bases of social and antisocial behavior." Dr. Delgado told reporters that he was particularly concerned with what he

called "the gap between our understanding of the atom and our understanding of the mind." Through the implantation of electrodes, scientists are able to study brain functions, and will possibly discover "the cerebral basis of anxiety, pleasure, aggression and other mental functions." More ominously, they may develop the means of influencing human behavior, of stimulating or inhibiting aggressiveness at will, as they have been able to do with monkeys. "The functions traditionally related to the psyche such as friendliness, pleasure or verbal expression can be induced, modified and inhibited by direct electrical stimulation of the brain." Fortunately, toward the end of the news account, Dr. Delgado is quoted as believing that control of mass human behavior would not work for various reasons, the most significant being that his own experiments have proved that electrical stimulation does not call up automatic responses, but "elicits reactions which become integrated into social behavior according to the individual's own personality or temperament."

Much of Dr. Delgado's report had already been established by brain surgeons working to relieve epilepsy by removing cortical tissue in what seemed to be the affected area. In the course of increasingly elaborate brain surgery, much information has been gleaned about the functions of the brain. What the *Times* obviously cannot discuss, and what is of vital interest to the artist, is not so much how the brain functions as how, in functioning, it *creates*. It would seem that as yet there is not even a faint ray of certitude as to how or why personality or temperament affect brain function. The news item, then, is startling not so much in its revelation of function as it is in its social implications. The "psyche" remains inexplicable, even if some of its functions have been explained in terms of mechanics.

The implications of the "Big Bang" story are almost unimaginable. Nothing less than the whole history of human cosmology is put to the question. In his resume, science reporter Walter Sullivan begins: "Did the universe begin with a cataclysmic explosion, and if so, will it meet an equally violent end? Is it changeless, eternal and infinite, or is it enclosed within itself and pulsating?" He notes that since the 1920s it has been known that distant galaxies beyond our own have been flying away from us. The farther from us

they are, the faster they are receding. Three basic cosmologies have been advanced to explain this motion:

1. The "Big Bang" theory accounts for the outward motion in terms of an explosion billions of years ago.

2. The "steady state" theory maintains that the universe expands into infinite space, and that new matter is always being formed to fill the gaps between the spreading galaxies.

3. The "oscillation theory" holds that the universe expands as the consequence of an explosion, then contracts until the galaxies fall together, setting off a new explosion in an eternal cycle.

The two "dramatic developments" within a single week, which might eventually clarify the universe, were the report that the flash of the primordial explosion may have been detected, and that five objects known as quasars were detected, so far away that their light has taken many billions of years to reach the earth. Both observations support the view that some sort of cosmic explosion occurred. "If the flash of the primordial fireball has indeed been detected, it might mean that we can see back to the beginning." One of the scientists, Dr. Allan R. Sundage of Mount Palomar Observatory, suggests that the brightness and velocities of the quasars are consistent with the theory of a universe that is closed and oscillating at a rate of one explosion every 82 billion years. Nothing can be ascertained, however, until the geometry of the universe is known. "Because large volumes of space cannot be seen simultaneously owing to the limited speed of light, time must be included as a dimension." Until the geometry of space-time is established, none of the three theories can be positively established.

It is quite enough, though, that a suggestion has been made that the final explosion of *our* universe is quite probable. It is enough of an apocalpytic vision to be told that ours is a closed universe in which the comforting principle of infinititude must be sacrificed. While these macrocosmic visions of cataclysmic future events exceed the imaginations of many, they do not go unheeded by the subconscious. Futurity, whether in terms of light years or calendar years, is a double-headed coin, with Dread written large on one side, and Hope on the other. All recent scientific announcements, however, seem to point to the side of Dread.

The third news item, the protest against American intervention

in Santo Domingo, is similar in nature to the continual protests against American intervention in Vietnam. In both instances, the intellectual community is cognizant of its collusion with abusive power and aware of the moral dangers involved. For two years the government had protested its innocence when accused by such eminent individuals as Lord Russell of having used napalm bombs against a civilian population. Suddenly, the government capitulated, releasing cautious stories, bit by bit, of its experimental weaponry in Vietnam. And suddenly, intellectuals old enough to remember were sickened by a terrible repetition: Mussolini's "experimental" bombing in Ethiopia, Franco's war as a "proving ground" for the weapons of the Second World War . . . The events of the 1930s—the dreams and lies scorchingly denounced in Picasso's etchings—were suddenly brought into high relief by the events of the 1960s. However somnolent the intellectual may have been during the postwar prosperity of the 1950s, he was now alarmed, guilt-stricken, desperate. The scandal of death, as Camus called it, was upon him.

No matter how banal the thought that the artist is a man of his time, the fact is that the history of art and literature is filled with statements, more or less eloquent, affirming the artist's sense of being shaped by the epoch in which he performs his art. In some cases, he is not so much shaped as prodded. In many statements there is a distinct impression of the artist's being drawn forcibly forward; to be of one's time is to be reeled in by a future which cannot be evaded. The "time" of an artist makes itself felt, even if only as a tyranny against which the artist reacts. (Much of the artist's concern with myth, for example, may be read as an attempt to go beyond, or avoid the traps of, his own limited and dreadful time.)

Although it is difficult to know how much the epoch impresses itself on the individual artist, it is not as difficult to see its impress on artists within movements. For instance, one wonders how Breton's conception of Surrealism would have evolved had not the terrible events of history intervened. The pressures felt by every sensitive intellectual from the mid-1920s until the fall of France were the cause of strife within, and, ultimately, the dissolution of, the Surrealist movement. Already by 1925 Breton had shifted his revo-

lutionary zeal as an artist into the field of international politics in the publication *The Revolution First and Always*. By 1930, when Mussolini had already indicated to intelligent spectators that the peace of Versailles would never hold, the ranks of the Surrealists were disrupted by the frantic political anxiety. The publication of *Surrealism in the Service of the Revolution* in 1930 marked this distraught condition within the movement.

All through the 1930s Europe sat, paralyzed with anxiety and horror, waiting for the inevitable cataclysm. It was heralded by the war in Spain, which again made tremendous inroads on what was left of the movement. The horrible exhaustion produced by marking time, by the unmistakable moral malaise working on every sensitized psyche, certainly reflects in Surrealist works of the period, and perhaps is responsible for the flaccid condition of painting and sculpture as a whole throughout those years.

In view of the one week summarized in a newspaper—and the dramatic quality of this news could be equaled in many other weeks, in view of the convincing attacks on old cosmologies, on traditional psychology and philosophy, on political folly, the reaction of the artist must be seen, in degrees differing from artist to artist, as a response to his "time."

One popular response to scientific observations that make God impossible has been a cool, rationalistic one on the part of the present young generation. The philosophical speculation of a Gauguin, who wondered who we are, why we are here, and where we are going, has no place in their lives. Rather, they proceed from the logic of a Vasarely: We are here, we are part of a dynamic universe, we must use the means provided by science and technology to enhance our material existence. Continuing the collective Utopian tradition, the young members of the various "research" groups that appeared during the late 1950s and early 1960s proclaim the ascendance of science and scientific method. Directly influenced by Vasarely, the Groupe de Recherche Visuel in Paris, founded in 1960, envisioned nothing less than a social revolution. "Stop Art!" they cried in a 1965 manifesto redolent of Futurist, Constructivist, and De Stijl terms of reference. Art as we have known it, they said, is a tremendous bluff. The only hope for the artist is to fit himself into

"the whole framework." He does this, such groups maintain, by availing himself of the methods of technology, by subsuming his personality in group endeavor, and by recognizing that the spectator—the man on the street, literally—"is able to react with a common means of perception." Denouncing the unique art object, these young artists dream of dressing the city with their collective inventions. Moreover, they wish to change the traditional relationship between the observer and the observed. There must be, hereafter, an "interaction."

This interaction is effected, by the groups following in Vasarely's footsteps, through "kinetic" art: art that "places the artist in a situation that he sets in motion and masters." Accordingly, many of the works of these artists are based on the principles of optical mechanics, in which mathematical forms play upon the eye and induce an immediate, involuntary reaction. In lieu of the old contemplation of the unique work, which involves a psychological set, a will to examine piece by piece and slowly the figured surface, these artists substitute what one of them calls "visual aggression." This can be practiced through stable pieces designed to produce a jumpy optical illusion, or through pieces that are motorized.

The uncompromising position taken by these youths may be seen as a direct repudiation of sentimental bourgeois values, and as a symmetrical response to the kinds of events—Vietnam and Santo Domingo for Americans, Algeria for the French—which seem inevitable in bourgeois democratic systems. It must also be seen as a complete acceptance of the practical sciences of the moment, and, most particularly, of cybernetics. Many artists, both as members of groups and individually, accept the world view sponsored by information theory. In this view, the human being is a model machine through which information passes, is processed, and is then fed back to the world. There is no worry about psyches, depth psychology, and man's tragic position in the world; the soul, as it has always been for rationalists, is a sad fiction maintained by the deluded bourgeois. Thus, the visual "data" provided by kinetic artists is offered to the human cybernetician, who quickly processes it. The pleasures of the activation of his psycho-motor responses are the sole aim of this art.

It is not unreasonable for the young artist to posit his faith in modern tools of science. After all, through the elaborate tools evolved at Mt. Palomar the entire cosmos is questioned. Through the harnessing of radio waves the human mind is opened to scrutiny. Poetic speculation, in view of these technological advances, seems like child's play to the young, constantly exposed to information.

Yet, the questions inherent in the science of cybernetics itself, it becomes increasingly clear, are still the same old questions. Still the same grand old themes. As Dr. W. Grey Walter has pointed out, an unprejudiced scientist working in cybernetics is compelled to re-admit an old philosophical concern, that of teleology. Using the humble water closet as an illustration of the feed-back principle, Dr. Walter points out that "failure of the reflexive mechanism would leave the tank either overflowing or empty; the water level would seem to be the controlled variable and the ball-cock to control it. But the ball-cock is also controlled *by* the water level."[1] In this case, he maintains, the introduction of the question, What then controls what, and for what purpose? is essential. Cause and effect reenter philosophic discussions. Cybernetics—in its broadcast definition, the science of governing—has, he feels, the possibility of resolving philosophical paradoxes, and even of influencing the political destiny of mankind. The outstanding feature of cybernetics is its "inter-disciplinary texture." Because common principles have been found in mathematics, biology, engineering, and many other fields of scientific research, the ultimate fusion of traditionally detached topics is within sight, and with it, a vastly improved image of human nature and the world. Even here, then, the collective tendency is prominent.

Most of the kineticist experiments pertaining to art have yet to broach specifically the classic philosophic questions. Rather, they seem intent on discovering simple general principles and exploiting them in the work of art in the same way the cybernetician makes a "model" to establish a theory beyond his powers of verbal description. Redundant patterns of light reflections in certain plastic reliefs—for instance, a rectangle of raised bars which proceed in monotonous intervals part way across the picture plane and then

sing the optical nerve to jump—seem to represent
principle constructed in a model. The receptors
dy, that is, always respond with the same unit im-
of the stimulus. A stronger stimulus would only
imber of unit impulses. The brain response to any
measure of its novelty or innovation. According to
he mechanisms responsible for distributing signals
to the non-specific brain regions constantly compute the informa-
tion-content of the signals and suppress those that are redundant,
while novel or surprising signals, however small, are transmitted
with amplified intensity."[2]

The artist intending to surround his viewers with stimuli, as the
kineticists profess to do, is most interested in the mechanism which
quickly "computes" out the redundant and gives an intense, light-
ning reaction to the viewer. This attitude toward the experience of
life as a constant stream of "information," of "stimuli" processed
by the brain, is "realistic," in that it does not dally with problematic
considerations. The role of the imagination is no longer ques-
tioned, since it is presumed that physiological process, carefully
studied, will reveal its mechanism: yet there is ample scientific evi-
dence of the contrary. The artist who resists the cybernetic appeal
can find justification in the testimony of numerous brain physiolo-
gists who have determined that "stimuli" and "information" are
only a single aspect of consciousness, that the mysterious workings
of the brain and afferent system often continue creating when
stimuli and information are withheld. Their findings tend to con-
firm Baudelaire's view of the imagination as the queen of the fa-
culties, and Bergson's notion of "powers that are complementary
to the understanding."

Studies of dreaming subjects are of great interest to those con-
cerned with the mystery of the imagination. According to one brain
physiologist and psychiatrist, dream studies may eventually offer
proof that creative cognitive activity can occur independent of ex-
ternal stimuli. He points out that everyone dreams every single
night, and that the brainwaves during dreaming periods are indis-
tinguishable from the brainwave patterns of the person who is
awake, alert, and focusing attention on something either perceived

or imagined. Dream experiments suggest that while dreaming, the brain, though not conscious, is working intensively in cognitive and emotional ways. During this time the brain shuts off sensory input, yet contrives to function cognitively.

The ancients, the Surrealists, and many individual artists throughout history have understood the importance of dreams. Nietzsche spoke of the "deep and happy sense of the necessity of dream experiences," and of "our profound awareness of nature's healing powers during the interval of sleep and dream" long before Freud's hypothesis. The "internal sensations" related to imaginative activity in dreamers, which experimenters have found hard to measure, are strenuously at work. It is possible that the dream is a fabrication of the imagination and that the imagination alone creates the images which are the soul of the work of art.

Repeatedly, scientific experiments of both a psychological and physiological order suggest that the internal experiences of the mind, and the kind of imagery it invents and shapes into works of art, are self-generating at least to some degree. Dogmatic approaches to art which insist on the cybernetic verities, and which do not take into account the numerous indications of internal, originating activity in the nervous systems—both central and reticular—provide only skeletal and impoverished methods of understanding. Man in the world is more than a mechanical receptor, and it is in the "more than" that the mystery of artistic genesis lies.

18

Certainty and Solutions:
Purism in the
Fifties and Sixties

Progressively detached from tradition, the grand line of purist painting renewed itself with a burst of energy during the late 1950s, carrying many of the older assumptions and replacing others. The idea of a painting of "pure visibility" persisted, although definitions of pure visibility varied greatly. In its most common usage, the term pure visibility seems to refer to painting in which the artist's intention is to eliminate any overtones of psychological interpretation, any suggestion of symbol, in order to achieve the purest plastic result.

Increasingly the purist artist takes it for granted that pure visibility is the result of his complete absorption in the basic elements of painting. The younger purist no longer indulges in polemics, but quite simply paints his pictures and expects that through their plastic organization, they will take their place, whatever it may be, in the world. These new paintings are seen matter-of-factly as entities in the world. When their creators take to polemics, it is to divest painting of previous associations and place it in the context of contemporary thought.

An instance is the publication of the "Anonima" group, in which a spokesman flatly states that the new art (for such group endeavors, art is always "new") must be "an art of *things*, a phenomenological art. This is a requirement because it is with things in the world that consciousness deals." He explains that the new artist does not paint pictures of things; he does not devise metaphors of

ideality, like Mondrian, he does not "throw personal fits in the manner of the Action painters," but he constructs. He builds "unique structures of concrete reality."[1]

Although such reasoning, when carried to its extremes, inevitably restores metaphysical speculation—what, after all, is a structure of concrete reality?—it is very often left in its simplicity, and the artist proceeds, confident that he can construct a "thing" which is expressive by virtue of its adequate or well-calculated construction. The nature of such constructions, or paintings, is generally based on the power of color, once it is detached from figurative seeing. In a sense, all painting until the late nineteenth century was tonal. Color was used to enhance perspective, or to establish pictorial rhythms in conjunction with perspective and drawing, but it was rarely used independently. The twentieth century set out to release color from its subordination. The new spaces envisioned by Kandinsky or Delaunay were to be spaces defined chiefly by color. Delaunay saw color as universal light, as something inherently expressive and dynamic. It moves. It moves us, and, above all, in its capacity as light, it can take us into the transparency of a light-filled world, unified, harmonious.

For Vasarely, the dynamic aspects of color were the great lure. By producing movement through the manipulation of color, or, as he prefers to say, color-form, he investigates the complicated experience of seeing, the million possibilities of physiological and physical experiences contained in this one area of investigation. For Josef Albers, the inherently expressive character of color is a vast enough field to encompass his entire life's work. The alchemy of his studio trials is conveyed poetically by means of a simple formula, the square within a square. His countless experiments with complementary colors, with tonal and intensity gradations, resolve themselves in the stately rhythms contained in the ideal, eternally constant format.

But the young artists of the late 1950s have carried the stripping impulse even further. Not a vestige of metaphysics is left over. As an emphatically non-romantic expression, the artists whom Clement Greenberg grouped under the title of "post-painterly abstraction" make no claims for their art other than that it is a vehicle for

the expression of visible movement and activation of the visual sense. Painting is considered by many young purists to be a purely conceptual transaction. The notion of process is disdained. "Painting is a thing of the mind": so much so that certain younger painters, Frank Stella for instance, seek to establish their pictures definitively before they are painted. In other words, they "program" their paintings, which then become, like the cybernetic model, a concrete exemplification of the program.

Although the artists whom Greenberg singled out as the new generation in the late 1950s are not given to polemicizing, their position can be read clearly as a repudiation of the extreme romanticism of the Abstract Expressionist generation. They stand flatly against the metaphorical or analogical interpretation of the world. Their "objects" stand for nothing, interpret nothing; they are, merely, esthetically conceived objects, dealing with spatial experiences and with certain kinds of visual "information." It is sometimes said that Barnett Newman is the admired elder statesman of the group. But Newman's exalted involvement with the pure "idea" of painting, and his concern with the "sublime," swerve over into the area of Abstract Expressionist intoxication, of Nietzschean transport. Newman's "idea" described on the plane surface of his large canvases, divided by a single plane in the form of a narrow band, attaches far more to the tradition of Neo-Plastic metaphysics than to the contemporary rationalist position.

A number of the artists who have been associated with the postpainterly abstractionist tendency, in fact, are not true exponents of the conceptual rigors advocated by Greenberg. The "hard-edge" painter is not always what he seems, and in many cases is a hardy survivor (or a healthy advancer) of certain established twentieth-century traditions, above all the tradition created by Matisse.

What is most viable in the Matisse tradition for the younger artist today is undoubtedly based on his cut-paper paintings, which date back as far as 1939, but which were developed in 1943 in the *Jazz* series. He wrote that to cut directly into color reminded him of the direct carving of sculptors. When he wielded his scissors, he was drawing form out from color as the sculptor draws form out from stone. His idea in this new form, which had little in common

Synthetic polymer paint on canvas, 8′ 3″ x 9′ 1″.
Collection, Mr. & Mrs. Victor W. Ganz, New York.

24. Frank Stella: Tuftonboro I, 1966.

Oil on canvas, 8' 5" x 7' 4".
Collection: Mr. & Mrs. C. Bagley Wright, Seattle; photo, courtesy Sidney Janis Gallery, New York.

25. Ellsworth Kelly: Blue Green Red II, 1965.

with the conventional collage, was the culmination of his original idea of color as an autonomously moving element. Matisse insisted these be called *découpages*, wrote Aragon, because "if the color wasn't brought into the picture with a brush it was prepared none-theless with gouache on sheets of paper."[2] Instead of drawing com-ing before the color, as in painting, and instead of the drawing closing in or preparing the spaces, here the color was painted first, then cut out. By giving precedence to the color in which the scissors draw, Matisse established a new idiom. In his various *découpages* it will be seen that the idea of drawing with color is given a fresh interpretation. The blue gouache paper is chiseled so that the den-sity of the blue and all its nuances extend to the edge, a thing that qualifies its form in the most perfect condensation.

In accomplishing the magical fusion of painting and color, Ma-tisse brought earlier insights to their highest potential. That he was faithful to earlier conceptions can be seen in his *Jazz* essay. In a pas-sage called "My Curves Are Not Mad" he wrote:

> The plumb line in determining the vertical direction forms, with its opposite, the horizontal, the draftsman's point of com-pass. Ingres used a plumb line. See, in his studies of stand-ing figures, this unerased line which passes through the sternum and inner ankle bone of the weight-bearing leg. Around this fictive line the "arabesque" develops. . . . There is something vertical in my spirit. It helps me give my lines a precise direc-tion and in my quick drawings I never indicate a curve, for ex-ample, that of a branch in a landscape, without a conscious-ness of its relationship to the vertical. There is no madness in my curves.[3]

Here, with his allusion still to the arabesque, and with his rigorous sense of the structure of all things, Matisse indicates the depth of reflection backing up his works. The *découpages* are the final re-statement of originality, the final fertilizing inspiration which con-tinues to nourish new fruit in others.

Ellsworth Kelly is a case in point. He developed his "hard-edge" manner in Paris, where echoes of the old concrete tradition could still be detected. With unperturbed independence he was exhibit-ing his bold abstractions in the immediate postwar period, which

was celebrating the Informal, or Abstract Expressionist, move-
ment. His own work, he has said, is not conceived as "hard-edge"
at all. "I'm interested in the mass and color, the black and white.
The edges happen because the forms get as quiet as they can be. I
want the masses to perform."[4] All painting, he maintains, comes
out of painting, and it seems clear to me that his own painting
comes not out of the conceptualist purist tradition, but, rather, from
the modern tradition shaped by Matisse. Matisse, who drew con-
stantly, and whose concern for spaces, not only within the canvas
as a whole, but between forms (think of all the adjustments he
made during the long months he worked on *Dance*), pointed the
way to a simple art of mass and color. It is true that Kelly now uses
highly saturated colors that in juxtaposition create strong tensions
and reactions of the eye. Place a blue and a red of roughly equal
intensity in proximity and invariably the eye is mobilized. Yet, the
predominant impression in Kelly's work is still one of illusion, in
which the artist carefully weighs out shape and color in order to
produce unique spatial experiences.

Vision is not only a matter of the stimulation of optic nerves.
Vision, most physiologists tell us, is quite subjective. The laws of
color do not clarify Kelly's paintings; they have no visible rules.
What *is* visible is Kelly's consummate draftsmanship. Without his
tremendous instinct for shaping various color areas, these paintings
would be little more than skillfully contrived ornamental surfaces.
They are compelling because no single form is inert. When Kelly
paints an elongated oval and rests it in a vertical rectangle, the
curved edges of the oval contain enormous massed energy within.
If that oval is bright orange, sunk into a blue field, it is even more
tautly dynamic. It expresses and symbolizes vitality. When Kelly
places two enormous half-circles back to back—one blue, one grass
green—so that their edges barely touch at a minuscule point, they
are drawn to suggest not flat, quasi-geometric shapes but, rather,
expanding, spherical forms with dynamic interior structures. Seen
in one focus, the dense red field in which they press their shapes
tends to push them back, to flatten them. Seen in another focus, the
red takes its place as a form. If the cliché "negative space" covers
this equivocal and interesting visual situation, let us use it.

Much of the effect of structured, animated form in Kelly's painting is achieved, then, through choice of color. Kelly has unerring instinct. His reds, blues, greens, and oranges are always (or appear to be) mixed; he paints with oil on canvas, and can give a sense of enclosed life by means of the density of his color. It is much richer, more vibrant than any plastic paint could be, and gives a reality to the surface lacking in the shriller synthetic paints. By his invention of pure and eloquent shapes, Kelly controls the energy of his high-keyed colors. If certain compositions strain to the edge and others concentrate on a central void, it is because color is vitally linked with shape. Obviously, color and shape are mutually influential, and so intimately linked that analysis tends to be untruth. Yet, it is important to stress Kelly's interest in illusion of a non-mechanical order. In shaping his ostensibly simple compositions, he is causing a taut, self-contained image to be born, an image that is frankly dependent on the two-dimensional surface of a canvas and the imagination of the viewer who is able to catch the nuances of movement and full shape within. His purism is undeniable, but of a more complicated order than is generally thought.

Morris Louis, on the other hand, was a creature, in terms of both temperament and formation, of the lyrical rather than the purist tradition. The "tragedy" despised by the purists was never far from his thoughts: tragedy as the volatility of forms in the world; as the expression of greatly moving or ominous experience; as the summum of man's supposed inherent *horror vacui*, was written large in Louis' psyche, no matter how cheerful and purely visible certain of his paintings may seem. His initial choice of Pollock as an admired model remained significant even after he abandoned the complicated, tempestuous spaces he had wrought by using Pollock's technique. Louis' own process of stripping consisted in taking those ambiguous and continuous spaces and making them the vital subject in his paintings. The ribbons of saturated color falling like curtains on either side of an enormous stage are not mere color determinations; they are there only to insist that the full sensation, the full breathtaking vacuum of the central image, be grasped. In this, Louis is closer to Clyfford Still than to any constructivist or purist painter. Even when he narrowed his canvas and slid closely

articulated, brilliantly colored stripes down the central surface, it was to say something about those empty spaces and how they can move, in two senses: move the viewer, and move within an imaginary realm.

It would be impossible to see Louis' paintings as purely conceptual. There is too much organic evidence on their surface. The veils of color, moving like the smoke from a faraway cataclysm, are enough of a reminder of metaphorical association to keep Louis' work from the cool detachment of the real purist. If, as Greenberg insists, Louis was not interested in symbol, his temperament and background nevertheless endowed his work with symbolic overtones.

Kenneth Noland, who was closely allied with Louis in their early experiments in Washington, is far closer to the conceptualist ideal posited by Greenberg. He had accepted the reductions effected by Pollock, and early attempted to inject rigor into his stained canvases. Though for a time he maintained the inconsistent edges typical of the lyrical painter, his impulse was to clarify the articulation of color and void. His early targets, with their rainbow-stained, wavering circles, were experiments in unorthodox equilibrium, an equilibrium precariously maintained. From this stage, Noland's painting went in the direction of the "dynamic equilibrium" of which Mondrian had spoken: an equilibrium effected by the allocation of colors on the plane which, although they moved energetically, eventually formed a whole.

Noland's "stripping" consisted in opening the plane in order that his injunctions might be followed beyond the canvas by the viewer. In other words, a singing yellow or scarlet band is offered as a "datum" which the eye processes. This information—yellow shooting east or west on a white surface—cannot be avoided, for everything conspires to direct the viewer's single response in a single apprehension. In this painting, the pleasure in number is apparent. Noland has succeeded in divesting his paintings of overtones, and depends completely on the distribution of color notes, on the intervals between them, for esthetic effect. He measures out his intervals as would a composer.

Still younger than Noland is a generation that aggressively insists

upon its "cool" detachment, its objectivity, and its right to use mechanical illusion. Their interest in pre-conception is dogmatic, and their use of cause and effect techniques, ironic. The artist manipulating the chemistry of complementary colors knows beforehand that if you put a red next to a green, they both will jump, as will the spectator. This in itself is an anti-romantic approach, since the concern with the unforeseen preoccupying the generation of Bergson, and of Miró, is minimized greatly. Following the old injunction for reduction, the young artists start again at zero point, but somewhere else in the cosmos. Malevich is far from the thought of these young purists. Yet, in their dependence on what Barbara Rose calls "the primacy of color," they too emerge from the mainstream of purism, and even from Matisse and Delaunay and Kandinsky.

According to Miss Rose, who is of their generation, and their first plausible critic, these young artists "eschew image or symbolical allusion for pure, non-gestural chromatic abstraction."[5] Her diction in describing their works is at times oddly vernacular. One artist's paintings, for instance, are like "streamlined fast cars," and the colors are "jazzy." But her analysis of their aims is sober and professionally historical, and is worth summarizing. She sees a "new kind of all-over composition," in which identical, usually geometric, motifs are repeated over the entire surface of the canvas. The canvas is conceived as either a limitless field or an object. "When the object quality of the painting is paramount, then edges assume primary importance." The picture space, she says, is conceived as a screen onto which two-dimensional forms are projected: a space "with no illusionism, no detaching, advancing or receding of planes, no overlapping." (This of course is an old purist criterion.)

The present-day purists use a non-tactile, non-painterly technique. While this may be traditionally related to geometric abstraction, Miss Rose sees it more as the result of Pollock's gesture, which made the paint brush superfluous. The tradition of "hand-painting" is over. The kinds of precision sought by her artists, who mostly work with compass and ruler, is not purely mechanical, though, but leaves some margin for human error. Conspicuous

among the ideals she outlines is the conceptual approach mentioned above, according to which the idea exists before the actual painting. She recalls the work of Ad Reinhardt, in which preconceived idea is an absolute guide to final execution. The main thing is that the "relativity of relational painting" be avoided.

Characterizing the "new art," Miss Rose calls it "uningratiating, unsentimental, unbiographical and not open to interpretation." The artist who strives "for the immediate impact of an image that comes across whole rather than as a series of related parts hierarchically ordered." (Baudelaire had already stipulated paintings whose complete significance should be grasped before the details.) She consistently implies that this new art is an aggressive assault on the slippery relativism of the art that came just before it. "Order, logic, coherence, system, repetition, internal necessity and perhaps what one might term a Calvinistic sense of conceptual predestination are common to the new abstract painting."

In practice, painting characterized as unsentimental, unbiographical, not open to interpretation, is sufficiently stripped to be instantaneously perceived and often quickly dismissed. The optical illusion practiced by Larry Poons *is* a form of illusion, true, but not a nourishing form; it does what Miss Rose says it sets out to do, and in so doing expends itself finally and absolutely as an object of esthetic contemplation. The distancing intended to create a detached art, as impersonal as possible, succeeds in pushing off the spectator.

Swiftly as moods change in contemporary art, the essential impersonality of the younger painters of the 1960s is borne out even in the work of so adventurous a painter as Frank Stella. After the initial rigors of his rectangle-within-rectangle schema and the experiments with unrhyming color, still within a rectilinear format, Stella moved toward another emphasis: that of stressing the "objectness" of his picture by giving it a shape. Once this attitude was clearly enunciated, Stella played with the possible illusions within his object. He repeated by means of painting the shape within the canvas, and he extrapolated many possible witticisms based on the nature of his object, or, rather, of its shape. Once this loosened approach was begun, the schemata of his earlier work were no longer possible. At length, in a logical way, Stella plunged into a

coldly governed dialogue with anarchy. The colors in his shaped canvases were heightened, but made still less relative. The interior forms were broken and reassembled, avoiding any overall law, but indicating an awareness of its ultimate necessity. The fertile imagination at work here calls up interesting and often interconnected forms, but never permits them to mean anything other than the immediate fact of their pictorial liveliness. In a way, he has reached the position of the Abstract Expressionists via his own puritanical purism. But unlike them he has preserved his detachment intact, as a matter of principle.

Such detachment was, in a sense, implicit in the evolution of purist painting. Malevich's pioneer essay contains illustrations of the various "environments" that stimulate painters. The reality that stimulates the Academician was illustrated by plough horses, hunting dogs, peasant families, and an accordionist. The Futurist was inspired by zeppelins, boatyards, girders, and criss-crossing searchlights. The Suprematist, however, was inspired by a distant aerial view, a world of bridges seen from great distances, city-plans, rivers, and airplanes in a sky without horizon. Everything was seen as remote, detached, in the large and public places in which the individual, the world of intimate detail are absolutely submerged.

The tendency of emblematic painters—an emblem being the visible symbol of an idea—is to protract their ideas serially, making only minor modifications. Eventually, the idea loses its interior energy and reads more like a device. The difference between an emblem and a device is only slight, but important: a device represents the next step, in which the idea has been simplified, made more tractable and more practical for repetition. The word "design" appears in the dictionary definition of "device," but is absent from the definition of "emblem."

The devices of many younger generation painters are clearly related to information, to the wide diffusion, in stark and simple terms, of visual data. By the brightness of color, achieved by using new plastic paints, distinctness of shape, or speed of optical effects, the painter of the device assures his work quick reception. He also reaches toward the goal posed so loftily by Vasarely, which is to move out of the confines of dwellings and museums into the public spaces of collective life.

19

All Is in the Regard

Many years ago Hans Arp wrote that he wished to "cure human beings of the raging madness of genius and return them to their rightful place in nature."[1] The raging madness, epitomized in the nineteenth-century apotheosis of individualism, is frequently denounced by twentieth-century artists who came to believe that man was no longer the center around whom everything revolved. Anthropomorphic habits of mind, along with other habits inherited from the previous century, were challenged repeatedly by artists seeking a new image of the universe.

The protest of Arp was still a humanist reaction, in that he assumed that man *had* a rightful place in nature. More recent reactions registered by younger artists make no presumption of a specific "nature" and are not concerned with man's "place." On the contrary, in the polemics of the new purists, nature as conventionally conceived doesn't enter at all. Since nature was one of the major concerns of the Romantics, and since the surge of anti-Romanticism is concentrated on the exclusion of every concern associated with Romantic individualism, nature is simply dropped as an unnecessary hypothesis.

How far beyond Arp's still essentially humanist vision the new anti-Romantics go is illustrated to perfection in the critical writings of Alain Robbe-Grillet. In his essays of the late 1950s, the voice of an extremely irritated young man is heard behind the scene, exorcising the giants of his youth, casting off in succession the spells

of Nietzsche (for his tremendous exposition of the power of tragedy), Baudelaire (for his symbolism and doctrine of analogy), Rimbaud (for his mysticism), Dostoyevsky (for his psychologism), and Camus and Sartre for their subjectivism. In 1957, he ascribes to his generation "a growing repugnance for visceral, analogical, and incantatory" diction. He shares with the purists in the visual arts a violent distaste for Romantic ambiguity and the convolutions of psychology. Like them he posits a non-transitive, non-metaphorical art of things-in-the-world in which the de-emphasis of self, or what Maurice Blanchot has brilliantly isolated as the "passion of indifference," is the supreme goal.

For Robbe-Grillet, all is in the regard. But the essence of his esthetic is expressed in a single phrase: Man looks at the world and the world doesn't return his gaze. All of his intellectual fury is directed against the Romantic assumption that things take on qualities only as they are perceived by a sensitive individual. It is revealing that when he wishes to destroy the remnants of anthropomorphic or "analogical" diction in modern literature, he takes as an example the description of Mont Blanc. His is a diametrically opposite reaction to the assumption of mystical unity between nature and man as epitomized in the Shelley poem (to which, however, he does not allude). Adjectives such as majestic, magnificent, heroic, noble, proud, sad, and others customarily attached to a landscape such as Shelley contemplated are despicable projections of the individual, he feels, and have no objective meaning. Robbe-Grillet reacts so strongly to anthropomorphic analogies that he calls a landscape so described "contaminated," and suggests that once you admit that a mountain can have human qualities of majesty or nobility, or that a sun can be "pitiless," you can admit anything, and there are no limits to the nonsense that ensues.

The diction of Robbe-Grillet's articles, when examined closely, is the diction of the stubbornly righteous man. The word "deceptive" appears frequently, most often applied to writers that persist in metaphorical approaches. His determined dryness, his dogged insistence that "things are things and man is only man" lead him to the kind of axiomatic pedantry so evident in writings of purists in any art. The invisible enemy, for Robbe-Grillet and many young

artists of his generation, is the metaphysician seeking an impossible ideal of unity. Let us take things as they are, they say, separate, unrelated, merely there. The "abstract beyond" does not exist, and there can be no underlying unity to be presented to man's regard; and if it cannot be present to the regard, it cannot be talked about. Metaphysics, for Robbe-Grillet, whose puritanism is extraordinary, is another of those "deceiving" humanist exercises that obscure the truth. The truth, as he sees it, is that "something exists in the world that is not man, that addresses no sign to him, that has nothing in common with him."[2] The "something" inevitably turns out to be the universe of objects (he has said elsewhere that he likes "dry and hard objects") that can be rendered in crisp, factual, descriptive terms free of all emotive color. These objects are opaque, and, above all, they have no meaningful interiors. They are detached from the myth of "nature," and free of man's arrogant aspirations to grandeur. "To refuse our pretended 'nature' and the vocabulary that perpetuates the myth, to pose objects as purely exterior and superficial is not—as they [critics] have said—to deny man; but it is to push away the 'pananthropic' idea in traditional humanism."[3]

After denying the conventional view of external nature, Robbe-Grillet goes on to present his determinedly impersonal view of man's nature. There is no human nature, in his view. Since things are only things and man is only man, it is ridiculous to insist on the tragedy of man's condition. In speaking of tragedy, Robbe-Grillet adopts a tone reminiscent of Mondrian. He prefaces his essay "Nature, Humanism and Tragedy" with a quotation from Roland Barthes:

> Tragedy is only a way of harvesting human misery, of subsuming it, thus of justifying it under the form of a necessity, of a wisdom, of a purification: to refuse this recovery and to seek the technical means of not traitorously succumbing (nothing is more insidious than tragedy) is a necessary enterprise today.

Here, Robbe-Grillet not only seeks to negate the potent lingering influence of Nietzsche, whom he doesn't mention, but also to slap back at the Existentialists, and more particularly at Jean-Paul Sartre. His indirect resentment of Sartre's viewpoint is evident in one

of his examples, the case of the notion of "solitude." I call, Sartre says, and no one answers. I conclude *not* that there is simply no one there, but that someone doesn't want to answer. "The silence that follows my call, then, is not a *real* silence; it is charged with a content, a depth, a soul."[4] The tragedy created in this situation is, in Robbe-Grillet's view, a false sentimentalism.

Another example illustrates his view more emphatically: Take a man and his hammer, he says. While the man uses it, the hammer is only form and matter. When he is not using it, the hammer is only a thing among other things. "Beyond its use, it has no significance." This lack of significance he says is no longer felt as a lack, a "laceration." The man of today, he says, refuses communion with things, and therefore refuses tragedy. But what would Robbe-Grillet say to the man who goes to select a hammer? A man who holds twenty seemingly similar hammers in his hand in order to select the one that "feels" right? Why does the carpenter select one hammer over another seemingly identical hammer? Why does the workman cherish his tools, even caress them? Not only because they fit a practical need. It is obvious that the objects a workman prizes have a significance—perhaps an esthetic significance—which goes beyond their strictly defined purpose of utility.

To admit such a significance is in Robbe-Grillet's view an anachronism. It leads to subjective, emotional, nonverifiable literature saturated with tragedy of a false kind. His impatience with reflective or analogical literature is almost hysterical: "Everywhere a distance, a separation, a doubling, a cleavage"—these are to him the distasteful remnants of nineteenth-century anthropomorphism. Literature, he says again and again, is "contaminated" by the "double," by the "equivocal." (Both are words that appear regularly in Baudelaire and later in the Symbolists.) "Drowned in the depths of things, man finishes by not seeing them."[5] In order to see them, the writer must strip his language to the barest notation of superficial characteristics. For himself, Robbe-Grillet only wants to register the distances between the object and the I, or between the objects alone, and to insist that these are *only* distances, without any values attached to them. Opaque objects must remain opaque. There is no "profound" nature.

Robbe-Grillet's rebellion is directed first against his immediate

background, the postwar background of Existentialism. The Existentialist's assumption of tragedy, his choice of death rather than hope as the great philosophic touchstone, is considered an artificial choice. He, the young writer, will test another possibility: the possibility that anxiety is nothing but a capricious invention kept alive by sentimental mechanical habits. He forges his style in direct opposition to the pervasive influence of Heideggerian pathos. In resisting the reverberations of Heidegger, felt through the works of his admirers, Robbe-Grillet draws his polemic strength. What Emmanuel Levinas has called Heidegger's great transformation, which "consisted in retrieving those thoughts which may be called 'pathetic' disseminated over the length and breadth of history," is passionately rejected. In its stead Robbe-Grillet adopts the tough, objective tone of the realist.

In Robbe-Grillet's views there are obvious kinships with the views of the purists in the visual arts. His concern with pure information, unsullied by subjective association, is not substantially different from the concerns of Vasarely and some younger artists. Moreover, in a paradoxical way, Robbe-Grillet leans toward the visual artist, seeking a freedom he imagines has been attained by the twentieth-century painter. When he speaks of the autonomy of a work of art, and insists that its reality resides in its form, he speaks from a knowledge gained through the painters. Like them, he wishes to divest his writing of "added" values, above all, of the values added by the freely associating, metaphorical mind. For the notion of communion, he, like certain painters, substitutes the notion of communication.

His critical position has often been linked with that of the Structuralists. He admires Roland Barthes, but he lacks the flexibility apparent in Barthes' explanations of Structuralism. Barthes appears to be extending earlier theories of form and function rather than shunning the insights of previous artists and critics, while Robbe-Grillet tries to effect a stern cutoff point in his references, almost never conceding a past for his views.

Barthes may be seen as taking the ideas of dynamic function expressed by many artists in the past and making them plausible for our own period, with its new areas of speculation, such as informa-

tion theory. He suggests, for instance, that the structural work of art is not an impression of an object, but, rather, a homologue. Although the Structuralists give special emphasis to this esthetic view, it has appeared in the past in almost the same shape. When Coleridge spoke of a "companionable form," when Klee spoke of a "prehistory of the visible," when Kandinsky claimed to paint his intuitions of the forces of the universe (a structure homologous to the world as he experienced it), when Pound eliminated analogy, and when certain Purists spoke of "parallel structures," Barthes' Structuralism was prefigured. The emphasis on "function" and "structure" itself appears early in the century, at the moment that philosophy and science took man out of the center of the universe and made him a unit among a vast network of interconnected units, or of interpenetrating forces.

Barthes' Structuralism is, as he insists, an *activity*, not a method. This implies that it is a way of apprehending the world, a philosophic orientation against which Robbe-Grillet would no doubt protest. Barthes talks of the *exercise* of structure by Structuralist man (much as Breton congratulates his friend for speaking Surrealism). He defines Structuralist man by the way he experiences structure in his mind. The artist, he says, takes the real object, decomposes and then recomposes it, with the intention of revealing the rules that govern not the composition but the function of this object. The artists's Structuralist activity does not render an impression of the real world but, rather, creates another world resembling it, and thus makes the real world more intelligible. Such activity naturally admits of abstract painting, in which the artist is structuring an imagined world, and at the same time defining its functions. It doesn't matter if we begin with a real object in the real world, or an imagined one—the rules of function still obtain in a work of art.

Barthes, being not so exclusive as Robbe-Grillet, qualifies his approach by saying that structuralism can be thought of as a new poetics that is not so much interested in assigning complete meanings as in finding out how meaning is possible. He says that the fabrication of meaning—the tireless and timeless efforts of artists and intellectuals to analyze the real world—is more important

than the meanings themselves. This, in different words and tone, is a repetition of the idea that the process is more important than the product.[6] While Robbe-Grillet might in theory agree with Barthes, his own endeavor is more concerned with the expulsion of the problem of meaning in an effort to define his forms with certitude. Barthes' more traditional conception of the organism that is the work of art allows for little certitude, and is the richer for it.

Robbe-Grillet's discourse opens in two directions that are precisely parallel to directions in the plastic arts. The one is the purist reduction in form, which makes no claims to significance other than the significance of the visible. The other is the pronounced interest in objects as equal to man in the world; as independent, opaque furnishings that must be invested with no meaning other than that which they derive from displacing a certain amount of space, and that are either useful or useless to the observer.

20

Furnishing an Objective World

If I look around me as I work, I see a glass of pencils, a wooden table, a parquet floor with burns and scars, a window with a broken latch, a sheaf of letters, some books scattered on a couch.

If I am thinking of writing a letter, these objects leave my field of consciousness. But they might, at any time, reenter. At such a moment, I might contemplate the brown recesses in the ocher parquet, and remember my distress when the electric heater scorched the wood. Or I might remember the tempest during which the window threatened to tear itself away from the house because of the broken latch. The letters would recall to me their senders, and the books might lead me to Brazilian jungles.

If, by chance, I stopped to contemplate the nature of these objects, I might then engage in speculation having to do with distance, relationships of solids, utility, or strangeness. Intimate focus always produces a sense of strangeness. What I do with these speculations is certainly conditioned by overheard fragments in newspapers and magazines, perhaps even in philosophical or technical books, concerning the nature of the universe and the ultimate composition of its furnishings, organic and inorganic.

I could, on the one hand, think of Merleau-Ponty, whose wide lens focuses on man's seeing and on his seeing himself as seeing; whose concept of vision opens myriad possibilities for enlarging the basic notion of correspondences; for whom objects have a vast reflexive possibility; and for whom all in the world—man and

thing alike—is transitive. Or I could think of Ionesco, for whom objects are massive obstacles around which his thoughts cannot pass. His "new tenant," entombed, finally, by enormous wardrobes, is a victim of insuperable material obstacles capable of destroying physical and spiritual life at the same time. I could return to the nightmare of Kandinsky, a world in which objects disintegrate into miniscule, invisible particles, and from there go back to Plato, reducing each object to its numerical sum total; or go forward to modern microphysics, and learn of the tense pitched battles amongst galaxies of infinitesimal particles as they seek to establish equilibrium.

In short, my view of objects, once it becomes conscious, is a view formed not only by the matter-of-fact encounter with "opaque" things but by an encounter with many other views of objects. The pencil, the window, the book—all things made by man, and therefore, in some measure, a projection of his self—are at once things and signals to my imagination.

It is a truism that to the painter, this was always so. The old masters were as much preoccupied with the mysterious presence of objects as the modern painters and sculptors. Very often a Renaissance painter used carefully studied objects as foils against which the fantasy of a human tableau might unfold. Sketchbooks throughout the history of Western art are filled with painstaking studies of objects. When the Maître de Flémalle places his musing Virgin in a room in which a series of isolated, carefully detailed objects circulate, he speculates plastically: this human figure, this spirit about to have an enormous emotional experience—the Annunciation—is far from and yet near to man-made objects. They at once put her into relief and locate her in the picture space. The vase of flowers on the uptilted table is the pivot for a series of detailed images. A crisply folded white towel, the polished metal candle sconces, the leaded windows are both near and far from her, a part of her (perhaps she herself polished the brasses) and yet distinct from her, beautiful in their isolation. Even her voluminous skirt, billowing out to form a semicircle, is at once a part of her and an independent, fascinating plastic substance with a life of its own—a life descried by the artist. In a great banquet scene of a

Acrylic on canvas, 7′ 6½″ x 11′ 8¼″.
Courtesy, André Emmerich Gallery, New York.

26. Morris Louis: Curtain, 1958.

Oil on canvas, 3' 0" x 2' 8".
Collection of the artist.

Stephen Greene: One — One — Three, 1965.

28. Robert Campin (The Master of Flémalle): Triptych (The Campin Altarpiece), 1420-30.

Oil on wood: central panel 2′ 1 3/16″ x 2′ 7/8″; side panels 2′ 1 3/8″ x 10 3/4″.
The Cloisters Collection, The Metropolitan Museum of Art, New York.

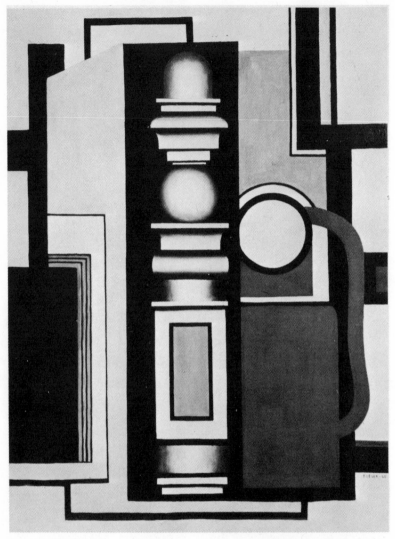

Oil on canvas, 4′ 3″ x 3′ 1½″.
Courtesy, Sidney Janis Gallery, New York.

29. Fernand Léger: Composition, 1925.

Tintoretto or Veronese, the verisimilitude of a Mantuan roll, a copper jug, a dish of fruit contrasts with the wild fantasy of human movement, of swirling drapes and tilted tables. Instinctively the painter speculates on the position of objects vis-à-vis the human presence; he did so long before the still life became an independent genre.

These complex relationships between the artist and the objects he draws into his universe were well understood by Marcel Proust, who wrote about Chardin's modest scenes of daily life:

> Into these rooms where you see nothing but a representation of other people's limited minds and the reflection of your own boredom, Chardin enters as does the light, giving its color to everything, conjuring up from the timeless obscurity where they lay entombed all nature's creatures, animate and inanimate, together with the meaning of her design, so brilliant to the eye, so dark to the understanding.[1]

That objects have certain magical properties as stimulants to the eye and mind was known to the bodegonistas as well as to Chardin; to the Flemish little masters as well as to Juan Gris; to both the Roman muralists and Magritte. Yet, the relationships change constantly. The painter does not discover new information about his world, he discovers his world. When Matisse paints the awning of a French Riviera window as though it were equal to the striped dress of his almost faceless model, he discovers his world as a world of warm equality among things, a world of infinite relationships. When Bonnard places a woman amongst the bric-a-brac of her boudoir, her hand is no more significant than her powder box, for everything is equally significant in a harmoniously closed vision of a universe.

Léger, on the other hand, discovers his world in the kind of "dry and hard objects" preferred by Robbe-Grillet. An umbrella, a piece of architecture, an artichoke, a length of rope, a ladder are seen in the dry light of their most salient outlines. Yet they are rendered in terms of equality with the presence of the human being, and they are considered as spatially related entities at all times. Far from departing from nature, Maurice Raynal remarks, Léger assigns it a

new role. "The object, for him, is no longer an ensemble of in-
animate forms, but an aggregate of living cells that animate
space."[2] The animation of his spaces, then, was to assume major
importance to Léger, who eventually, in his doctrine of New Real-
ism, sought to illuminate his spaces by means of unusual relation-
ships among objects. The human being and the ladder then would
be scaled down, while the rope would become gigantic and the egg-
plant would swell to mammoth proportions. Léger's new relativism,
in his last works, was an extension of that original vision of objects
launched in the first decade of the century, of objects animated
from within by their boundless energy. As mechanical as Léger's
forms seem, his esthetic is firmly rooted in the organic tradition.

In view of the dynamic concept of energy, the Cubist interest in
the object as a "certitude" is understandable. Picasso told Marius
de Zayas that painting inevitably depends on illusion but if, for in-
stance, you paint a sculpture pink, the pink remains pink. At times
weary of the painting paradox, Picasso turned to the object as a
"certitude," as a solid reality which, despite his inventive treat-
ment, remained intransigently present as an object. The guitar, the
absinthe glass, the owl, which had been offered in painterly illusion,
all found their way into three dimensions.

For the Dadaist, the object retained something of its Cubist cer-
titude. When Schwitters applied kirschwasser labels in a collage,
they functioned in much the same way as the Cubist labels, but
when he built his Merzbau in Hanover, the architecture itself be-
came a chaos of crazily juxtaposed objects vying for spatial suprem-
acy; the room itself became an object, seen from the inside out,
with complicated angles, curves, and tilted rectangles pressing out-
ward to the invisible rind. Ionesco's nightmare and Schwitters'
fantasy are not dissimilar.

For the Surrealist, the object becomes talismanic, evocative, mag-
ically transitive. Oddly enough, Breton also wrote from a distaste
for the kind of naturalistic nineteenth-century fiction which Robbe-
Grillet protests. But Breton's opposition leads him away from
"utilitarian realism" to the marvelous. His interest in the object, as
he explained in 1936 in an essay, "Crisis of the Object," is in its
"latencies." In other words, in the very associational properties

that irritate Robbe-Grillet so much. Objects became so important to the Surrealists that they were able to list scores of objects, appropriated by the Surrealist spirit (natural, mathematical, poetic, etc.), in their reviews. Dali wrote in 1931:

> Objects, endowed with a minimum of mechanical function are based on ghostly fancies and are provoked by unconscious acts. . . . Objects with symbolical function leave no loophole for formal preoccupations. Only amorous imagination is responsible for them and they are extra-plastic.[3]

Whether dealing with the painting as an independent object, as is the case with the purist or formal strain in modern art, or with the object itself as an "extra-plastic" symbol, as is the case with the Dadaist and Surrealist, and, more recently, the Pop artist; or dealing with the object as congealed energy, as in the case with the organic abstract painter, the twentieth-century artist is preoccupied with defining the object and its relationship to the human subject. Robbe-Grillet's materialism versus Francis Ponge's animism is only a minor argument in the major stream of speculation concerning the nature of an object. (It is interesting to follow the attack on Ponge, a poet much admired by painters for his articulation of matter: Robbe-Grillet in his enfant-terrible voice petulantly insists that "to say Ponge speaks *for* things, *with* things, in their *heart* is to deny their reality, their opaque presences.")[4]

Inevitably, the fate of figure painting has been affected by persistent speculation about objects in relation to individual consciousness. Most of the younger artists engaged in painting nudes, for instance, paint them in a harsh light, articulating their limbs as though they were objects. Often they truncate the composition so that the face or the gesturing hand is cut off. The face, traditionally, suggests the meaning of the painting in its expression. This tradition, controverted by Matisse when he insisted that the whole provides the expression, not just the face or a random gesture, seems to be eclipsed by the new tradition of the figure as an object equal to any other.

Matisse's view probably influenced Richard Diebenkorn, for instance. When Diebenkorn paints a figure, it is invariably in a spe-

cific context—room or landscape—which is described summarily. The figure itself takes its place in the context, but is not specifically emphasized. Diebenkorn rarely indicates the character of his model. There are no facial details that can be interpreted, nor are there salient gestures. His models are objects seen in a universe of objects, moving amongst them, or merely placed amongst them, but not in any significant way superior to them. He denies his human models the animation which would differentiate them.

Diebenkorn's bland indifference to specific characteristics and personality in his sitters is clearly intentional, a serious statement of our changed relationship to things within the tradition of figure painting. Yves Klein, who rolled a nude in blue paint and then impressed her on a canvas, makes a gesture of finality. The thing which is the person meets the thing which is the canvas, and another object results. Reductio ad absurdum. In a successful fusion of figurative and abstract painting, Richard Lindner also reduces his subjects to objectlike hardness. His brittle surfaces shape the subjects of his paintings into patterns of dense, stonelike materials. The thigh of a taxi-hall dancer is as impermeable and dentproof as the equipment of a weight lifter. Lindner's unique vision deals with the figures as objects, but they are objects in a declared fantasy world, in which everything is equally improbable and equally menacing. The objects, then, are not cast in either a subjective or objective mode, but are symbolic. Because of this consistency, Lindner escapes the dilemma and the failure of many younger artists attempting to deal with the human as object.

As soon as the idea of the *peinture-objet* or *sculpture-objet* appeared, in the first decades of the twentieth century, it dispersed itself in countless directions. From the Surrealist concern with "primary matter" a painter such as Antoní Tàpies developed a painting vocabulary in which the materials themselves—sand and paste— were expressed. On his vast surfaces of biscuit-colored sands Tàpies scores equivocal marks; the presence of a man is seen in rare signs, while his environment, the rude matter from which he draws his survival, is of primary importance. When Tàpies wants to speak of his obsessions with the hieroglyphs nature conceals, and with man's eternal effort to wrest the secrets of the earth and

write them down, he can express himself explicitly in the sand-and-paste medium he has perfected. His cryptology is not lighthearted; if he makes a huge square of natural-color sand and incises into it a few stitchlike marks, this can be read as an allusion to the act of writing on the sands of time. The incisions are not ornamental, not mere tricks of manipulating materials; they are messages. Yet, each painting, with its freight of heavy matter, is in itself a massive object, not content to impress only with its allusive potential.

Jasper Johns still remains interested in painterly paradox—this is paint, but it is also something else—but the presence of the object in his consciousness is commanding. His paintings are conceived as objects among others in the world, but their thing-ness is not enough; he must stress his definitions, and make his paradox acute. Thus, he hangs a spoon or a cup from the top of his stretcher, or he chains a bench to a floor-length painting. By bringing together the plastic and the extra-plastic, Johns partakes of the troubled discourse shaping recent art.

Much of what has been said of his work derives from speculation about his intention. Critics explain that he wants to dissociate objects from their usual symbolic connotations, that he wants to "avoid the determination of meaning," that he wants to "put the work of art into a kind of pure condition, isolated in its own terms and removed from the artist, from his needs, from his own failings."[5] All writers have been forced to deal with Johns' repeated introduction of the concrete object. In one of his most successful fusions of painting with a concrete object. *4 the News*, Johns combined four horizontal painted panels, two of which are slightly parted to admit a tightly rolled newspaper. Here, the luminous brush strokes, the shimmering sequence of tiny echoing tones, is contrasted with the tightness, the taut narrowness of the slit with its imprisoned object. So deftly does Johns intrude the real into the illusion that the eye and imagination immediately fuse them into a single stirring image removed from the "real," or so-called objective, world, by their unusual marriage.

Robert Rauschenberg's pretext of objectivity is expressed in his insistence that he takes the world as it is and that "there is more in the world than paint."[6] He reacts against the metaphysical tend-

ency of his Abstract Expressionist progenitors by a faintly mock-
ing technique of juxtaposition. His friend John Cage's idea of the
role of chance fits very well into Rauschenberg's vision of an urban
world crowded with things. "We initiate an experience," says Cage.
Beyond placing things and representations of things in rapport,
Rauschenberg denies any other function for his works. From his
idea of building a bridge between art and life—an idea expressed
in most elementary terms—a whole generation of would-be artists
takes heart. If art and life are composed of much the same objects,
then all the discourse surrounding art is for naught; the object will
initiate an experience without much help from the artist.

However the objects in so-called Pop Art are seen, they are part
of a sustained polemic against the confines of a framed, two-dimen-
sional world. The urge to move out into other spaces, to fill up in-
different spaces with dense things, is not confined to the sculptor.
The painter and sculptor merge in an assault on conventional per-
spectives, and hybrid work is undertaken increasingly often. A case
in point is the work of George Segal, usually considered a sculp-
tor, but in many ways a painter. Segal resorts to the *tableau-vivant*
principle, although his tableaux are deliberately cast in a deathly
rather than a vital mood. His plaster figures are immobilized in
realistic settings—a kitchen cluttered with dishes, an obscure hall-
way of a tenement, a bus. Obviously these quasi-waxwork figures,
often taken from life casts, raise eternal questions concerning ap-
pearance and reality. Schopenhauer's speculations are not beside
the point here. In "The Metaphysics of Fine Art," he argued that as
"a work of art is some objective reality as it appears after it has
passed through a subject," the objective reality must exist in its
form, or idea, alone.

> It is, therefore, *essential* to a work of art that it should give
> the form alone without the matter; and further, that it should
> do so without any possibility of mistake on the part of the spec-
> tator. This is really the reason why wax figures produce no
> esthetic impression, and therefore are not, in the esthetic sense,
> works of art at all; although if they were well made, they pro-
> duce an illusion a hundred times greater than the best picture
> or statue could effect; so that if deceptive imitation of reality

were the object of art, they would have to take the first place. For the wax figure of a man appears to give not only the mere form but with it the matter as well, so that it produces the illusion that the man himself is standing before you.

But, as a man lives once and once only, and art goes beyond the particular, Schopenhauer says, the waxwork figure in the end is only like a corpse.

Segal is still a "subject," through which objective reality appears. His figures, posed in real-life situations, are generally modified enough to escape the charge of waxwork verisimilitude. The contrast between real things—dishes, cafe tables, cinema marquees—that have not been modified by a subject and human figures is a willed paradox. In the narrow margin between, Segal finds his expressive vehicle. Since his "sculptures" cannot exist without their realistic environments, his "form" verges on theater. The tableau absolutely requires its setting, and that setting must be composed of objects which inspire the least amount of allegorical response. His is a literal illustration of the phenomenologist's idea of man among and with things.

The ambiguous hypernaturalism of Segal's tableaux is matched by a new kind of theater in which objects, again, are essential. Such theater was proposed by Julian Beck and his wife, Judith Malina, in several productions, the most notable among them *The Brig*. This is a grim, naturalistic representation of life in a Marine prison. The stage is covered with a real wire pen and real prison furniture. In this confined set, ten prisoners are bullied, tortured, and taunted by four jailers from 4:30 A.M. until nightfall—a constant, tedious, and scarcely differentiated round of savage pummeling and noise. Out of the shouting ("Sir, Prisoner Number Five requests permission to cross the white line, Sir!") and dog-trotting movements emerges an absurd opera complete with choreography. Not lines but cues from the Marine manual provide the operatic chorus. In this play, the authors use exaggerated naturalism until it verges on fantasy. The vision of objects as they are in Marine life, and of men as they are treated as objects, raises the same philosophical questions implicit in a style such as Segal's. The slice-of-life concept of theater is rendered absurd by the absurdity of veracity.

In theater, the effort to break convention in the twentieth century has gone through many phases (Apollinaire and Kandinsky both wrote of their concepts of a chaotic freedom on stage). Perhaps the strongest and most disconcerting influence on avant-garde theater was Antonin Artaud. The Becks, for instance, in their strong anti-bourgeois passion, aim toward Artaud's concept of non-literary theater, theater that makes the audience feel rather than think. Emphasis on feeling, rather than on reason, is apparent in many other forms of object-focusing, and is perhaps the raison d'être of the grotesque giant hamburgers and vinyl toilets created by Claes Oldenburg and the disordered bed of Rauschenberg, with its cargo of dirty linen propped vertically against the wall, things among the many things of the world.

Mixed media on canvas, 3′ 0″ x 2′ 4½″.
Courtesy, Martha Jackson Gallery, Inc., New York.

30. Antoní Tàpies: Shadow on Grey, 1962.

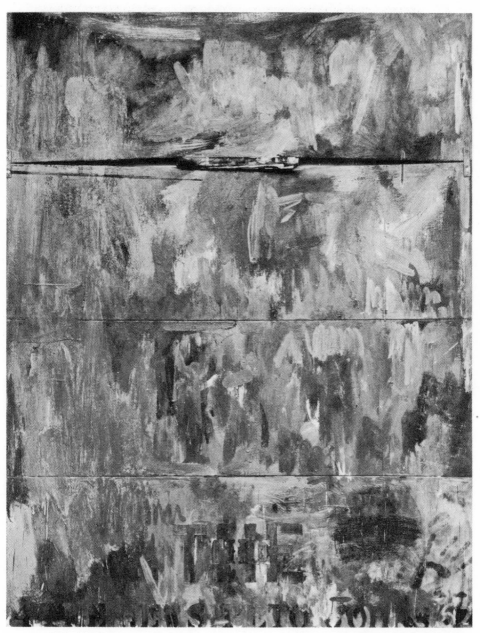

Encaustic and collage on canvas, 5′ 5″ x 4′ 2″.
Collection, Mr. & Mrs. Robert C. Scull.

31. Jasper Johns: 4 the News, 1962.

Sized muslin, stuffed with kapok; wooden "keys." 27½" x 26" x 9".
Private collection; photo, courtesy Sidney Janis Gallery, New York.

32. Claes Oldenburg: Model (Ghost) Typewriter, 1963.

21

The Breakdown of Categories

The thrust of objects into the world of the artist continues the polemic implicit in many early twentieth-century visions. The compelling drive to smash all conventions, perceptible in the works of Apollinaire, Kandinsky, the Futurists, focuses frequently on the destruction of the established forms. The call for a "clear comprehension of the times," launched by Apollinaire and his contemporaries, carried an implicit injunction to notice the changes in practical life and find means to use them in artistic life. If radio and cinema reflected the new popular arts, they were to be accepted and transformed. Into the body of art all matter could be absorbed. If objects exist, why not put them into works of art? Why should a book, for instance, not be written on a twenty-foot panel? Why shouldn't a poet take refrains from popular songs, ready-made, and slip them unaltered into his poems? Why shouldn't machines be the subject of the artist? asked Picabia. Why shouldn't a poem be made of random newspaper headlines? suggested Breton. Why, in sum, should there be any a priori limitations?

The floodgates were opened before the First World War, and the experimental attitude remained a constant thereafter. Thoughtful artists and writers watched the development of the new arts, particularly films, and drew their conclusions. All the arts were living in a kind of tense community in which the interchange, sometimes imperceptible, was greater than ever before in history.

Certainly, the development of the film had an incalculable influence on the plastic arts. Not only objects but spaces were subject to revision in this startling medium. The close-up was perhaps the

most significant mode of image-casting proposed in the century.
Out of the tradition of the visual arts film-makers drew rich ma-
terials. Practically all of Eisenstein's observations are made from
the point of view of the initiate in the history of art. He was able to
find strange and exciting suggestions toward his new art in the
works of the masters. His sources were not limited to the visual
arts, for, like other inspired artists of his generation, he was open
to the "new spirit," and was concerned with all its manifestations.
One of his most illuminating discussions in *The Film Sense* is based
on an article by René Guillère on the jazz age, titled significantly,
"Il n'y a plus de perspective."

Guillère stated that jazz is angular, that it "seeks volume of
sound." He saw classical music as an art of planes erected one atop
the other, creating an architecture of "palaces with terraces, colon-
nades, flights of monumental steps—all receding in deep perspec-
tive." In jazz, on the other hand, "all elements are brought to the
foreground. . . . In our new perspective, there are no steps, no pro-
menades. A man enters his environment—the environment is seen
through man." Musical volume, he says, is no longer created
through receding planes with a sound foreground and appropriate
recessions, but is created by the volume of sound itself. Each instru-
ment performs its solo while participating in the whole. "In jazz
each man plays for himself in a general ensemble."[1]

Eisenstein's interest in this article stems not only from his in-
herited dream of a fusion of the arts (he was thoroughly informed
about all the nineteenth-century visions which culminated in the
Wagnerian *Gesamtkunstwerk*) but also from his consciousness of
the profound changes in modern environment. Jazz, for him, was
an equivalent of the modern urban landscape, in which

> all sense of perspective and realistic depth is washed away by a
> nocturnal sea of electric advertising. Far and near, small (in the
> *foreground*) and large (in the *background*) soaring aloft and
> dying away, racing and circling, bursting and vanished—these
> lights tend to abolish all sense of real space, finally melting into
> a single plane of color light points and neon lines moving over
> a surface of black velvet sky.[2]

The cross-references of the new arts in the twentieth century
worked both ways. While Eisenstein could hear jazz and "see" cor-

relations with his own art, composers could "see" spaces and visual phenomena as influential in their work. Edgard Varèse's early statements about his music, and much of the more serious criticism of it, abound with references to the urban landscape and to the kinds of spaces which hitherto had been exclusive to the visual arts. Of *Deserts*, for instance, Varèse noted that "the music given to the instrumental ensemble may be said to evolve in opposing planes and volumes, producing the sensation of movement in space."

Younger composers are even more pronounced in their use of the diction of the plastic arts and their deliberate "confusion of aural and visual," in the words of Morton Feldman. Feldman, for instance, reiterates, whenever he writes accompanying notes for concerts, that "sound *in itself* can be a totally plastic phenomenon, suggesting its own shape, design and poetic metaphor." Both Feldman and Earle Brown have claimed specific kinships with living plastic artists, such as Guston, Pollock, Calder, Rauschenberg, and Johns. Feldman has conceived of his compositions as blocks of time, alternating with microscopic close-ups in the form of silent intervals. He can organize sound in great gauzy veils, in smooth wall-like masses, in delicately training chains of weblike fineness. Through the use of "chance," in which certain compositions are scored with the sounds given but the instrumentalists left to choose their own durations, he also comes very close to the descriptions of new musical spaces cited by Eisenstein: each instrument performs its solo while participating in the whole. The fixed perspectives that governed both art and music until the early twentieth century have dissolved with the appearance of the "new spirit."

Because of the dissolution of fixed perspective, Eisenstein was able to develop his theories of montage—theories which were so soundly based on historical sources that they are valid still today. His intention, stressed repeatedly in his theoretical writings, was to show that the arts, fused together, correspond to the very image of an epoch and to the image of the reasoning process of those linked to the epoch. This process continues to flourish. It is clear that the vision of Vasarely or of the French sculptor Nicholas Schöffer, who envisions whole cities dematerialized by electronic plays of light and sound, has been nourished by such previous speculations. Vasarely's insistence on the cinematic function of plastic art is part of

his attack on historical fixed perspective. Movement, as epitomized in the film, is liberation from law, from perspective in any of its conventional forms. (Eisenstein had already noted that there are precedents. Haven't Japanese prints, he wrote, used super-close-up foregrounds and effectively disproportionate features in super-close-up faces?)

The new spaces so strongly sensed by Eisenstein—the same spaces Matisse has in mind when he speaks of the aviator traversing the sky—are filled with objects represented in a new light, a shifting, many-faceted light that changes their lineaments and expresses their essential mobility. Simultaneity of event—a notion saturating the paintings of the Cubists, and even, in a sense, those of Matisse—is a new concept which has to be infused with life via the image.

In certain recent manifestations, the notion of the image as a complex and more or less *formed* thing gives way completely to the notion of mobility. When Jean Cassou writes an introduction for an exhibition of kinetic art, he notes that for a long time artists working in certain styles have felt a will to expand into space, and thus into time. "The thirst for movement seems to belong to our epoch,"[3] he writes, and adds that the capital art of our time is the art of cinema. From this great thirst for movement comes the art of the kinetic sculptors and painters, who bypass the art object, whose objects become in themselves movement. Movement and immediate impact, characteristic of films, become, then, an esthetic ideal derived from the initial philosophic speculations of geniuses such as Eisenstein.

In one sector of art activity, the drive is away from the metaphorical spaces proposed in easel painting. Even in the orthodox rectangular canvases of Stella, the impact of the close-up and of the immediate visual movement is great, and tends to diminish the metaphorical allusions. The color shapes are upon us; there is no depth, no background, only moving extension. More banal evidence of the close-up impact resides in the works of those Pop artists who assimilate the mannerisms of the billboard painters—the flat, rude immediacy of image which can be taken in from a taxi as it rushes by.

The fusion of the arts which Eisenstein saw as the very image of the epoch, and which earlier artists had already attempted, continues to attract artists in all fields. Mutual nourishment is common to painting and films, and in the works of Resnais, Antonioni, and Teshigahara, to mention just a few, there are clear proveniences. When Antonioni, in *The Red Desert*, offers a landscape of flats, of no horizons; when he shows depth as lateral (the red ship moving slowly across the screen, covering it entirely); when he uses colors in huge planes without dimming the recessions (certain visions of the marshes), he relates to the paintings by Rothko, whom he admires. There are no deep prospects, but allusions to space of an endlessly unfurling, psychological type. Teshigahara's *Woman in the Dunes* is saturated with techniques common to the visual plastic arts. His close-ups of sand, grain by grain, recall Miró's blade-by-blade close-ups of grass. His way of focusing on an insect, so that it takes up the whole screen and transforms itself into an attenuated, hardly identifiable object, is similar to many approaches in metamorphic or organic abstraction—that of Arshile Gorky, for instance. Resnais' insistence on objects in multiple perspective in *Muriel*, and his way of dissociating objects and personages, is common to the painters who speculate on "thingness," who reproduce objects of everyday life and try to show their strangeness, their isolate opacity. Resnais' association with Robbe-Grillet was purposeful.

The breakdown of categories initially proposed before the First World War and pursued unrelentingly since occurs in both positive and negative shape. When Picasso clothed his personages in constructions for Satie's *Parade*—costumes that were inflexible *things*, and that moved their wearers rather than the other way around—he proposed a positive alteration of perception and movement. His collages and constructions, leading to the numerous objects of more recent date called "assemblages," were still undertaken in a spirit of open experiment and positive development.

When T. S. Eliot called attention to Jules Laforgue, and admired Laforgue's incorporation of the living language of the streets, his was a positive gesture, designed to revitalize his art. When he inserts a popular ditty: "Mrs. Porter and her daughter wash their

feet in soda water"—he probably has in mind an ironic contrast, a
Dantesque overall view of existence rather than an undermining
mockery. His use of popular materials was controlled by a broad
and clearly determined vision of a whole. In this sense both he and
Picasso extend the Apollonian tradition, since form, distinct whole-
ness—no matter how disparate the content—was finally their goal.

The Dionysiac breakdown of category undertaken by the Dada-
ists had negative implications. Chaos and anti-form were erected as
acceptable functions for the arts. Since traditional values had
proved impotent, or, rather, since values as such no longer took a
hierarchical position in the spirit, the Dadaists declared through
their works in all media that perhaps nothing had any precedence
over anything else. What made a painting superior to a chromo?
Why was a sonnet superior to a newspaper account? All things be-
ing equal . . .

Dada derision was a serious matter, as even so logical a thinker
as André Gide conceded. It sustained the probing scepticism al-
ready apparent in nineteenth-century Romanticism and added vari-
ous intonations of irony and burlesque. The Alfred Jarry whose
Père Ubu was so powerful an absurd figure that Ubuism entered
the French language as a noun, and who was a spiritual father to
the World War I Dada heroes, was Jarry in his most complex guise.
For Jarry was not merely a delayed adolescent mischief-maker; he,
too, had a program which he hoped to achieve through purgative
nonsense. His Père Ubu understood certain necessities demanded
by his time. In his title page for *Ubu Enchaîné*, Jarry quotes Père
Ubu: "We will not have destroyed everything until we have de-
stroyed even the ruins." But in order to do that, Ubu adds, there is
no other way than to build beautiful edifices.

Jarry's Dadaism *avant la lettre*, with its serious purpose con-
cealed, shows up everywhere in his work, and in his dealings with
the public, whom he always called "the crowd." In a note on Jarry's
lectures, Jean Saltas relates how he attended one of Jarry's perform-
ances in the lecture hall, and afterwards congratulated Jarry but
admitted that he hadn't understood a thing. "That's what I
wanted," Jarry replied, "because to relate comprehensible things
only serves to weigh down the imagination and deceive the mem-

ory, while the absurd exercises the imagination and makes memory work."[4]

The necessity of demolition, of the breaking down of old entities and the hybrid reformation of new entities, was felt not only by extravagant parodists and ironists such as Jarry and Apollinaire, but by many more sober artists. Thomas Mann, in his epic attempt to sum up an era in *Dr. Faustus* (Jarry had written his own Dr. Faustus in the person of Dr. Faustroll), has Adrian demand of his mentor Kretschmar, "Why does almost everything seem to me like its own parody? Why must I think that almost all, no, all the methods and conventions of art today *are good for parody only?*" Kretschmar's answer is couched in the distanced terms of historical perspective:

> Art strides on and does so through the medium of the personality, which is the product and the tool of the time, and in which objective and subjective motives combine indistinguishably, each taking the shape of the others. The vital need of art for revolutionary progress and the coming of the new addresses itself to whatever vehicle has the strongest subjective sense of the staleness, fatuity, and emptiness of the means still current. It avails itself of the apparently unvital, or that personal satiety and intellectual boredom, that disgust at seeing "how it works," that accursed itch to look at things in the light of their own parody; that sense of the ridiculous—I tell you that the will to life and to living, growing art puts on the mask of these fainthearted personal qualities, to manifest itself therein, to objectivate, to fulfill itself.[5]

The sense of the ridiculous, which can be seen on the one hand in the healthy light of play and Huizinga's *homo ludens* (James Johnson Sweeney has written of Miró's playfulness in Huizinga's terms) and on the other in the violent temper of destruction, is certainly one of the stressed traditions in modern art. Iconoclastic efforts to purge society of its unvital habits occur again and again. Many of the younger American artists and writers were brought up on Dadaism and Surrealism and have projected the various ideals, or antiideals, of these in their work.

"The elements of disbelief are very strong in the morning," wrote

poet and critic Frank O'Hara in one of his poems,[6] but in another, he echoes the ironic constructivism of Jarry when he writes: "Oh my posterity! This is the miracle: that our elegant invention the natural world redeems by filth."[7]

Filth, in a rather more unpoetic vision, is sought for redemptive purposes by many younger artists engaged in the breaking down of given categories. The affluent society with its new academies—many of the most "way out" artists live and work in university situations—seems to spawn pornography and esthetic radicalism. Both self-abnegation and self-assertion are at war in these young protestants whose malaise is visible in the phallic and scatological allusions in their work. They are unwilling to take over established forms, and unwilling to commit themselves to their own inventions. Symptomatic of the malaise is the loosely conceived movement called Fluxus, which has adherents in the United States, Europe, and Japan. Fluxus sponsors any form of expression that is not pre-established. As a Fluxus exponent, George Brecht, wrote in May 1964,

> In Fluxus there has never been any attempt to agree on aims or methods; individuals with something unnameable in common have simply naturally coalesced to publish and perform the work. Perhaps this common something is a feeling that the bounds of art are much wider than they have conventionally seemed, or that art and certain long-established bounds are no longer very useful.

Further, Brecht writes,

> Whether you think that concert halls, theatres, and art galleries are the natural places to present music, performances, and objects, or find these places mummifying, preferring streets, homes, and railway stations, or do not find it useful to distinguish between these two aspects of the world theatre, there is someone associated with Fluxus who agrees with you. Artists, anti-artists, non-artists, the politically committed and the apolitical, poets of non-poetry, non-dancers dancing, doers, undoers and non-doers, Fluxus encompasses opposites. . . .[8]

The proud anarchy of the original Dadas finds a more diffuse expression in such phenomena as Fluxus, but, as the century wears on,

the assault on the bourgeoisie loses its force. Once it was the proud prerogative of the dissenting artist to batter at the foundations of tradition and bourgeois complacency. Now the artist, like the Red Queen, is breathlessly trying to keep ahead of the anarchy originating with the bourgeois consumer himself. While once it was shocking to hear the Futurists demand that the museums be burned down; while once it was a scandal to hear the Dadaists attack old-master art and see them desecrate the Mona Lisa, it is now merely diverting. In fact, like drugs, doses of derision must always get bigger, and eventually lose their inebriating effect. Surely it must have been a blow to proud spirits among the Pop artists to have their fire stolen by the patrons. Here is a Jarry-like pronunciamento by a Pop Art collector in *Life* Magazine:

> All that other stuff—it's old, it's old, it's antique. Renoir? I hate him. Cézanne? Bedroom pictures. It's all the same. It's the same with the Cubists, the Abstract Expressionists, all of them. Decoration. There's no satire, there's no today, there's no *fun*. That other art is for the old ladies. . . . Pop art is the art of to-day, and tomorrow, and all the future. . . .

The absence of "fun" in art was, it is true, one of Dada's complaints, but it was not fun in this collector's sense. Rather, the Dadas wished to rend the artificial sobriety of the bourgeois, who was loving art to death. The negative implications of Dada philosophy, its emphasis on total *tabula rasa* techniques, have sponsored volumes of works born of naïveté and indecision.

The Dada legacy passed on to contemporary artists is expressed in the hybrids produced, for instance, by Claes Oldenburg. A replica of a shirt, painted to look wrinkled and soiled, is enlarged to fill indifferent spaces. It is an object that has no attached value. It is there: meaningless, absurd, but there. Similarly, in the "happenings" there is no organic development, but a series of confused events aimed at the articulation of chaos. The use of countless rags, broken crockery, tin cans, and other throwaway material is an obvious arrow pointing to a negative polemic. Painting, sculpture, the dance, music are thrown into a happening at random. This is not the divine fusion envisioned by the Wagnerites, but, rather, a

diffusion which these young protagonists consider characteristic of existence. Apollinaire's burlesque, and even Dadaist criticism, are dropped out in this process of condensation, of stripping in reverse. By throwing everything in, the young happening artist reaches the same point as the purist, who throws everything out. But unlike the purist, he seeks no "style," since even style represents value, and the establishment of value is sincerely questionable in his eyes. Dissociation, proposed seriously in easel painting, is a mechanical reflex in much recent hybrid art, aiming at the illustration of rather than the expression of chaos.

22

Vital Arguments: The
Living Past and
the Emerging Future

In our century, each revolt engenders another, each encapsuled history winds itself like a snail's shell into the next, and a host of assumptions are kept alive by constant challenge.

No sooner had the purist tendency been revived in the United States and Europe in the late 1950s than the reaction set in. Scores of very young aspiring artists challenged the puritanical reductions by reverting to other traditions. At the same time, others of the the same generation as the "post-painterly abstractionists" proposed alternatives to the stern factualism of the purists, seeking a "content," an abiding symbolic meaning which the estheticism of the purists disdains. While such stormy, restless evolution often seems incoherent, an examination of the basic assumptions guiding each new manifestation indicates that the traditions engendered in the early part of the century are still being explored and expanded. For instance, despite the insistent decision throughout the century to eliminate the lingering traces of Symbolism once and for all; despite the supreme irritation of artists such as Robbe-Grillet, who rage against the "double" principle in art, the tremendous energy of the Symbolist state of mind sustains itself. It is deployed in the works of artists using very different means, but it reads clearly nevertheless.

Amongst certain artists, it takes the form of a perpetual quest for the stern, hieratic solemnity of ancient iconic art. The silent mysteries of a Piero della Francesca allegory, or of a Giorgione

Madonna Enthroned, continue to perplex and attract these artists,
who try, in abstract painting, to activate the hidden sources of sym-
bolism. Such artists take static forms—Ad Reinhardt's cruciform
black paintings are an example—and cast them symmetrically. By
the inevitable alchemy of symmetry, a certain mysterious increment
is assumed by the artist, and often by the receiver. The eternal co-
nundrums posed by de Chirico, with his mysterious objects, his ge-
ometer's instruments, his dotted lines and diagrammatic indica-
tions, find heirs in the younger symbolists.

Even where the symbolic intention is faint, as in the work of
Frank Roth, the overtones are unmistakable. Roth offers paintings
that cannot be read specifically but are filled with suggestive cues.
He likes to suggest unlimited prospects, in which veering lines seem
to race into infinity, until the viewer realizes that they are only half-
articulated. Then several spatial ambiguities complicate the read-
ing. Often Roth uses the meticulously clear technique of Magritte
to present his abstract fantasies. While he never paints objects as
such, the elements within his compositions seem to coalesce into
identifiable things. He might, for instance, leave a filmy white
space on a blue ground that reads like a cloud. Or like absence. Or,
he might make a sharp drawing of a corner in brilliant colors. The
corner is there, mystifying in its presence, since its fulfillment must
be in the imagination of the beholder. There is a feeling for strange
landscapes in Roth's work that reminds us of deKooning's imagi-
nary landscapes, although Roth's technique is precise, free of ex-
pressionist brushwork. There is also an insistent symmetry, and oc-
casional forms (squares within squares, triangles, or circles) that
carry with them the aura of symbolism. However Roth's work is
perceived, it clearly carries with it a burden of meaning that is just
behind the smartly rapped-out, sharp forms on its surfaces. The
paradox of his clean, hard-edged technique and his dreamy or am-
biguous images endows his work with remarkable tension.

Nor is the symbolic-intent fully clear, though visible, in the
work of Allen d'Arcangelo, whose early highway paintings seemed
an extension of the American lyrical tradition. Yet, by insisting on
the presence of signs—those arrows pointing beyond the horizon;
those lights indicating an endless trajectory; those half-raised,

Acrylic on canvas, 3′ 11⅞″ x 3′ 9″.
Courtesy, Fischbach Gallery, New York.

33. Allan d'Arcangelo: Untitled #71, 1967.

Mixed media on paper; each drawing 7¾" x 11".
Private collection; photo, courtesy Sidney Janis Gallery, New York.

34. Öyvind Fahlström: Notes for Sitting.

striped barriers at railroad crossings—d'Arcangelo plays upon the same psychological resources that de Chirico exploited in his characterizations of "distant horizons heavy with adventure." It is true that d'Arcangelo uses the clean surfaces, the sharp planes of the modern designer, borrowing certain idioms from high-class magazine illustrators. But all this is in the cause of enhancing the mystery of his paintings. His symbolizing impulse is apparent in his recent paintings, in which the signs that mark off the landscape are forcibly separated from their habitual meanings. They float, soar, or span the spaces, and there is just enough teasing, identifiable meaning to offer the viewer a mystery. Nostalgia for infinite landscapes and dreams of disparate spaces, without logic, relate d'Arcangelo's work to the modern symbolist tradition, and bring him closer to the established metaphysical tradition than the recent Pop Art movement with which he is sometimes mistakenly identified.

In a debased form, symbolism is to be found even in the work of young artists who have gone out into the world with objects. Recent British exhibitions have been full of semaphoric and traffic-sign paintings that are literally signs, and therefore intended to suggest something other than their bare and limited surfaces.

In California, there is an unmistakable drive toward the revival of Surrealism, with all its metaphorical stress, its alchemy, its interest in the unexpected, the unprepared. The wild paintings and small drawings of William Wiley, to mention only one of a large group, are based on the principle of surprise juxtapositions: hints of a highway veering into nothingness juxtaposed with a geometric shape reminiscent of the alchemist's symbology; or classical architecture disrupted by a growing thing of ambiguous and uncomfortable amorphousness.

Even in certain artists identified with the emergence of Pop Art there are strong Symbolist overtones. I think of the work of Ronald Kitaj, for instance, who, along with his caricatures of gangsters and of advertising art, sustains an interest in the double meaning, in criticism and "otherness." His whole dialogue in collage and pasted allegories, in their allusion to past history, is a deliberate instigation of mythic process.

Amongst the very young California artists there are several who

have quite obviously turned back to have another look at de Chirico, and possibly Magritte. De Chirico's mannequins are now motorcyclists and Hollywood cuties, but they are poised in de Chirico's infinity, and something other than their immediate presence is intended to be read in the work.

In the happenings of Allan Kaprow, the portentous tone of ancient myth is repeatedly invoked. Kaprow sees the happening as satisfying three interacting functions. First, it is, as all art is, a fantasy, a performed fantasy "whose actions are direct, yet embodied in images of intense emotional pressure." Secondly, it is a structured arrangement of forms and relationships. For this he depends on a succinct scenario which rarely covers more than two typewritten pages. Thirdly, it is a structure of meanings. Kaprow considers the content so important that he does not rule out symbolism as do other devotees of happenings. But the "meanings" he elicits are in the realm of prelogical areas of experience. The same necessity that drove early twentieth-century artists to examine what was called "savage" art drives Kaprow to plot his happenings as though they were archetypal rituals.

The poetic strain in Kaprow's vision separates him from many of his former collaborators, who depend more on aggressively visual, fragmented shocks. Some of his scenarios read like *précis* of Greek dramas such as Euripides' tempestuous script for *The Bacchae*. Here, ritual, archetype, and unprepared violence are blended in a permanently shocking composition.

An example is *Household*, set in "a lonesome dump out in the country. Trash heaps all around, some smoking. Parts of dump enclosed by old, red, tin fence. Trees around rest of it." In this forlorn setting, Kaprow plots an all-day happening that is most emphatically geared to the imagination that responds to archetypes. But he attempts to make the "content" consonant with the epoch, as can be sensed in reading some of the manuscript. A few sections:

> 11 A.M. Men build wooden tower on a trash mound. Poles topped with tarpaper clusters are stuck around it.
> Women build nest of saplings and strings on another mound. Around a nest on a clothesline they hang old shirts.

2 P.M. Cars arrive, towing smoking wreck, park outside dump,
people get out. . . .
Women go inside nest and screech.
Men go for smoking wreck, roll it into dump, cover it with
strawberry jam. . . .
Women go to car and lick jam.
Men destroy nest with shouts and cursing. . . .
Men return to women at wreck, yank them away, eat jam with
fingers. . . .
Women destroy men's poles and tower, laughing, yelling
"Watch this! Watch this!" . . .[1]

and so on to the denouement, which consists of everyone quietly
smoking, watching the car burn up, and then leaving silently.

In another manuscript, the quality of archaic poesy and primor-
dial nostalgia is also pronounced. The happening takes place in a
patch of woods near a lake. Women are perched in trees "widely
separated and some can only hear each other." These "birds" in the
trees are like harpies, teasing the men who are building a wall, who
in turn taunt their taunters. A bread man hawks bread and jam
throughout, and the finale is: "Tree women rhythmically yell in
unison 'Yah, yah, yah' as bread man does this [bombs rubble with
bits of bread]."[2]

From these bareboned structures Kaprow hopes to elicit funda-
mental responses. Aware of the deep emotional potentials embed-
ded in ritual, he scans his own environment for significant situa-
tions. A ritual, he points out, can be as simple as the ritual we
perform when we go to the supermarket. From this he siphons off
a meaning, for by taking his materials from commonplace activities
and sights, Kaprow initiates an activity which is *not* habitual. And
the wayward, seemingly random activities his participants engage
in are carefully selected by him. They must move in a fluid medium
toward a final "meaning."

Artists engaged in happenings and other hybrid, experimental
phenomena are in direct contrast to the purists and factualists. Like
Bouvard and Pécuchet, those two original anti-heroes whom Flau-
bert used to challenge his materialistic century, they have attempted
to cope with the world of fact, and have found that it is only a small
and unreliable portion of existence. Bouvard and Pécuchet under-

took an encyclopediac enterprise, examining and trying to put into practice all the latest scientific developments; they failed in agriculture, in religion, in economics, in politics, in every area in which they had been assured that reason and science would triumph. So it is with many young artists, to whom the visible fact is only part of their story. They turn back respectfully to Matisse, to Miró, to de Chirico, to Magritte, to the Surrealists, because in them they find permission to take into their consciousness the inexplicable, the psychological, the "other." The claims of the dreaming psyche are evident in the perpetual need for myth, even so banal a myth as the Hollywood film star. They are evident in the results of scientific experiments which, having deprived man of his dreams, thereby destroyed his psychic entity. They are evident in repeated salvage operations in our century in which the arts have again and again been infused with symbolism.

Not only the lyrical artist, but the temperamentally intellectual artist, too, is drawn into the salvaging quest. Many of the new manifestations which appear Dadaist or ironic have a serious basis. Ever since Paul Klee, painters have repeatedly turned to hieroglyphic symbolism. Sometimes the hieroglyph is left semiobscure; sometimes, however, it grows into direct written language. In the painters whom the French critic Jean Clarence Lambert has discussed, the use of words and letters as well as figured symbols is toward an extra-plastic end: not the illustration of a poem, necessarily, but signals to the imagination for further expansion. Lettrism in poetry and painting can continue Dada non-sense experiments, but it also nourishes the germ of symbolist doubling. The painting has a meaning as a painting, and a meaning as a gloss on itself and on other idea-objects.

The work of the Swedish artist Öyvind Fahlström, based on an elaborate principle of games, is essentially symbolist. In his most scholarly diction, Fahlström has written that his work is based on the "character-form" which can be recognized when it is repeated, varied, or "dressed."[3] This approach "implies a balance of partial significations amalgamating into a new and nameless yet prodding signification." His language is strongly reminiscent of the language of the late nineteenth-century Symbolists, best summarized by Mal-

larmé. Fahlström leads the way toward a fearlessly literary art; many of his paintings relate to contemporary fiction. His intimations of an attitude concerning human relations are clearly based on a well-thought-out scheme. When he places men and women on a surface, and invites the spectator to move them about or dress them, he invites a literary summation. In addition, Fahlström uses materials that are pointedly political. His choice of snippets from newspapers or illustrations from popular magazines very often hinges on the topical events bursting daily upon the newspaper reader's consciousness. Wars, civic outrages, cruelty become symbolized poles within which his generous fantasy operates. But Fahlström also reflects twentieth-century drifts of philosophical thought. Certainly, his reference to his works as game structures with game rules recalls Wittgenstein. His concern with a "discontinuous image" and with pictures that are not confined to any stylistic unity ("all styles and techniques, character-forms, real objects, words, sounds, light etc. can be related to form a game of character")[4] indicates that the twentieth-century will toward dissolution of fixed perspectives and forms is operating strongly in him.

For enthusiasts of progress, or at least of unremitting discovery in science and technology, perhaps there can be sufficient nourishment in the assimilation of new facts. For instance, for that wild, irritating—and often very wrong—dreamer Marshall McLuhan, the advent of electricity changed the structure of life:

> The electric light ended the regime of night and day, of indoors and out-of-doors. But it is when the light encounters already existing patterns of human organization the hybrid energy is released. Cars can travel all night and windows can be left out of buildings. In a word, the message of the electric light is total change. It is pure information without any content to restrict its transforming and informing power.[5]

But the message of the electric light, its pure "information," is only one message of significance to the human psyche. It ends the regime of night and day for the baseball player perhaps, but not for the dreaming artist. For him, there are two speeds, two messages,

one dream-suspended, the other practical and informed by such events as the extension of electricity. Night and day are essential, biological phenomena. They remain so for the farmer, for the housewife taking her children to air, for the secretary imprisoned in those windowless buildings longing for the five-o'clock light out of doors. And they are there for the poet for whom the pulse beat cannot change.

McLuhan may be correct to say that "in the space-time world of electric technology, the older mechanical time begins to feel unacceptable, if only because it is uniform,"[6] but the still older millennial sense of time remains, for it is embedded in the evolution of the species. Long before the electronic era, poets noted that time stood still at certain moments while it sped vertiginously at others. Psychological apprehension of time cannot be manipulated beyond the limits of the organism. For the imagination, time has always had the non-mechanical dimensions McLuhan claims the era describes. And space-time is, and has always been, its natural habitat.

It is true, perhaps, that modern technology, in offering man the possibility to respire underwater or while orbiting the universe, shapes the kinds of spatial experiences he has. Yet the correlations between dreamed spaces (dreams that go back to the origin of language) and the spaces directly experienced by twentieth-century man are very close. The Surrealists ecstatically discovered J. J. Grandville, a dreamer of extraordinary dreams which he rendered as an illustrator in the first half of the nineteenth century. Grandville wrote letters about his drawings. He asked his editor, what shall our title be? And suggests *Metamorphoses in Sleep, Transformations, Deformations, Reformations of Reveries,* and *Chain of Ideas in Reveries, Nightmares, Dreams, Ecstasies, etc.*

Grandville's nightmares are classically Freudian. He deals with terrifying experiences, such as dropping from great heights or drowning in vast seas. "In my opinion," he wrote in 1847, "one never dreams anything which one hasn't seen or thought when awake, and it is the amalgam of these diverse objects, seen or thought, which form these strange, heteroclitic dreams due to the greater or lesser activity of the blood when it circulates."[7]

Recognizing a physiological basis for his monstrous dreaming

fantasies, Grandville was far ahead of his time. The Surrealists, had they looked further back, would have found similar insights in Dante and the ancients. For the strangeness of dreamed spaces is familiar to all men. Men throughout the history of art have sensed that the dreamed spaces are a continuity of the known spaces. The strange experiences of the deep sea navigators are only proved, not discovered, through the direct experience of the depths. Jacques Cousteau's account of the one-week sojourn in an underwater villa in the Mediterranean, undertaken by two of his ablest men, is summarized when he exclaims: "An unpredictable metamorphosis was taking place before our eyes: the two oceanauts were forgetting all about the world above!" For the first two days the two men were restless, and telephoned above frequently. After the third day they no longer phoned, and they stopped watching television and listening to records. "The surface and its problems, our earthly problems have lost their weight for them," Cousteau observed, and one remarked after surfacing: "It's as though I had lived another life."[8]

Such "other" lives, of course, are known to the imagination, as countless poems and paintings about quiet, vastly extending spaces testify. Certain space sensations are given. (Experiments with immersion undertaken in England and the United States bear this out: subjects often responded positively and even sought opportunities to spend long periods immersed in a warm-water tank.)

These spaces that change man's relationship to time and in which he feels at home have been called by Gaston Bachelard the "happy spaces," and considered as archetypal patterns of experience. The happy spaces, and the experience of suspension in time, are described in art again and again. Not only Matta and Pollock, Rothko and Guston, but a host of painters and poets are specifically concerned with them. The effort to "live back its own genesis," ascribed to intelligence by Henri Bergson, is repeatedly made.

> Yet a beneficent fluid bathes us, whence we draw the very force to labor and to live. From this ocean of life, in which we are immersed, we are continually drawing something, and we feel that our being, or at least the intellect that guides it has been formed therein by a kind of local concentration. Philos-

ophy can only be an effort to dissolve again into the Whole. In-
telligence reabsorbed into its principle, may thus live back its
own genesis.[9]

Not all spaces, however, are happy spaces, and the history of the
tragic in the arts is as full as the history of spiritual contentment.
The tragic, as the Existentialists sought to bring out, is a natural cir-
cumstance in human existence, since death is the one incontrovert-
ible fact with which it must contend. Certain temperaments are
more attuned to the tragic than others, of course. As Unamuno
pointed out, "The tragic sense of life does not so much flow from
ideas as determine them."[10] The Surrealist preoccupation with *de-
paysement* is, in a sense, an extension of Baudelaire's preoccupation
with vastness and estrangement. The thread of the tragic in twen-
tieth-century letters is unbroken, even when it appears under the
guise of irony or the despair of the absurd.

"There's no *terra incognita* nowadays," laments the protagonist
in Max Frisch's novel *I'm Not Stiller*. What with illustrated maga-
zines and documentary films, there is nothing left to discover.
"And it's just the same with the inner life of man. Anyone can
know about it nowadays."[11] And Claude Lévi-Strauss, in *Tristes
Tropiques*, sadly notes that "there was once a time when the voyage
confronted the voyager with civilizations radically different from
his own and important mainly for their strangeness." The modern
voyager, however, is less surprised than he knows:

> The quest of exoticism leads to the collection of anticipated or
> retarded states of familiar developments. The voyager becomes
> an antiquarian, constrained by the lack of objects to leave his
> gallery of Negro art in order to find old souvenirs in the flea
> markets of inhabited territories.[12]

The modern spiritual flea markets are recognized and deplored
both by the artists intent on dismantling conventions—the Dadaists
and their successors—and by the artists concerned with positive,
constructive optimism. Responding to their "time," many young
artists display a healthy nostalgia, though they might be shocked to
think so. Certainly the rebellious poets, painters, and musicians that

have linked themselves internationally to form "new" concepts of art work always in relation to modern traditions—whether by furious bucking or by calm extension.

When, during the year celebrating Dante, the Italian poets, painters, and musicians in Group 70 in Florence staged their festival, they were at pains to protest the attention rendered to Dante, and asserted themselves as living artists who were about to make use of the modern means of mass diffusion to make themselves heard. In this day of information theory, they tell us, and in this day of technological progress, poetry must keep up, as must music. They proposed "visual poetry," and music by technicians informed by modern technology (a proposal, in sum, that differs little from Apollinaire's). Their nostalgia is for the future, the future that has been dreamed and redreamed by certain temperaments in the twentieth century.

The Florentines were only a small section in a chorus of young artists who claimed the right to change the received ideas and fixed boundaries of the various art forms. Many youths who could not relate to traditional poetry seized the opportunity to make "visual" poetry, or, as it is called in the United States, concrete poetry. To them, the way a poem looks on a page (or on any other surface) is the way it is. A poem can be made by dispersing names from a telephone directory on a page, or by typing a series of semicolons densely on a square page, and leaving out a sequence of three semicolons. It can be made by finding words at random in a dictionary and printing them in designed sequences of white space versus print. It can be made by printing one word at a time, page for page, in a sort of flip-book, imitating the old children's animated books. It can also be made for declamation, as it has since the Dada days, of assorted sounds or false words that seem like mere sounds, or real words that have no visible ligatures.

In the same way, the Florentines and their colleagues all over the Western world claim the right for music to be produced by machines—either electronically, or by computer—and to be defined in terms of sound or sound clusters. Scoring becomes obsolete, or so eccentric as to be more closely related to the visual than the aural arts. The fashionableness of avant-garde concerts, in which

the audience is at no time in contact with either human performer or creator, bears out this universal will toward art as nurtured by technology.

Just as the artists in Florence, a most hallowed, most tradition-bound city, react furiously to their environment, so the artists in California react with forceful contempt to that state's reactionary traditions. In California, where there are more witch-hunts, more ladies' vigilante committees to protect youth from "bad" books than in any state in the union, the young artist hits back with the most phallic, the most scatological, the most pornographic means he can conceive. Years of censorship, of McCarthyism, of vigilante crimes have given the young American an implacable urge to fling back obscenity, latrine art, and whatever else he can think of, to strike at the heart of American bourgeois hypocrisy. Here, again, the discourse has a long twentieth-century history and is still vital.

If badboyism is one response, intellectual control and cold reason is another, and the tradition is a long one. Boccaccio praised Giotto for not painting to charm the regard of the ignorant but to please the minds of the intelligent. Michelangelo insisted that you paint with your mind, not with your hands. Mondrian and Van Does-burg brought these theories up to date, and a new generation of artists has taken them up. Given the outrages of the century, their firm determination to maintain the light of reason and control is understandable. The emotional forces which have driven men to destructions beyond imagining are feared and rejected by these artists, who, nevertheless, have not been able to offer convincing evidence that intuition is not still a prime mover in the arts.

The proclamation that intuition was the principal force in the evolution of the arts in our century remains valid. The artist is, in a sense, a delicately balanced compass needle, going back and forth from points of interior reconnaissance to points of exterior rapport. In our century, the needle quivers ceaselessly. Artists have sought to find a balance between the notion of-self and the notion of self-transcendence. Picasso asks us not to inquire what the bird's song means (self-transcendence), and Miró insists, "I work like a gar-dener." Arp yearns back to primordial anonymity along with Va-sarely, who dreams of vast, anonymous sites epitomizing intellec-tual beauty. The extremes touch.

Both Miró and Matisse, toward the end of their long creative lives, summed up their experiences in almost mystical, self-transcending terms. Miró described his state of mind when he works as similar to the Zen master's. And Matisse, shortly before he died, in a talk with Reverdy quoted a musician with whom he had spoken recently:

> In art, truth and reality start at the point when you no longer understand what you are doing or what you know and when your remaining energy is all the stronger for being thwarted, hemmed in and compressed. You must then come forward with the greatest humility, in spotless purity and innocence, with a vacant mind and in a state not unlike a worshipper about to receive Holy Communion. Of course you must have your accumulated experience behind you and at the same time, manage to retain all the freshness of Instinct.[13]

Notes

CHAPTER 1

1. Alfred H. Barr, Jr., *Matisse, His Art and His Public* (New York: Museum of Modern Art, 1951), p. 119.
2. Wassily Kandinsky, "Text Artista," published in Moscow in 1918, reprinted in *Wassily Kandinsky* (New York: Museum of Non-Objective Painting, 1945), p. 60.
3. Barr, *Matisse*, p. 101.
4. Ibid., p. 123.
5. Georges Duthuit, *The Fauvist Painters* (New York: Wittenborn, 1950), p. 82.
6. Ibid.
7. Ibid., p. 82 n.
8. Barr, *Matisse*, p. 122.
9. Ibid., p. 562.
10. Ibid., p. 136.
11. John Rewald, *Pierre Bonnard* (New York: Museum of Modern Art, 1948), p. 40.
12. Ibid., p. 51.

CHAPTER 2

1. Barr, *Matisse*, p. 101.
2. Ibid., p. 119.
3. Charles Baudelaire, *Art in Paris 1845–1862*, ed. Jonathan Mayne (London: Phaidon, 1965), p. 50.
4. Charles Baudelaire, *The Mirror of Art*, ed. Jonathan Mayne (New York: Doubleday, 1956), p. 319.
5. From Cahier IV, p. 23, of Gustave Moreau's notebooks, cited by Ragnar von Holten, *Gustave Moreau* (Paris: Pauvert, 1960).

6. Barr, *Matisse*, p. 245.

7. Ibid., p. 122.

8. Paul Gauguin, *Intimate Journals* (Bloomington, Ind.: Indiana University Press, 1958), p. 72.

9. Barr, *Matisse*, p. 122.

10. Ibid., p. 38.

11. Jean Leymarie, "The Painting of Matisse," in catalogue for the University of California's 1966 retrospective exhibition, p. 13.

12. Barr, *Matisse*, p. 562.

13. Ibid., p. 120.

14. Ibid., p. 102.

15. Wassily Kandinsky, *Concerning the Spiritual in Art* (New York: Wittenborn, 1947), p. 70.

CHAPTER 3

1. Lecture at Pratt Institute, reported by the author in *New York Times,* October 21, 1958.

2. Kandinsky, *Concerning the Spiritual In Art*, p. 73.

CHAPTER 4

1. Henri Bergson, *Creative Evolution* (New York: Modern Library, 1944), p. 53.

2. Ibid., p. 195.

3. Kandinsky, *Concerning the Spiritual in Art*, p. 39.

4. Guillaume Apollinaire, *Chroniques d'Art* (Paris: Gallimard, 1960), p. 267.

5. Quoted by René Jullian in the catalogue for a Léger exhibition at the Musée de Lyon, 1959.

6. Apollinaire, *Chroniques d'Art*, p. 269.

7. Fernand Léger, "Les origines de la peinture et sa valeur représentative," *Montjoie*, Paris, May-June 1913.

8. Lecture at the Museum of Modern Art, New York, in 1935. Quoted in Robert Goldwater and Marco Treves, *Artists on Art* (New York: Pantheon, 1945), p. 426.

9. Ibid.

CHAPTER 5

1. Lecture at the Vieux Colombier theater in 1918, cited by André Billy, *Guillaume Apollinaire* (Paris: Pierre Seghers, 1947), p. 37.

2. *Guillaume Apollinaire*, p. 37.
3. Ibid., p. 36.
4. Ibid., p. 36.
5. Guillaume Apollinaire, *Les Mamelles de Tirésias*, translated by Louis Simpson in *Odyssey Review*, December 1961, Vol. I.
6. Ibid.
7. Ibid.

CHAPTER 6
1. Gaston Bachelard, *La Poétique de l'Espace* (Paris: Presses Universitaires de France, 1957), p. 16.
2. Duchamp's found object, a china urinal called *Fountain* and signed R. Mutt, was rejected by the newly formed Society of Independent Artists in 1917, after which Duchamp resigned.
3. From Paul Klee, "Schöpferische Konfession," 1920, cited by Will Grohmann, *Paul Klee* (New York: Abrams, n.d.), p. 98.
4. Paul Klee, *The Thinking Eye*, ed. Jurg Spiller (New York: Wittenborn, 1961), p. 9.
5. Ibid., p. 4.
6. Mircea Eliade, *Cosmos and History* (New York: Harper, 1959), p. 9.
7. Klee, *The Thinking Eye*, p. 93.

CHAPTER 7
1. Johann Wolfgang von Goethe, *The Sorrows of Young Werther*, tr. Catherine Hutter (New York: Signet Books, 1962), p. 30.
2. F. G. Gregory, "Form in Plants," in *Aspects of Form*, ed. Lancelot Law Whyte (Bloomington, Ind.: Indiana University Press, 1961), p. 57.
3. Barker Fairley, *A Study of Goethe* (London: Oxford University Press, 1947).
4. Johann Wolfgang von Goethe, *Faust,* transl. Peter Salm (New York: Bantam, 1967), p. 75.
5. Thomas Mann, "Goethe and Tolstoy," in *Three Essays*, tr. H. T. Lowe-Porter (New York: Knopf, 1929).
6. Klee, *The Thinking Eye*, p. 63.
7. Ibid., p. 66.
8. Ibid., p. 69.

CHAPTER 8
1. Dupin, *Miró*, p. 81.

2. Ibid., p. 65.

3. Ibid., p. 83.

4. Mark Tobey, letter dated October 28, 1954, in *Art Institute of Chicago Quarterly*, February 1, 1955, p. 9.

5. Dupin, *Miró*, p. 84.

6. Ibid., p. 139.

7. Ibid., p. 140.

8. Cited in Max Brod, *Heine: The Artist in Revolt* (New York: Collier, 1962), p. 213.

9. Lancelot Law Whyte, *The Unconscious Before Freud* (New York: Doubleday, 1962), p. 113.

10. Novalis, *Hymns to the Night*, tr. Eugene Jolas, *Transition Workshop* (New York: Vanguard, 1949).

11. Dupin, *Miró*, p. 179.

12. Joán Miró, "Jeux Poetiques," *Cahiers d'Art* Vols. XX–XXI, (1945–46), pp. 269–72.

13. *The Portable Coleridge*, ed. I. A. Richards (New York: Viking, 1950), p. 225.

14. Rosamond Bernier, "Propos de Joán Miró," *L'Oeil*, Nos. 79–80, July-August, 1961.

15. James Johnson Sweeney, *Miró* (New York: Museum of Modern Art, 1941).

16. Claude Lévi-Strauss, *Totemism* (Boston: Beacon Press, 1962), p. 28.

17. Ibid.

18. Ibid.

CHAPTER 9

1. Jacques Dupin, *Miró* (New York: Abrams, 1962), p. 462.

CHAPTER 10

1. Roger Fry, *Transformations* (New York: Doubleday, 1956), p. v.

2. Henri Focillon, *The Life of Forms in Art* (New York: Wittenborn, 1948), p. 7.

3. Alfred H. Barr, Jr., *Picasso: Fifty Years of His Art* (New York: Museum of Modern Art, 1946), p. 149.

4. Ibid., p. 263.

5. Ibid., p. 241.

6. *Cahiers d'Art*, 1948 I, p. 54.

7. Ibid. p. 58.

8. Wilhelm Fränger, *The Millennium of Hieronymus Bosch* (Chicago: University of Chicago Press, 1951), p. 13.

9. Hans Arp, *On My Way* (New York: Wittenborn, 1948), p. 50.

10. *Arp*, ed. J. T. Soby (New York: Museum of Modern Art, 1958), p. 14.

11. Ionel Jianou, *Brancusi* (New York: Tudor, 1963), p. 13.

12. Max Ernst, *Was ist surrealismus* (Zurich: Zurich Kunsthaus, 1934).

13. Stanley Kunitz, "Roethke, A Poet of Transformations," *New Republic*, January 23, 1965.

14. *Poets and the Past*, ed. Dore Ashton (New York: Emmerich, 1959), p. 39.

15. Ibid.

16. Dante, *The Inferno*, tr. John Ciardi (New York: Mentor Books, 1954), p. 215.

CHAPTER 11

1. André Breton, *Manifeste du surréalisme* (Paris: Editions du Sagittaire, 1924).

2. Bergson, *Creative Evolution*, p. 10.

3. Ludwig Binswanger, "Existential Analysis and Psychotherapy," in *Psychoanalysis and Existential Philosophy*, ed. Hendrik Ruitenbeek (New York: Dutton, 1962), p. 19.

4. Ibid.

5. Ibid, p. 158.

CHAPTER 12

1. Miró, interviewed by Francis Lee in *Possibilities I*, (1947–48), p. 66.

2. Conversation with the author.

3. Conversation with the author.

4. D. T. Suzuki, *Zen Buddhism* (New York: Doubleday, 1956), p. 143.

5. André Breton, *Le surrealisme et la peinture* (Paris: Gallimard, 1928).

CHAPTER 13

1. Weldon Kees, *Magazine of Art*, XLI, 3, p. 86.

2. Conversation with the author.

3. Conversation with the author.

4. Louis Aragon, "La Peinture au défi," 1930, reprinted in *Les Collages* (Paris: Hermann, 1965), p. 43.

5. Conversation with the author.

6. Robert Motherwell, "A Tour of the Sublime," *Tiger's Eye*, December 1948.

CHAPTER 14

1. *Three Classics in Music* (New York: Dover, 1962), p. 17.
2. Ibid, p. 89.
3. Ferruccio Busoni, *The Essence of Music and other Essays* (London: Rockliff, 1957), p. 21.
4. Ibid, p. 23.
5. *The Letters of Ezra Pound*, ed. D. D. Paige (New York: Harcourt, Brace, 1950), p. 90.

CHAPTER 15

1. *Wassily Kandinsky*, Museum of Non-Objective Art, p. 63.
2. *De Stijl*, June 16, 1917.
3. *De Stijl*, November 1918.
4. H. L. C. Jaffe, *De Stijl 1917–1931* (Amsterdam: Meulenhoff, 1956).
5. Walter Gropius, *Bauhaus 1919–1928* (Boston: Branford, 1952).
6. G. C. Argan, *Walter Gropius e la Bauhaus* (Turin: Einaudi, 1951).
7. Gropius, *Bauhaus 1919–1928*.
8. Ibid.
9. Alfred H. Barr, Jr., *Bauhaus 1919–1928* (New York: Museum of Modern Art, 1938).
10. László Moholy-Nagy, *The New Vision and Abstract of An Artist* (New York: Wittenborn, 1947).

CHAPTER 16

1. Vasarely, "Fragments d'un journal," *Art International*, VIII/3 (April 25, 1964), p. 25.
2. Jean Dewasne, *Vasarely* (Paris: Les Presses Litteraires, 1952).
3. Julien Alvard, "Herbin," *Cimaise*, No. 8, July-August 1954.
4. Dewasne, *Vasarely*.
5. *Temoignages pour l'art abstrait* (Paris: Edition d'Aujourd'hui, 1952).
6. Vasarely, "Fragments d'un journal."
7. Ibid.
8. Ibid.
9. Ibid.
10. *Temoignages pour l'art abstrait.*

11. *Temoinages pour l'art abstrait.*
12. Stephen Spender, "Modern Writers in a World of Necessity," *Partisan Review*, Summer 1945.
13. Dewasne, *Vasarely.*
14. "Notes pour un manifeste," in catalgoue for the exhibition "Le Mouvement," Galerie Denise René, Paris, 1964.
15. Dewasne, *Vasarely.*
16. *From Invention to Re-Creation*, catalogue for Galerie Denise René, 1955.
17. Vasarely, "Fragments d'un journal."
18. *Vasarely*, catalogue for exhibition at Musée des Arts Décoratifs, Paris, March–April 1963.
19. "Ce que devrait être la critique d'art," *Les Beaux Arts*, Nos. 907–908, Brussels.
20. Ibid.
21. Maxim Gorky, *Reminiscences* (New York: Dover, 1946), p. 211.
22. Vasarely, "Fragments d'un journal."

CHAPTER 17
1. W. Grey Walter, "Development and Significance of Cybernetics," *Civiltà delle Macchine*, Anno X, Numero 6, (November-December 1962), p. 30.
2. Ibid.

CHAPTER 18
1. George M. Reid, *Anonima*, Vol. 1, No. 2 (March 1964).
2. Louis Aragon, *Les Collages*, p. 135.
3. *Jazz* (Paris: Edition *Verve*), 1947.
4. Interview by Henry Geldzahler, *Art International*, VIII/I, 1964, p. 47.
5. Barbara Rose, "The Primacy of Color," *Art International*, VIII/4, 1964.

CHAPTER 19
1. Hans Arp in catalogue for exhibition at the Cabaret Voltaire, Zurich, 1915.
2. Alain Robbe-Grillet, "Nature, humanisme et tragedie," *Nouvelle Revue Française*, No. 70 (October 1, 1958).
3. Ibid.
4. Ibid.

5. Ibid.
6. See: Roland Barthes, *Essais Critiques* (Paris: Editions du Seuil, 1964).

CHAPTER 20

1. *Marcel Proust on Art and Literature* (New York: Meridian, 1958), p. 326.
2. Maurice Raynal, *Du Picasso au Surrealisme* (Geneva: Skira, 1950).
3. *Fantastic Art, Dada and Surrealism*, ed. A. H. Barr, Jr. (New York: Museum of Modern Art, 1936), p. 49.
4. Alain Robbe-Grillet, "Nature, humanisme et tragedie."
5. *Jasper Johns, with an essay by Alan Solomon*. Catalogue for an exhibition at the Jewish Museum, 1964.
6. Conversation with the author.

CHAPTER 21

1. Sergei M. Eisenstein, *The Film Sense* (New York: Harcourt, Brace, 1947), p. 96.
2. Ibid., p. 98.
3. Catalogue for "Mouvement 2" at Galerie Denise René, December 1964.
4. Alfred Jarry, *Ubu Enchaine*. Preface by Jean Saltas (Paris: Fasquelle, 1953).
5. Thomas Mann, *Doctor Faustus*, tr. H. T. Lowe-Porter (New York: Knopf, 1948), p. 135.
6. Catalogue for "An Exhibition of Pictures with Poems," at the Tibor de Nagy Gallery, November 24, 1959.
7. Ibid.
8. *Fluxus*, June 1964.

CHAPTER 22

1. Allan Kaprow, typescripts of happenings given to the author.
2. Ibid.
3. Öyvind Fahlström, "A Game of Character," *Art and Literature*, No. 3, Autumn-Winter, 1964.
4. Ibid.
5. Marshall McLuhan, *Understanding Media* (New York: McGraw-Hill, 1964), p. 52.
6. Ibid.
7. J. J. Grandville, *Les Lettres Nouvelles*, November 1961, reprinted from *Le Magasin Pittoresque*, 1847.

8. Reported by Joseph Barry in the *New York Post*, date unavailable.

9. Bergson, *Creative Evolution*, p. 210.

10. Miguel de Unamuno, *Tragic Sense of Life* (New York: Dover, 1954), p. 17.

11. Max Frisch, *I'm Not Stiller* (New York: Vintage Books, 1962), p. 152.

12. Claude Lévi-Strauss. *Tristes Tropiques* (Paris: Librairie Plon, 1955), p. 69.

13. Pierre Reverdy, "Matisse in Light and Happiness," in *Last Works of Henri Matisse* (New York: Harcourt, Brace, 1958). English edition of *Verve* publication.

Index

(Numbers in italics refer to illustrations)